Vietnam Images: War and Representation

Edited by

JEFFREY WALSH
Principal Lecturer in English
Manchester Polytechnic

and

JAMES AULICH
Lecturer in History of Art and Design
Manchester Polytechnic

MACMILLAN
PRESS

First published 1989

Published by
THE MACMILLAN PRESS LTD
Houndmills, Basingstoke, Hampshire RG21 2XS
and London
Companies and representatives
throughout the world

Typeset by Wessex Typesetters
(Division of The Eastern Press Ltd)
Frome, Somerset

Printed in China

British Library Cataloguing in Publication Data
Walsh, Jeffrey, *1938*–
Vietnam images: war and representation.—(Insights).
1. American arts, 1961–1987. Special themes.
Vietnamese wars
I. Title II. Aulich, James, *1952*–
III. Series
700'.973
ISBN 0–333–45800–1 (hc)
ISBN 0–333–45801–X (pbk)

Contents

List of Plates

30 Mike Golden, *Savage Tales*, no. 1 (Marvel Comics) p. 9
31 R. Ledwell, *In-Country Nam*, no. 1 (Survival Art Press, 1987) p. 7
32 Eddie Adams, *The Execution of a VC Suspect* (1968)
33 Maya Lin, Vietnam Veterans Memorial
34 Fred Hart, Vietnam Veterans Memorial

Preface

It is apparent from a large number of films, popular novels and other works that the Vietnam War is continuing to have major cultural repercussions. The war's after-image dominates the consciousness of two generations: those who remember living through the war years of the 1960s and early 1970s, and those for whom the war is only received second-hand. For those in the second category, particularly the young people of the 1980s, the imagery of Vietnam, of napalm, Agent Orange (a defoliant with long-lasting genetic side-effects on humans), choppers, body bags, is transmitted through popular songs, comic books and television series. Vietnam, as remarked by a character in David Morrell's fictional version of the movie *Rambo*, is a gift that keeps on giving. It supplies the symbolic landscapes and action narratives for a plethora of cultural artefacts, and like the two world wars conjures up an aura of loss, deceit, betrayal, nightmare and mind-numbing experience. In other words 'Vietnam' is a word imbued with powerful psychological, social and historical resonances; it is a metaphor for the primary military ordeal of our time.

Although there have been some impressive scholarly accounts of the literature and history of American involvement in the Asian conflict and many excellent memoirs and oral histories, it is extremely important now that the culturally pervasive legacies be studied more widely in an interdisciplinary and multidisciplinary way. Such a methodology lies behind this volume, which represents a spectrum of opinions and analyses of varying lengths but united by a concern with how images structure consciousness and participate in ideological discourse. The volume begins with studies that explore broad cultural archetypes and stereotypes, which are intended to map out wide areas of domain, and these wide analyses are followed by studies of specific genres and works. The book, therefore, is united in its three central concerns: it investigates cultural representations of the war in both popular and high art; it focuses specifically upon American productions and authors; and it scrutinises how the historical imagination of Vietnam is formed, tracing out nuances and inflections in taste and sensibility. Thus culture and ideology are the twin subjects of the essays taken

collectively. One feature of the collection is that it includes essays
by British and continental European writers as well as essays by
scholars born in the United States; thus it has a wider perspective
than a narrowly American ethnocentric one. This opens out the
range of opinion, and lessens the risks of nationalistic bias. Finally,
in looking at images of the Vietnam War, the book centrally
addresses the visual and graphic. The choice of illustrations is
designed to help the reader obtain an insight into iconography and
specular codes.

<div align="right">

J.A.
J.W.

</div>

Acknowledgements

The publishers and editors wish to thank all of those individuals and organisations who generously gave permission for the reproduction of copyright material. Without the illustrations the book would have been severely handicapped, and we are particularly grateful to the Associated Press; the Department of Defense, Still Media Records Center, Washington, DC; Richard L. Feigen; Leon Golub; Richard Hamilton; R. B. Kitaj; David Kunzle; Marlborough Galleries; Marvel Comics; Annalee Newman; the Reinhard Onnasch Galerie, Berlin; James Rosenquist; Gerald Scarfe; Nancy Spero; and Topham Picture Library.

The editors extend their sincere thanks to the staff of the Macmillan Press, and particularly Frances Arnold, Valery Rose and Graham Eyre, for much help and encouragement. Thanks are also due to Clive Bloom and his associates at the Lumiere Press.

The idea for the book came from a research project, 'The Effects of Vietnam on American Culture' (EVAC), at Manchester Polytechnic, funded by the Polytechnic's Research Committee. The project culminated in an international conference, and several papers presented at the conference form the basis of essays included in this volume. The Director of the Polytechnic, Sir Kenneth Green, along with the Dean of the Faculty of Humanities, Law and Social Science, David Melling, and the Chairman of the Polytechnic's Research Committee, Mike Crompton, greatly supported the research work and the editors would particularly like to thank them.

In the preparation of the volume many people played a key role initially in the germination of ideas, and attended seminars, lectures and discussions where opinions were exchanged. In this respect the editors wish to acknowledge the contribution of Alan Fair, Alf Louvre, Antony Easthope, David Huxley, Robert Hamilton, Alasdair Spark, Teresa Wilkie, John Dumbrell, Julian Spalding, Howard Smith, Tim Wilcox, Diana Donald, Michael Klein, Phil Melling, Jon Roper, Katrina Porteous, Sal Lopes, David A. Willson, David and Maureen Harker, Paul Vesty, Liz Yorke, Anthony Barnett, David Leitch, Andy Spinoza, Dennis Pass, Roger Hariban, John Gaul, Peter Davenport, Peter Eldon, Bernard Owen, Jeff Cole,

Larry Campbell, Dave Olive, Elspeth Graham, Pam Watts, Jeff Wainwright, Margaret Beetham and Patrick Noctor.

A collection of essays such as this one would not be possible without hard and often unglamorous work by support and administrative staff. The editors have been extremely fortunate in the valuable help given by the following people, whose skills and expertise have made their task a great deal easier: Carole Burns and Jean Roebuck, who helped with administration; Miranda Shield and Kathy Wilk, who typed most of the script; Martin Mackenzie and Stephen Yates of the Art History Department and Slide Library of the Polytechnic; Beattie Hanley, who assisted with reprographic matters; and Dr Ian Rogerson and his staff in the Polytechnic Library.

Notes on the Contributors

James Aulich is a Lecturer in History of Art and Design at Manchester Polytechnic. He is a specialist in post-war British and American art and graphic design, and has organised exhibitions of contemporary art and graphics, including 'Vietnam and the Graphic Arts'. He has published articles in the *Oxford Art Journal*, *Art Monthly* and *Artists' Newsletter*. He was awarded his doctorate by Manchester University in 1986 for work on R. B. Kitaj.

John D. Bee is head of the department of communications in the College of Fine and Applied Arts at the University of Akron, Ohio. His academic research includes rhetorical theory and criticism.

Mary Ellison has taught general American history and specialised Black Studies courses at Keele University for over ten years. She is author of *Support for Secession* (1972), *The Black Experience* (1974) and *Extensions of the Blues* (1988), as well as numerous articles.

Terrance M. Fox until recently was Assistant Professor of Aeronautical Science at Embry Riddle Aeronautical University, European Division. He now lives in Florida. Professor Fox, who has worked in the theatre as actor, director and producer, is a veteran of the Vietnam War, in which he served as a pilot.

James William Gibson teaches sociology at Southern Methodist University, Dallas, Texas. He is the author of *The Perfect War: Technowar in Vietnam* (1986). He is currently working on a book about paramilitary culture, *Return of the Warriors*.

Harry W. Haines teaches at Trinity University, San Antonio, Texas. He has recently submitted a doctoral dissertation on the cultural repercussions of the Vietnam conflict, and has also written on how Accuracy in Media have responded to the Public Broadcasting Service series *A Television History*. Professor Haines is a Vietnam veteran who has recently revisited Vietnam after an interval of twenty years.

Robert Hamilton is currently conducting doctoral research at the University of Leeds on the role of British photographers during the Vietnam War. He has worked on various exhibitions, including 'Vietnam and the Graphic Arts'. His articles include one that discusses photo-journalists in Vietnam, published in the *Oxford Art Journal* in 1986.

Walter Hölbling is Vice-Chair of the American Studies Department at the University of Graz, Austria, from which he received his doctorate. He has recently been Visiting Professor at the English Department of the University of Minnesota, and is author of *The Discourse of War in Recent American Novels* (1987).

David Huxley, who trained as a painter, was co-organiser of the 'Vietnam and the Graphic Arts' exhibition at Manchester Polytechnic's International Conference of 1986. He has written and drawn stories for British and American underground comics, and is currently researching the growth and development of British alternative graphic magazines. He also organised an exhibition of twenty-two comic artists in 1972.

David Kunzle is Professor of History of Art at the University of California, Los Angeles. He specialises in popular culture as reflected in prints, posters, comic books, fashion design, and so on. His numerous publications include *The Early Comic Strip* (1973), *Fashions and Fetishism* (1982), *Dispossession by Ducks* on the Disney Comic, and the definitive book on American political posters, *Posters of Protest: The Posters of Political Satire, 1966–70* (1971). Professor Kunzle has also written on cartoon and caricature, and has arranged several influential exhibitions of Vietnam War posters.

Robert J. McKeever, who received his doctorate from Keele University for research into American politics, became Lecturer in United States Studies at Bulmershe College of Higher Education, Berkshire, in 1981. He specialises in the interrelationships of American politics, film, literature and history, and also has a particular interest in the United States Supreme Court and its political functions.

Katrina Porteous graduated from the University of Cambridge with Double First Class Honours in History in 1982, and is now

engaged in a doctoral research project, 'Images of War in American Descriptions of the Vietnam Conflict 1963–78'. Katrina Porteous presented a paper at the Vietnam International Conference at Manchester in 1986.

Alasdair Spark has recently been appointed Lecturer in History at King Alfred's College, Winchester. He is currently studying the history and culture of the Vietnam War for his doctorate, and has recently visited the historians of the US armed forces, in Washington. He is the author of several articles, including 'The Myth of the Green Berets'.

Jeffrey Walsh is Principal Lecturer in English at Manchester Polytechnic and co-ordinated the Polytechnic's EVAC ('Effects of Vietnam on American Culture') project. He has written widely on American literature, including the work of Hemingway and e. e. cummings, and is author of *A Tribute to Wilfred Owen* and *American War Literature: 1914 to Vietnam* (1982).

Adi Wimmer was awarded his doctorate by Salzburg University in 1976 and is now Assistant Professor of English and American Literature at the University of Klagenfurt, Austria. He received research grants from the John F. Kennedy Institute to carry out bibliographical research into the literature of the Vietnam War and from the American Council of Learned Societies, which enabled him to study at the State University of New York, Buffalo. He is currently writing a book on the poetry stimulated by the Vietnam War.

1

Introduction

JEFFREY WALSH and JAMES AULICH

It is instructive to consider how sets of images assist our imagination in understanding how wars were fought and what they were fought for. School lessons that perhaps informed us of the heroic Minutemen and of valorous deeds at Valley Forge are likely to construct our responses to the War of Independence, while we may associate the Indian wars with Custer's exploits at Little Big Horn. Possibly, in the latter case, a film starring Errol Flynn as Custer has created certain stereotyping in our minds, and so the reality of the war has more or less passed into film or dream, seemingly devoid of politics. Such an exercise, of trying to remember what images are dominant when we think of particular wars, will quickly teach us how tenuous the boundaries are between verifiable historical fact and mythical embellishment. Literature, of course, has a specially important part to play in making war over into the conventions of artifice. Hemingway's famous account of Caporetto in *A Farewell to Arms*, crystallised in the image of Frederick Henry making 'a separate peace', resonant with metaphors of betrayal, treachery and desertion, suggests the aura of the First World War more evocatively than a sheaf of *War Illustrated* magazines.

By definition the substance of the image is absence, as it conjures that which is no longer present, and, like the mirrored reflection, it can never totally embrace historical reality. Images are likely to decontextualise historical events and create symbolic battles often far removed from real ones. The American military invasion of Grenada is a relevant case. This engagement, recently discussed in a British newspaper[1] as an unmitigated military disaster involving basic communications errors, intelligence failures and logistical overkill, is treated in the successful film *Heartbreak Ridge* (1986). The complexities of America's involvement in Grenada, a member state of the British Commonwealth, are ignored in this film's simple storyline, a narrative which shows the process of myth-making in

1

its most fundamental form. *Heartbreak Ridge* dehistoricises actual political and economic conditions, omits many issues of imperialism or colonisation, and represents the Grenada events as a straightforward triumph of American manhood geared to achieving liberation over contending Communist forces. As a text, *Heartbreak Ridge* is thus not divorced from ideology; what it does not mention is highly significant.

The meanings of images are constantly changing according to their contexts, and this is particularly true of the American involvement in Indo-China. While there are certain images that have come to represent the essential nature of the Vietnam War in the popular media – we think probably of helicopters over the jungle or soldiers high on drugs acting excessively violently or of the Maya Lin wall in Washington – other, more traditional images take on new associations. The old idea of war as a game of chance is thus given new connotations in the Russian-roulette scenes of *The Deer Hunter*, where Vietnamese soldiers and civilians are portrayed as cruel, sadistic and irresponsible. Since there is no basis in fact for this representation of the Vietnamese, the image irresponsibly articulates racist prejudice. The image freezes the reality of the Vietnam conflict, distances its actual history, estranges the viewer from important moral issues, and refocuses the war so as to make scapegoats of the Vietnamese. In the same film, the controlling image of hunting is also open to ideological interpretation, since it serves to embody the spirit of masculine bonding. The male camaraderie of the hunt signifies an exclusive ethos: from this man's world, where the significant conflict of values takes place, women are barred. Interestingly the debate in the United States at present which seeks to give due weight to women's involvement and suffering in the conflict takes account of such sexist representations as *The Deer Hunter*.

As the above instances demonstrate, the easiest ways of coming to terms with the problem of how popular images of war relate to ideological values is to turn to box-office films or to television. War films such as *Top Gun* (1986) or popular television series such as *The A-Team* and *Magnum P. I.* are the most obvious examples. In *Top Gun* the handsome, clean-cut hero, played by Tom Cruise, is a Vietnam orphan, his father having been lost in heroic combat: early in the movie it is proclaimed by an instructor that America must never again depend too much, as in the case of Vietnam, upon technology, but must develop resourcefulness, bravery and

an independent fighting spirit. The film's narrative enacts how the son of Vietnam, Cruise, takes his father's place in fighting the war against Communism: daredevil American pilots outmanoeuvre Russian ones, and thus the story portrays all-American beliefs in healthy competition, red-blooded masculinity and old-fashioned uncomplicated patriotism. Both *The A-Team* and *Magnum P. I.* show well-adjusted Vietnam veterans who occasionally revisit Vietnam to reconfirm their warrior mythos and stiffen up the sinews. Both series suggest that it was the bungling and duplicity of bureaucrats and not the shortcomings of the American fighting-men who lost the war. Thomas Magnum and the A-Team are uncomplicated heroes whose skills, acquired in the 'Nam', are applied back in 'the World' to good causes. Previous disturbing images of the Vietnam veteran, focused in movies such as *Taxi Driver* (1976) and *Tracks* (1976), are sanitised and relegated to the memories of old movie buffs.

James William Gibson argues in Chapter 2 that in the 1970s the prevailing liberalism governed the dominant view of the Vietnam War as essentially a series of mistakes, while in the 1980s the hegemonic viewpoint is the conservative consensus that the war could and should have been won if politicians had not placed unsupportable constraints upon the military. Gibson's argument, which examines paramilitary culture and situates war films predominantly within this culture, acknowledges the reintegrative or revisionist phase of history in the 1980s. Cultural forms and images (notably the *Rambo* discourse discussed in Chapter 13 by Adi Wimmer) reconstitute the American war in Vietnam. Katrina Porteous's discussion of *Platoon* (1986), in Chapter 10, makes it apparent that such broad historical sensibilities and tastes affect the production and consumption of images. A plethora of films, including *Hamburger Hill*, *Full Metal Jacket* and *Gardens of Stone* are examining America's role in Vietnam: it is a fashionable subject and, following the success of *Rambo: First Blood II* (1985), an extremely viable one commercially. *Platoon* rejects the missing-in-action, return-to-Vietnam theme of *Rambo* and relies instead upon the time-honoured formula of the squad movie; it purports to represent collective experience and heavily draws upon the resonances and aura of a succession of earlier war films. For example, the jungle sequences in the film recall those of *Operation Burma* or *The Naked and the Dead*, and war is depicted, despite the occasional helicopter, within a timeless green landscape.

The viewer of *Platoon* receives imagery of the war – of body bags, physical exhaustion, jungle terrain and snakes, hand-to-hand combat, massive heaps of corpses shown in naturalistic detail – by way of myriad reflections caught in verbal and visual languages, all of which hold up imperfect, flawed mirored surfaces to reality. An example will perhaps make this point more firmly: let us take the film's most celebrated scene, where GIs set fire to a Vietnamese village and terrorise its inhabitants. At first viewing of this scene we are perhaps persuaded that the movie is attempting very bravely to confront a truth, perhaps the most fundamental of truths about the Vietnam War, that American troops carried out mass devastation without moral regard for Vietnamese civilians. And yet, if one looks much more closely the scene appears more equivocal, less censorious of the GIs. For example, it is clearly shown that they have been provoked by the enemy, that the hero, Taylor, refrains from actually causing harm, and that the good Americans prevent the rape of two Vietnamese girls, while the scene ends with images of rapport between the invaders and the villagers. Such iconography presents a version of how it was; whether it lies or represents an even-handed appraisal of American pacification or search-and-destroy tactics is really dependent upon how the viewer constructs and interprets the images. A large degree of ambiguity is thus present.

This collection of essays is concerned with such processes, and addresses itself to images of various kinds – filmic, literary, televisual, photographic, musical and auditory – along with the codes of fine art, of sculpture, of posters and comic books. Although the contributors do not represent any one methodological standpoint or political position, they are united in trying to understand how the Vietnam War has been represented both in popular and in high cultural discourse. All the essays deal with the interactions between artistic form and ideology: all look at image clusters and narratives as signifiers of social meanings. The collection, then, is heterogeneous, loosely textured and pluralist, and aims to allow readers space to make connections for themselves. Naturally in such an ensemble recurrent themes emerge – for example, how the shifting relationship between commercial forces and cultural forms affects the styles, modes and overtones of the popular arts.

One major issue to which the book by implication addresses itself is that of how the 'Vietnam' of the imagination changes. This

is essentially what the book is about. To clarify this it is helpful to recall the work of Aby Warburg, whose researches into pagan antiquity and the survival of images led him to theorise that images coined at a time of racial catharsis entered the 'social memory', buried in the history of culture, to await rediscovery. In this way the incomprehensible, the lost, the never-experienced and the unknowable can be articulated in terms of the already known, just as *Rambo: First Blood II*, the movie, comes to stand as much for Reaganite involvement in South America or the Middle East as it does for the recuperated experience of Vietnam (the President's approval of the film is widely known). In other words, the Vietnam War is mediated; it is made harmless; it frightens no longer and can be quite literally handled. Images of Vietnam are constantly resurfacing and being reassembled.

An over-reliance upon crude images of war can result in a massive neglect of historical evidence. The vast popular opposition to America's involvement in Vietnam may easily be forgotten by a generation of children accustomed only to myths of a Rambo rematch. It is an abiding problem of source material: how may one recover from cultural productions a sense of historical reality, so that, in this case, one can understand what it was like to participate in the anti-war opposition or to be moved to action by seeing shocking newspaper headlines or news photos? Several essays in this volume make preliminary attempts to activate such historical recovery. In Chapter 7, David Kunzle explores how the counter-culture and other sections of the population, through the iconography of posters of protest, communicated a powerful dissenting tone. Such posters in their internationalism and popular pacifist sentiment were stridently political and carried polemic and radical energy of a raw and vital kind. Mary Ellison, in analysing a different mode, the popular music written and sung by black Americans, suggests another level of opposition. Her essay (Chapter 4) counters white ethnocentrism as she shows how the musical statements of black performers and composers comprise cultural texts and documents of enormous value in arriving at historical judgements about the Vietnam era. The voices, assumptions, musical styles and rhythms of this music enact an irresistible current of defiance and offer a moving criticism of social injustice, loss of life and political incompetence. The excitement of the 1960s and 1970s as recalled in this account of music is echoed also in Robert Hamilton's attempt, in Chapter 12, to unpack

historical truths and untruths hidden in a single but widely influential news photograph, Eddie Adams' *Execution of a VC Suspect*, perhaps the most famous image of the war. Hamilton traces out the trajectory of the image through shifting contexts and asks pertinent questions about its credibility. Was the photograph stage-managed in any way? How important are its captions, the sites of its production and consumption? How do its meanings alter according to the different contexts in which it is published?

Such art-historical problems also form part of James Aulich's essay on fine art (Chapter 5), and of David Huxley's consideration of comic books (Chapter 11). Both writers are interested in audience, iconography, the specific conditions under which visual works are produced. Although the popular formulas of the comic books differ greatly from the experimental artefacts of *avant-garde* artists, both popular and received culture operate in practical and institutional realms. The 'iconicity' of the image resounds to the note of ideology. Comic books and admired works by established artists are trapped in a network of shifting power relations and are subject to the movements of commerce and capital. Aulich and Huxley argue that what is particularly clear in the case of the visual image is the importance of institutional and formal contexts. The meaning of a comic book or a work of Rosenquist is anchored in or mediated by the discourse of similar works, the technical mode of its production and the means of its consumption. The image finds particular strength in other representations of a similar kind – Vietnam comics thus draw upon conventions of older war comics. The newsworthy photo, such as the Eddie Adams photograph, becomes an event in itself despite its supposed objectivity and documentary status.

A major and recurrent theme in these essays is how America through images is forced to come to terms with defeat for the first time in its history. Jeff Walsh's essay on poetry (Chapter 9) and Walter Hölbling's on fiction (Chapter 8) both examine literary sense-making, how poetic and fictive configurations grapple with loss, suffering, defeat, the reality of facing a Vietnamese population and enemy. Out of such fictive reworkings come archetypal images such as that explored also in Alasdair Spark's essay on the helicopter (Chapter 6). Spark envisions the helicopter as god, technological conveyor of death, shaper of war tactics, image-maker, psychological agent and bringer of culture shock. How could men in tunnels or on foot defeat such an adversary? Spark

follows the dissemination of the helicopter stereotype in popular culture. But even more influential than this popular cultural assimilation of Vietnam technology, through such programmes as *Airwolf* or memoirs such as Mason's *Chickenhawk*, is the memory of defeat and loss. A period of reflection, mourning, reassessment has to take place.

The essays discussing the Vietnam Memorial confront the central issue of American self-identity. The single most potent icon of loss is Maya Lin's wall, whose reflective surfaces literally signify the simultaneously substantial and insubstantial nature of the image as it swings from the image of the present caught in the polished black marble and the historical death tangibly inscribed in its surface. History and the present are reconciled, and perhaps it is for this reason that the wall succeeds as a public monument to the war dead despite its almost universal condemnation as anonymous and unheroic by more conservative interpreters unwilling to grasp the significance of defeat. Terrance Fox in Chapter 16 argues that the monument speaks of bureaucratic and collective values, playing down individual heroism, and so is in keeping with the times, and is especially in tune with how the military are now viewed both by the public and, interestingly, by themselves. Harry Haines in Chapter 15 discusses the feminine characteristics of Maya Lin's wall and its body symbolism, and John D. Bee in Chapter 14 argues that the wall dramatises the principles of Thanatos and Eros. Eros, fulfilment of purpose, associated with spring, is defeated by Thanatos, the movement of death and defeat of purpose. Bee demonstrates how rhetorical criticism and semiology can help us to understand the nuances of images in stone.

Clearly the dominant media, such as television, film and popular fiction, replicate a more consistent and influential stream of images than those found in more marginal codes such as poster production and fine art, which find their strengths in diversity of response and simultaneous subversion of media stereotyping. The struggle over Vietnam and America's resultant examination of its own conscience take place in the media, which become an evolving ethical battleground. Hence the Vietnam War is being refought daily in popular culture all over the world and has become the primary image of war in Western consciousness. At present the conservative myth holds sway, and the dominant figure is that of the Chuck Norris or Stallone hero, a trope of the American individualist catapulted back to Vietnam. Such an avenger, taking

on a lawless foe in impenetrable terrain, is a survivalist endowed with the indomitable resourcefulness of the frontier spirit: he is a traditional hero, in fact, a paramilitary warrior betrayed by the loss of will displayed by bureaucrats and unpatriotic appeasers. This is essentially the argument of Robert J. McKeever in Chapter 3, that American culture altered history so that the events and consequences of Vietnam might be accommodated within an existing mythical framework. How we react to such films as *Missing in Action* or *Rambo* defines our own position in relation to the war and the issues it raised and is still raising today. The imagery of Vietnam is frequently mentioned in discussion of American foreign policy when El Salvador or Nicaragua is on the agenda.

Vietnam, the most publicised and widely viewed conflict in American history, the living-room war, can be represented by no single image. As James William Gibson argues in Chapter 2, only within a plethora of image constellations can its reality be approximated. In literature, for example, a spectrum of books, taking in pulp novels and those by more serious and literary writers, would need to be looked at. Such books form what may be termed sub-codes – there is a sub-code of dramatic literature, one of poetry, one of memoir, one of fiction, for instance. Writings which share similar themes, argot and language should ideally be studied in relation to each other, as Gibson and Hölbling study them; they comment chorically upon the various phases of the war and its outcome and link events in Vietnam with those at home in the United States. Such an evolving tradition, dominated by esoteric and recurrent images of, say, short-timers, medevac (medical/evacuation) choppers, tracers and fragging is paralleled in the genre of film. Similar caveats apply: only by considering a variety of films, taken in chronological sequence, looking at such widely different works as, say, *Who'll Stop the Rain*, *Heroes*, *Coming Home*, *Apocalypse Now* and *First Blood* can we begin to understand the inflections of cultural taste. Within such 'diachronic' or horizontal fields of force specific stories are expressed in 'synchronic' or vertical fashion. The bloodthirsty veteran gradually changes into a patriot, the rebel into a stereotyped ex-serviceman. Only by a methodology of studying a differentiated spectrum of cultural productions, which this book attempts in a preliminary and pioneering way, and through an interdisciplinary focus can we begin to understand one emerging facet of the reality of Vietnam – that it represents what Alasdair Spark calls 'a profusion of wars'.

This book juxtaposes the study of various discursive practices in trying to unearth the ideological significance of cultural representations. It is a valuable task, because images are not merely reflective – they are also active instruments; and popular images of a cruel foe are likely, however untruthful, to provoke action against that enemy. Images may provoke action, influence foreign policy, contribute either to the cessation or to the inauguration of hostilities. They are containers of action as well as receptacles of ideas.

NOTE

1. See 'Focus', *Sunday Times*, 2 Aug 1987, which discusses mistakes made by America's military planners.

2

American Paramilitary Culture and the Reconstitution of the Vietnam War

JAMES WILLIAM GIBSON

The Vietnam War was the United States' first military defeat. It was not a small one. When Vietnam declared its independence from French colonial domination in 1945, the United States backed British and French troops in their effort to regain control. From 1946 to 1954 the United States supported France in its colonial war to crush the Vietnamese independence movement, the Vietminh; after 1950 it paid 80 per cent of France's costs. After the French defeat in 1954, the United States created a government in southern Vietnam, and sent hundreds of millions of dollars in assistance and several hundred advisers and intelligence agents.

In the early 1960s, President John Kennedy escalated US involvement to over 15,000 counter-insurgency troops, advisers and logistics specialists fighting the Vietnamese revolutionary organisation called the National Liberation Front. President Johnson began main-force escalation in 1965. By 1969 over 550,000 US soldiers were in Vietnam. At its peak the Vietnam War involved 40 per cent of all US Army combat-ready divisions, more than half of all Marine Corps divisions, a third of US naval forces, roughly half of the fighter bombers, and between a quarter and a half of all B-52 bombers in the US Air Force Strategic Air Command.

About 58,000 Americans died in Vietnam. (The exact number changes from year to year as some of the 800 servicemen listed as missing in action are reclassified as dead.) Over 300,000 men were wounded; how many Vietnam veterans have later died from medical conditions connected to the war is not known. Over 2.5 million Vietnamese and Laotians were killed. Much of South East Asia was destroyed.

Defeat in Vietnam broke a long tradition of American military victories. All of the land-conquest wars fought against the American

10

Indians from the first skirmishes in the 1700s through to the final battles in the late 1880s ended with the 'Americans' victorious. US forces defeated Spain during the Spanish–American War, and subsequent imperial interventions to protect US corporate interests in Central America and the Caribbean during the 1920s and 1930s also resulted in US victories.

And, in a sense, the United States was the only country to win the Second World War. American allies, particularly the Soviet Union with its 20 million dead, suffered far more than the United States, with 300,000 dead. No combat occurred on American soil; instead the economy expanded tremendously through war production. After the war, the Central Intelligence Agency (CIA) staged coups and successfully manipulated politics in many Third World countries, establishing reliable 'client' regimes favourable to US corporate and political interests. Only the Korean War in the early 1950s ended in stalemate, a return to the pre-war division between North and South.

Debate over why the United States lost the Vietnam War has been confined to two positions. Some liberals have claimed that the great lesson to be learned concerned 'the limits of power'. The United States had expended too many men and too much money fighting in a country that wasn't so important after all. Other liberals viewed the war as a tragic drama fuelled by hubris. The US political leadership, the best and brightest of the land, made a series of 'small decisions', each being 'reasonably regarded at the time as the last that would be necessary'. Historian Arthur M. Schlesinger, Jr, concluded that Vietnam was simply a 'tragedy without villains'.[1]

In contrast, conservatives say that the United States lost the war because of 'self-imposed restraints'. During the war, US generals had constantly complained that political leaders kept them from fighting in the way they wanted to fight, even as troop allotments escalated in 'packages' of 50,000–100,000 combat and support troops and as bombing campaigns in North and South Vietnam and Laos reached levels far beyond the 2.1 million tons dropped by the United States in the Second World War.

After the 1975 debacle this claim became more pronounced. The most famous analysis is Colonel Harry Summer's book *On Strategy*.[2] Summers recapitulates the military's position that there was no peasant social revolution in South Vietnam seeking land reform and national reunification with the North. Instead, guerrilla war,

pacification and building a government that enjoyed popular support were all false idols that distracted US forces from the true enemy, North Vietnamese who were determined to conquer the South and expand the Communist empire. Summers says the United States should have lined up its forces like a wall in southern Laos to keep the foreign invaders out. Other US military men have said that in retrospect a *land invasion* of North Vietnam, taking the chief port, Haiphong, and the capital city, Hanoi, would have ended the war.[3]

But neither the liberal 'Vietnam-as-mistake' nor the conservative 'self-imposed restraint' theory explains what happened. By the technical and economic standards that US war-managers thought were the only appropriate measures in warfare, the United States should have won. After the Second World War the US military reconceptualised and reorganised itself along corporate lines. Officers became 'managers', the enlisted men 'workers', and the product was enemy deaths, the famous 'body count'. Just as the US economy prospered from high-technology, capital-intensive production systems, 'technowar' would produce so many enemy deaths that the other side would be driven 'bankrupt'.[4] General William Westmoreland called this the 'cross-over point', when the North Vietnamese would no longer be able to replace casualties fast enough to maintain a stable force.[5] After the cross-over point had been reached, the North Vietnamese would recognise US superiority and begin negotiations on that basis.

From the technowar paradigm, Vietnamese history, social structure and cultural arrangements did not appear important. Thus neither 'liberals' of the Kennedy and Johnson administrations nor 'conservatives' of the Nixon administration ever saw the significance of traditional Vietnamese resistance to foreign invaders. For thousands of years Vietnamese fought against the Chinese; then they fought against the French from the 1880s until their victory in 1954. Most Vietnamese cultural heroes were nationalist warriors.

Nor did the technological-production orientation towards warfare consider that most Vietnamese were poor peasants with little or no land. Under French rule, land-ownership had become concentrated in a small land-owning and merchant class. Frequently members of this ruling class converted to Catholicism, while the overwhelming peasant majority practised Buddhism, often mixed with Confucianism. The South Vietnamese ruling class

in turn monopolised army leadership, using its position both as a way to appropriate American aid and as a way to collect rents from the peasantry at gunpoint.[6]

Such crucial social dynamics have not been considered in the post-Vietnam liberal–conservative debate on why the United States lost. Both sides remain within the 'technowar' perspective. Within the confines of the debate, the conservative 'self-imposed restraint' school has achieved political hegemony. After Ronald Reagan won the presidential election in 1980, he called the Vietnam War a 'noble cause'. His Secretary of Defense, Caspar Weinberger, officially endorsed the self-imposed restraint position when he announced that the United States would never again ask its men to 'serve in a war that we did not intend to win'.[7]

To overcome these imaginary 'self-imposed restraints' the Reagan administration radically increased military expenditure. By 1984, military spending reached over $200 billion (thousand million) and plans were made for spending $1800 billion between 1984 and 1988. (Historically, major weapons systems have cost over three times their original estimates, and recent systems much more.) Weapons procurement constitutes $670.8 billion of this $1800 billion. In economic expenditures, the United States fought a more intense war in the early and mid 1980s than it did in the 1960s and plans to fight an even greater one in the late 1980s. By 1988 the US military will receive $87 for every $100 spent in the civilian economy for fixed capital formation.[8]

Some of these funds have gone to expand conventional US military forces for new expeditions in the Third World. The Central Command or Rapid Deployment Force, created in the early 1980s, now totals between 200,000 and 300,000 men, besides ships and aircraft. New long-range air transports and aerial-refuelling tankers have been ordered, as have amphibious warfare vessels and floating warehouses called 'near-term pre-positioning ships'. Extensive air bases and port facilities have been prepared in Honduras for rapid US escalation in a war against Nicaragua or leftist guerrillas in El Salvador. Other US bases have been prepared in Egypt and Somalia as staging areas for military deployment in the Middle East.[9]

Overt military operations and 'covert' paramilitary operations have also increased during the Reagan administration. Marines were sent to Lebanon in 1982. US military forces invaded Grenada and overthrew the government there in 1983. Libya was bombed by US planes. Covertly, the Mujahadeen in Afghanistan have

received massive assistance in their war to drive out Russian invaders. Former Nicaraguan dictator Anastasio Somoza's National Guard, now commonly known as the Contras, has received extensive US support in its war against the Sandanista revolution. Over 1000 sophisticated anti-tank missiles, together with jet-fighter and anti-aircraft missile parts, were covertly shipped to Iran in 1986 at a time when the United States was publicly calling for an arms embargo against Iran because of its support for terrorist groups.

Thus, just over a decade after defeat in Vietnam, the United States has expanded its military economy and is engaging in extensive covert operations and 'low-intensity' warfare. How did this happen? How did the massive military defeat in Vietnam become so inconsequential? How did US foreign policy return so quickly to the same basic directions it followed before and during the Vietnam War? Why have the American people supported this political–military direction when the record of expeditionary forces intervening in Third World revolutions and civil wars has been so poor in recent years?

To answer these questions it is necessary to examine not only US economic interests in Third World countries – the traditional question asked when investigating imperialism – but also the mythical place of war in American culture. According to historian Richard Slotkin, 'Myth describes a process, credible to its audience, by which knowledge is transformed into power; it provides a scenario or prescription for action, defining and limiting the possibilities for human response to the universe.'[10] The Indian wars formed a fundamental American myth: to justify taking away Indian lands, first colonists and later 'American' explorers and settlers developed a national mythology in which 'American' technological and logistic superiority in warfare became culturally transmitted as signs of cultural–moral superiority. European and 'American' 'civilisation' morally deserved to defeat Indian 'savagery'. Might made right and each victory recharged the culture and justified expansion – what Sloktin calls 'regeneration through violence'.[11]

Primary American mythology survived the closing of the frontier and the final subordination of the Indians by changing to incorporate new enemies at the very same time US economic and political interests wanted an overseas empire. No one knew for sure why the battleship *Maine* exploded in Havana harbour: Spanish soldiers

could have mined it or its steam boiler could have blown up, a common occurrence among steamships. Both the newspapers and the film industry claimed that the Spaniards were responsible. Early 'motion pictures' re-created the sinking by constructing a model battleship out of a rowboat, filling it with explosives and photographing the subsequent explosion. These special-effects films were highly effective in raising the 125,000 recruits needed for the war.[12]

On 20 April 1898, when President McKinley called for volunteers, he also authorised formation of the First US Volunteer Cavalry, 'to be composed exclusively of frontiersmen possessing special qualifications as horsemen and marksmen'. He immediately offered the unit to Theodore Roosevelt, Assistant Secretary of the Navy, who had long wanted to command a troop of 'harum-scarum rough-riders'.[13]

The name 'Rough Riders' – what the regiment was soon called – was already internationally famous. The original 'rough-riders' were the 'cowboys and Indians' of Willam Cody's (Buffalo Bill's) Wild West Show. Hundreds of dime novels and thousands of short stories had been written about Cody; he had succeeded Daniel Boone and Davy Crockett as the mythical Western hero. When Cody shot Chief Yellow Hand at Warbonnet Creek in 1876, he wore a Mexican black velvet suit trimmed in silver buttons and lace. As historian Henry Nash Smith notes in *Virgin Land*, by the 1870s the blending of the real Cody with his theatrical role had reached 'the point where no one – least of all the man himself – could say where the actual left off and where the dime novel fiction began'.[14]

Some Wild West show members enlisted in the First Cavalry under a special contract whereby Cody was assured they would return to the show once the war was over (Cody did not enlist). Roosevelt filled the unit with the frontier's last generation of cowboys and a sprinkling of Ivy League college men. He also took with him to Cuba two motion-picture photographers from the Vitagraph Corporation.

San Juan Hill has long been remembered as the Rough Riders' great victory. Although the First Cavalry was there, so too were several black infantry and cavalry units, and other white units. Nevertheless, Roosevelt got the glory (via Vitagraph) and successfully campaigned for the presidency as a war hero. Once in office he initiated the 'walk softly and carry a big stick' school of

gunboat diplomacy in the Caribbean and Central America.

Roosevelt also helped transform frontier mythology into the twentieth-century war movie. Stuart Blackton, a partner in Vitagraph, wanted to make a movie based on Hudson Maxim's *Defenseless America*, a book about how easily the United States could be invaded. (Hudson Maxim's brother, Sir Hiram Maxim, had invented smokeless gunpowder, the machine gun, and a high explosive for torpedoes – he worked for E. I. Dupont de Nemours Company, a munitions firm.) Roosevelt arranged a special meeting for Blackton with 'the mayor of New York, Admiral Dewy, Major General Leonard Wood, Elihu Root, president of the War College and Brigadier General Cornelius Vanderbuilt, of the National Guard'.[15] All became enthused about the prospect of much a magnificent sequel to Vitagraph's first feature film, D. W. Griffith's *Birth of a Nation*.

Battle Cry for Peace was released in 1915. A foreign agent named Emanon ('no name' spelled backwards) ideologically seduces a millionaire named Vandergriff to espouse peace. When Vandergriff makes his pro-peace speech in New York City, it is shelled by ships, bombed by planes, and invaded by foreign troops wearing Kaiser Wilhelm moustaches. Vandergriff is shot and his fiancée's mother kills her two daughters and then herself to avoid rape. Fifty million people saw the movie in the United States and Britain.

Vitagraph went on to make many war films based on novels by Sir Gilbert Parker, British Director of Propaganda. The sinking of the passenger liner *Lusitania* in 1915 enlisted the rest of the film industry. *Lusitania* films and the many heirs to *Battle Cry for Peace* formed a war-movie genre soon called 'Hate-the-Hun' films: Germans became a race apart, specialists in rape (allowing lurid sexual encounters) and general mayhem and murder.

War films released after the Armistice were neither uniformly successful, nor consistent in their portrayal of war. Although *Wings* (1927), a silent film about American fighter pilots moved towards its conclusion with the caption 'Home . . . and a man returning where a boy had gone away', and *What Price Glory* (1926) also celebrated the regenerative powers of war, other films, such as *The Big Parade* (1925) and *Dawn Patrol* (1930), were not so glorious.

Still, in the 1920s and 1930s radio heroes such as the Lone Ranger and Superman triumphed over domestic and foreign adversaries. Robert Jewett and John Lawrence see this interwar period as the crucial era for consolidating the 'American Monomyth':

A community in a harmonious paradise is threatened by evil: normal institutions fail to contend with this threat: a selfless superhero emerges to renounce temptations and carry out the redemptive task; aided by fate, his decisive victory restores the community to its paradisal condition: the superhero then recedes into obscurity.[16]

The legendary Western hero (such as Shane) fits this pattern, as do the 'masked crusaders' in comic books, television and films who anonymously save and regenerate their communities through violent action.

Mythic warriors and war culture became much more important during the Second World War. Hollywood and the Defense Department (successor to the War Department) formed a vital working relationship. Hollywood produced thousands of military training films – subjects ranged from political topics such as why Hitler was bad, to basic hygiene, to instruction on how to operate a radio. (Ronald Reagan spent the war making such films.) Hollywood also created war movies to boost American morale. John Wayne films such as *They were Expendable* (1945) and *Back to Bataan* (1945) showed American soldiers valiantly fighting delaying actions against superior Japanese forces.

After the great American victory in 1945, Hollywood and the Defense Department reaffirmed their relationship, with the military providing either free or low-cost technical advisers, tanks, planes, ships, guns and often soldiers to Hollywood film-makers. In exchange the Defense Department had the right to demand script changes to ensure favourable portrayal. According to various estimates, 5000 war movies were made between 1945 and 1965, and 1200 received major assistance from the Defense Department.[17]

This massive film celebration of US war success began just as the United States entered the Cold War. Selective Service initiated a draft for the Korean War that was retained throughout the 1950s. Naval and air forces obtained massive funding to fight strategic nuclear war. New military bases were constructed around the world to 'contain Communism'. A permanent war economy evolved to provide more advanced weapons systems.

In 1947 the House Un-American Activities Committee (HUAC) investigated 'Hollywood Communism'. Major studios, broadcasting networks and other media outlets, together with film-industry organisations such as the Screen Actors Guild (Ronald Reagan was

its president) all co-operated with HUAC, the Federal Bureau of Investigation (FBI) and 'private' security firms in blacklisting politically left-of-centre media workers. Making war movies and Westerns was politically safe, a sign of alignment with Cold War politics.

War movies and Westerns are not varieties of the same genre; each type has its complexities, and both changed from 1945 to 1965. Nevertheless, war movies and Westerns presented a highly coherent view of American war (with rare exceptions) that encompassed the Western wars against the Indians and the foreign battles of the Second World War.

First, war films show the United States always fighting on the morally correct side. While killing enemies is rarely shown as pleasurable, it is seldom portrayed as causing sorrow either.

Second, US soldiers win almost all battles and always win the war. Good American soldiers, with relatively egalitarian relationships with each other (even between formal ranks), shoot better than bad Indians, Japanese or Germans, who are regimented in a hierarchy and ultimately controlled by a dictator chief. Might and right go together in the war-movie code.

Third, war movies show good guys and bad guys, but few innocents. Warfare is portrayed as a clean fight between two forces; rarely are civilians caught in crossfire. When civilians are killed, they die at the hands of the bad guys.

Fourth, war does not appear dangerous. In most cases the principal American heroes and most of the secondary heroes survive battle. In those rare cases where the hero is killed, as John Wayne's Sergeant Stryker character is in *The Sands of Iwo Jima* (1949), his martial spirit passes on to a younger soldier. Bullet and shrapnel entry and exit holes appear as small red dots. No one screams in agony. The dead die quickly; the camera pans over the body and returns to the living.

Finally, war movies portray war as a crucial ritual transition from male adolescence into manhood. Boys arrive at basic training-camp, where a harsh but secretly loving drill instructor forces them to bond together. Recruits abandon their shallow class, ethnic and regional prejudices, replacing them with egalitarian mutual respect for their achievements in training as they collectively approach manhood. Soldiers then go off to war (where they bond even tighter) and the surviving victors are certified men. In Westerns the master warrior or warriors don't 'go home'. In war movies,

however, soldiers frequently talk of going home. War movies imply that the soldiers' victories will be well respected since they have both defended their society and embody the society's highest ideals; their war success infuses society with their powers.[18]

Baby-boomers grew up on this war and Western mythology. Around 3.5 million men went to Vietnam. Memoirs, oral histories, novels and poems by veterans make frequent mention of the war movies and Westerns they watched as teenagers. Ron Kovic writes in his memoir *Born on the Fourth of July*, 'Every Saturday afternoon we'd go down to the movies in the shopping center and watch gigantic prehistoric birds breathe fire, and war movies with John Wayne and Audie Murphy . . . I'll never forget Audie Murphy in *To Hell and Back*.'[19] Kovic enlisted after recruiters visited his high school. Philip Caputo entered Marine Officers Candidate School for similar reasons: 'For me, the classroom work was mind-numbing. I wanted the romance of war, bayonet charges, and desperate battles against impossible odds. I wanted the sort of thing I had seen in *Guadacanal Diary* and *Retreat, Hell!*'[20]

Most combat soldiers quickly learned the difference between war-movie fantasy and real war. On Kovic's first operation he accidentally killed an American corporal. Another man's movie dissolved when he killed an enemy soldier: 'I felt sorry. I don't know why I felt sorry. John Wayne never felt sorry.'[21] US military headquarters in Saigon was satirised as 'Hollywood West' and John Wayne's name soon was taken in vain, either as a metaphor for a foolish act, as in one sergeant's instruction to newcomers, 'Now, we don't want to see no John Wayne performances out there', or as an invective against war horror, as in Charles Anderson's *The Grunts*: 'There was no longer any doubt about what warfare in the modern industrial era had come to mean. The grunts – newbys, short-timers, and lifers alike – could see now that what happens to human beings in mechanized warfare has absolutely no poetic. Fuck you, John Wayne!'[22]

But politicians further removed from battle did not learn. President Richard Nixon saw *Patton* several times in spring 1970. George C. Scott portrayed the Second World War general as a brilliant eccentric whose vision and valour saved an American airborne division under siege from a German offensive. According to former Secretary of State William Rogers and White House Chief of Staff H. R. Haldeman, Nixon talked incessantly about the movie while deciding that US forces should invade Cambodia. Nixon even

ordered American military chaplains to pray for a change in weather, just as Patton did.[23]

In April 1972, when faced with a massive North Vietnamese attack, Nixon told General John Vogt, commander of the Seventh Air Force, that 'he wanted somebody to use some imagination, like Patton'. Vogt reports that Nixon made frequent allusions to the movie, telling him, 'I expect you to turn back the invasion and we will emerge with a victory. We will not abandon Vietnam.'[24] The first B-52 bomber attacks over the North began that month.

In November 1972, after Nixon had been re-elected and the United States had gone back on its agreement to sign the Paris Peace Accords, journalist Oriana Fallaci asked Secretary of State Henry Kissinger why he was so popular. Kissinger replied,

> I'll tell you. What do I care after all? The main point stems from the fact that I've always acted alone. Americans admire that enormously. Americans admire the cowboy leading the caravan alone astride his horse, the cowboy entering the village or city alone on his horse, without even a pistol maybe, because he doesn't go in for shooting! He acts, that's all: aiming at the right spot at the right time. A Wild West tale, if you like.[25]

When North Vietnam did not agree to reversing the terms of the treaty (from a recognition of US defeat to terms indicating US victory) Nixon and Kissinger ordered massive B-52 attacks on Hanoi and Haiphong. These bombing attacks failed; the treaty signed in January 1973 was almost identical to the previous one. In April 1975 US helicopters evacuated Americans from Vietnam.

Defeat in Vietnam created a twofold crisis for the United States. First, its inability successfully to exert its power ended US dominance in world affairs. Second, defeat created a cultural crisis among the American people. There had been no 'regeneration through violence'. Assumptions about what was right and how the world operated became problematic – and domestic challenges to the natural order of things had already been raised by the civil rights, anti-war and feminist movements.

American culture did not have any mythical narratives and visual symbols to explain why US forces had not achieved victory. There was no popular cultural archetype to account for successful Vietnamese resistance to foreign invaders – the Indians had always lost. Nor did the major news media, especially network television

news, provide any different framework for interpreting the war. For the most part, network news correspondents and politicians reported what leading US generals and politicians said about the war. News cameras in turn showed thousands of images of sophisticated American technology such as jet fighter bombers, helicopters, tanks and ships. Once ABC television news contrasted the immense power of the newly recommissioned battleship *New Jersey* to the 'Vietcong Flying Trashcan', a homemade rocket (looking like a trashcan) on a stick mounted in the mud along a river bank.[26] Weekly bodycount summaries always showed Vietcong losses as several times greater than those of US and allied forces. Relatively few bodies and almost no blood were shown. Technowar appeared clean and productive on the news; of course the United States would win.

But 'self-imposed restraint' offered the American people a way to make sense of failure in Vietnam; that position plunges into the core of American mythology. In Westerns, the hero must take law into his own hands, because the power structure has failed to confront a challenge to society. Masked superheroes operate outside the law to win victories the authorities cannot or will not win. The modern detective hero works outside the police bureaucracy and often outside the law to preserve the spirit of the law, justice. It is only a short cultural distance from these classic American heroes who act outside the power structure in order to save society to American soldiers who are *restrained by corrupt or cowardly politicians and thus not allowed to win the war*.

From the early 1970s to the late 1980s American culture has been reinterpreted to fit the war in Vietnam and those who fought it into this myth – reworked its classic heroes into a 'new' version of the warrior and war culture. This new 'hero' is the 'parliamentary warrior', paramilitary in the sense that the new heroes are rarely members of conventional military or law-enforcement bureaucracies. He is the centre of an emerging paramilitary culture that is actively redefining notions of peace and war to the American public. This culture posits *a mythical interpretation of the Vietnam War* and *a new war* as the path to health for the warrior and regeneration for a society weakened and troubled by mysterious military failure and a world it can no longer control. And it permeates movies, television, book and magazine publishing, even the clothing industry.

Hollywood's first wave of Vietnam films began in the late 1970s –

The Deer Hunter (1978), *Taxi Driver* (1976), *Who'll Stop the Rain* (1978) and *Apocalypse Now!* (1979). In each film, a Vietnam veteran returns to war. In *The Deer Hunter* Robert De Niro plays an elite US Army Special Forces soldier who returns to Vietnam to rescue a friend gone native, drug-addicted and insane. His warrior skills enable him to maintain his sanity and survive. In *Taxi Driver*, De Niro plays a Vietnam veteran who cannot create a meaningful life for himself in New York City, and decides to become a warrior again. After failing to assassinate a presidential candidate, he shifts his war towards the pimps who manage a young prostitute he has tried to befriend. *Who'll Stop the Rain* finds Ray Hicks as a veteran who must go to war inside the heroin trade to save a journalist friend he knew in Vietnam who tried to make money importing the drug from Vietnam to the United States but did not have the warrior skills to survive.

In *Apocalypse Now* Martin Sheen plays a drunken, distraught Army captain in the Studies and Observations Group (SOG, the principal covert-operations commando organisation in Vietnam) who returns to Vietnam begging a new mission because he can no longer function back in the United States. Sheen's character, Willard, becomes progressively healthier as he moves up-river on his mission to assassinate a renegade colonel who no longer takes orders from higher command.

But these 1970s films demonstrate great ambivalence about the desirability of returning to war. The De Niro character in *The Deer Hunter* brings back his friends' body, not a living man. Although taxi driver Travis Bickle becomes a media hero, his second war does not make him sane. Ray Hicks saves his friend, but is killed in the effort and intelligence agents get the heroin. And Willard kills Colonel Kurtz (played by Marlon Brando) because Kurtz wants to die. His death only frees Willard from his last connections to the military.

In January 1981 Ronald Reagan replaced Jimmy Carter as President. At the same time fifty-one American hostages who had been held prisoner by Iran were released. Interviews with Hollywood directors, Robert K. Brown (publisher of *Soldier of Fortune* magazine) and editors of paperback commando novels all confirm that the Iran hostage crisis with its failed 'Desert One' rescue mission and the election of President Reagan marked the ascendancy of paramilitary culture.[27]

The transition film appeared in 1983. *Uncommon Valor* introduces

an unhappy array of Vietnam veterans. Some are clearly down and out; one is in jail. Those with middle-class jobs and families seem a bit bored. At first they resist the call to return to war, but duty to lost comrades beckons. When these men regroup to train for an independent, privately financed mission to rescue their missing comrades held prisoner in Laos, they become mentally and physically healthy warriors again complete with a transcendent purpose in life for which they are willing to die. And most do; the trade-off of rescuers for prisoners is about one to one.

A new war-movie genre soon blossomed. Sylvester Stallone's John Rambo character illustrates this change from ambivalence about the value of a second war to redemption through war. In *First Blood* (1983) Rambo suffers from post-traumatic stress disorder and inadvertently destroys a small Oregon town after being persecuted and then hunted by an arrogant sheriff. Instead of being treated for his affliction, he is sentenced to years of hard labour on a chain gang breaking rocks. In *First Blood II* (1985) Rambo is offered a presidential pardon if he will rescue American prisoners still in Vietnam. His first question to Colonel Trautman is framed around the self-imposed-restraint position: 'Do we get to win this time?' Rambo finds the prisoners only to be betrayed and abandoned by the commanding CIA officer. No prisoners are to be brought back because they would embarrass the government. Left on his own, however, he becomes the unrestrained warrior of myth who readily vanquishes Vietnamese who wear Second World War Japanese Army caps and their Russian KGB superiors, who look and sound much like war-movie Nazis. Myth readily substitutes one enemy for another, combining them in ways that make cultural sense: if white Russians really controlled and directed yellow Vietnamese, then US defeat becomes more understandable and belief in white superiority is confirmed.

Rambo illustrates four other vital aspects of paramilitary culture. First, the Vietnamese are not shown as real people from a different culture with different political values. Instead the Vietnamese are portrayed as *criminals*. They retain American prisoners as slave labourers and savagely abuse them. One prisoner is crucified on a bamboo cross. Vietnamese guards sadistically enjoy such abuse; the Communists are *sexually perverted*. As criminal sexual perverts, the Vietnamese do not represent an alternative kind of society, different from American capitalism, but rather they are *outside the*

boundary of moral conduct of any sort. Communism is thus shown as a kind of organised criminal hierarchy.

Second, Stallone exemplifies the paramilitary warrior's bodily power. Modern warrior heroes are almost all in superb physical shape, often having extensive martial-arts skills. Neither the classical Western hero with his fast gun draw nor the detective with his reasoning ability nor the soldier leader achieved power from tremendous bodily strength. The new warrior appears as a unified biological and mechanical *weapons system*; there is no separation between body and weapons. Rambo is, as Colonel Trautman calls him, a 'pure fighting machine'.

Third, Rambo illustrates the paramilitary warrior's inclination to work either alone or in very small groups of brother warriors. American mythology has traditionally portrayed the Western hero warrior operating this way. Warriors are shown as consummate male individualists; to be a warrior is to reach the social position that has the most autonomy. As a mythic warrior, a man expresses his individual potential with his own personal style. Real military organisations are very different; the military is a completely hierarchical institution.

Fourth, the warrior's sexuality often kills his women lovers. When Rambo kisses his female Vietnamese contact, he marks her for death. A warrior's masculinity is confirmed by battle against other men, and his valour is judged by male accomplices or superiors. Sexual relations with women do not confer manhood, and are secondary to more essential relations with fellow warriors. The principal male enemy whom the paramilitary warrior kills in the final 'duel' is often a far more intimate partner to the hero than women lovers.

While many new war movies place their second, redeeming battles in Vietnam, the genre has rapidly expanded to include victories on a worldwide battlefield. *Delta Force* (1986) begins with scenes of a helicopter crashing into a C-130 transport in the Iranian desert. Years later Chuck Norris (who plays a retired commando) is watching television and drinking a Budweiser when the news announces a jet-hijacking by Arab terrorists belonging to the New World Revolution. He rushes to Fort Bragg and rejoins Delta Force and off they go. Norris kills the Arab leader with his rocket-firing motorcycle.

Iron Eagle (1986) opens with an unnamed Middle East country shooting down an American F-16 that has challenged its claim to a

was well versed in paramilitary operations.[28] Many of the elite 'commando' oriented men who served in SOG and other special units, such as Army and Marine reconnaissance and Navy SEALs (Sea–Air Land), became professional warriors, operating as contract operatives for US intelligence missions, serving in other countries' armies (such as Rhodesia and Nicaragua before their respective revolutions), and working as bodyguards or security experts for corporations and businessmen.

20,000–30,000 men served in the commando and reconnaissance units during the Vietnam War. In 1987 around 30,000 US soldiers had been trained and assigned to service in commando, reconnaissance, counter-insurgency and special assault units. Several thousand policemen have volunteered for duty in Special Weapons and Tactics (SWAT) teams across the country. Taking all these together (plus the few hundred real mercenaries), the potential *SOF* community of real warriors totals perhaps 75,000 at most (and that may be way too high). Although this may sound a large number, it is relatively small compared to either the total number of Vietnam veterans (3.5 million men) or the number of American men aged between eighteen and fifty. 75,000 is also too small a number to make a mass-market magazine profitable.

But one of *SOF*'s most brilliant features is that it has extended its appeal far beyond the audience of professional warriors. The image of the paramilitary warrior fulfils traditional concepts of masculinity, and in him *SOF* successfully creates a gender ideal for all men – the magazine makes such an identity seem more accessible than movies do. Soldiers and policemen can be warriors, but so can factory workers, clerks, small businessmen, professors and corporate executives. Being a warrior is not an occupation but a male identity.

What characterises the *SOF* warrior? First and foremost, the magazine presents what can be called 'cosmopolitan anti-Communism'. *SOF* reporters and freelancers travel to many of the world's war zones. Photo essays on Afghan rebels have appeared regularly. *SOF* training-teams frequently travel to Central America. In El Salvador they teach elite shock batallions how to maintain their M-60 machine guns and fire 81mm mortars accurately. In Honduras they assist the Contras – Brown and other *SOF* personnel have been implicated in shipping arms – and *SOF* freelancers accompany them on raids in Nicaragua. Interviews with Contra leaders are a routine feature. Other stories come from travels with South African

The A-Team ran for several years as an elite commando group that was accused by corrupt elements of higher command of killing Vietnamese civilians. Convicted of murder and sent to military prison, they escaped and became a Robin Hood style mercenary force for hire by victims of injustice who were not helped by the legal authorities.

Magnum P. I. is about a Hawaii-based detective who served in Vietnam as a Naval Intelligence officer. Magnum still has contacts with Naval Intelligence (he's in the naval reserves), hangs around with former members of his Vietnam team and one retired British Army Intelligence officer, and has easy access to his buddy's helicopter. Over the years Magnum and his group have rescued dissidents in Kampuchea (Cambodia) from his former Vietnamese Communist enemies, killed both Russian KGB agents and North Vietnamese agents operating in Hawaii, and performed a few jobs for former Navy bosses.

Miami Vice shows two Vietnam veterans who return to war as detectives trying to stop drug-dealers and gun-runners, who have made America itself a *war zone*. 'Bad guys' armed with submachine guns routinely shoot it out with Crockett and Tubbs. The two detectives' girl friends often die or just disappear; the male warriors remain undomesticated. Crockett and Tubbs often meet defeat because their investigations are stopped by the CIA or other high-level government agencies who need the gun-runners or drug-dealers (and their corporate-banker partners) for covert actions. In this respect *Miami Vice* sometimes presents the most radical analysis of the US government and corporate capitalism found on commercial television.

Moreover, when the Vietnam War is discussed, the conversations focus on American massacres, drug-dealing and high-level government lies. In one 1987 episode, *Miami Vice* even had a North Vietnamese intelligence agent as the hero – he successfully tracked down a political assassin who first worked for the CIA's Phoenix assassination programme in Vietnam and was now killing leftist politicians for a former CIA colleague and his unnamed anti-Communist group. Often, though, the show just puts a hip, luxurious twist on paramilitary culture.

In November 1986 the Crockett character appeared on the cover of *Soldier of Fortune* magazine. *SOF* was started in 1975 by a retired Army Special Forces colonel named Robert Brown. Brown had served as an 'A-team' commander during the Vietnam War and

commander's order prohibiting the platoon from capturing a crucial hill. In the process, both a black enlisted man who wanted to become a rock musician and the lieutenant discover their true warrior selves. At the end the sergeant is reconciled with his ex-wife (who always loved him but couldn't stand the strain of waiting while he was at war) and faces retirement secure in the knowledge that he has spiritually reproduced himself. He leaves the Marine Corps with 'one, one, and one' – one victory (Grenada), one tie (Korea) and one loss (Vietnam).

The real Grenada invasion came only days after 245 Marines were killed in Beirut; part of the invasion force was *en route* to Lebanon to replace the soldiers garrisoned there. Bernard Coard's regime had offered to co-operate in evacuating all Americans from the island. The medical students whose 'rescue' provided the pretext for the invasion weren't secured until late in the second day of the invasion, giving the Grenadans plenty of time to execute them if they so wished. The 'military' airport on Grenada was built with assistance from many countries, including the US Agency for International Development. In essence the Reagan administration sought to replace defeat in Lebanon with a public-relations victory in Grenada.

Hollywood redemption of Beirut came a few months after the Grenada film. *Death before Dishonor* (1987) shows Fred Dyer as a Marine Corps sergeant and Brian Keith as a colonel stationed at the US embassy in a Middle East country. International terrorists (white Europeans, dressed in punk fashion) help local Arabs steal US weapons. Sergeant Burns pursues, but the bad guys get away. The black ambassador chastises him, 'At no time were your orders to pursue hijackers through the streets endangering civilians.' The terrorists then kidnap the colonel (who was friends with the sergeant's father) and a Latino private. Even after the enlisted man's body is dumped in front of the embassy, Ambassador Morgan intones, 'You realize this does not change anything.' But then the embassy is blown-up by a Beirut-style truck bomb.

Sergeant Burns goes to war, assisted by the Israeli Mossad, and his brother Marines. They storm the terrorist garrison and rescue the colonel. Burns kills the Arab leader, and then chases the European terrorists through the desert, finally crashing his jeep into their truck. Neckbones protrude from the male terrorist, while the female has a .45 crater in her forehead. Burns emerges unhurt.

In television these themes continue, but without the sharp edges.

200-mile offshore territorial boundary. The pilot is captured, tried as a criminal and sentenced to hang in three days. Back at their California base, the squadron commander tells the pilot's son that 'The White House has our hands tied.' Doug (the son) then steals two F-16s with the help of a retired black pilot and successfully rescues his father, shooting down several enemy planes as he goes. To reach the high plateau of mind–body co-ordination needed for this mission he plays hard-beating disco music from a cassette recorder strapped to his thigh.

In *Top Gun* (1986) Tom Cruise's 'Maverick' character ranks among the Navy's top 1 per cent of fighter pilots, but he is cocky and unstable, secretly troubled by the legacy of his dead father's mysterious bad reputation. Although he graduates from advanced air-to-air combat school, he is not head gunfighter. But on a subsequent mission he shoots down several MIGs, subordinates his egotism to group safety and emerges a mature man. He then learns that his father was really a Vietnam War hero killed on a secret mission.

By the end of the movie Maverick has overcome his grief at the death of his former navigator, found a father substitute (the senior Top Gun instructor, who was saved by the father on the secret mission), won the respect of his peers, regained the lustful love of a beautiful, brilliant woman, kept his other mistress (his very hot F-14) and become a Top Gun instructor with the task of reproducing his warrior skills among new fledgling top guns. When the movie came out, naval recruiters did quite well. Female students at the University of California at Los Angeles reported that the bars near the Top Gun base near San Diego were the place to go, and that even in Los Angeles strange men began singing to them as a pick-up technique, just like in the movie. This film grossed $175 million in 1986.

Clint Eastwood goes back to war for a *third* time in *Heartbreak Ridge* (1986). As an aging gunnery sergeant approaching retirement he takes command of a sloppy reconnaissance platoon. He inspires the soldiers, ignores a weak intellectual lieutenant who formally commands the platoon, and becomes into conflict with the ambitious battalion commander, who has no combat experience but is instead an Annapolis graduate whose expertise resides in management and logistics.

Eastwood leads his platoon to great victory over the Cuban Army during the Grenada invasion by defying the battalion

Army commando groups and Angolan guerrillas (Holden Roberto's UNITA organisation) as they try to destroy the leftist Angolan government and various anti-apartheid guerrilla groups which are categorised as pro-Communist, and therefore the enemy.

SOF also reports on the world's elite commando units – the British Special Air Service and Special Boat Service, Germany's anti-terrorist organisation GS-9, the French Foreign Legion, Israeli paratroopers, and so on. *SOF* thus reads much like *National Geographic* in that both are structured around travelogue narratives with extensive colour photography, except that *National Geographic* looks at Third World cultures and animals, while *SOF* examines small warrior societies and Third World insurgencies and counter-insurgency efforts.

Underlying these world travels to battlegrounds and barracks is the familiar image of the war that could have been won except for self-imposed restraints. Brown founded *SOF* in 1975, the year American efforts in Vietnam finally collapsed. The 'I Was There' monthly feature frequently revisits personal combat encounters in Vietnam, while longer articles cover more famous battles such as Khe Sanh in 1968 or survey different military units serving in Vietnam, especially special-operations units. Almost all individual battles end in US victory. Political leaders and the Pentagon are routinely criticised for general US defeat in Vietnam; their lack of resolve in pursuing becomes the justification for 'independent' or paramilitary warriors who will do what governments are afraid to do.

Another crucial component of being a paramilitary warrior is being an expert on contemporary 'weapons families' – the rifles, machine guns, submachine guns, pistols, knives, grenades and anti-tank rocket-launchers carried by both Western and Communist light infantry. Each *SOF* issue covers at least one modern weapon in depth. In this respect it resembles *Consumer's Report*; indeed, some new weapons are taken to Central America for 'battlefield testing'.

Paramilitary culture calls for extensive consumer purchases. Not only must a paramilitary warrior know about the weapons: he must own them. Semi-automatic assault rifles and carbines begin at around $300 and most cost $500 and upwards. Almost all the world's assault rifles (including Chinese and Yugoslavian manufactured AK-47s) are now sold in American gun stores and most manufacturers advertise in *SOF*. A back-cover advertisement

by the German firm Heckler and Koch shows a commando dressed in black (with black warpaint on his face and a black bandana covering his head) crouched over a log in about three feet of water. There's a big rope on the log and in his hand he holds a HK-91 semi-automatic assault rifle. The caption reads, 'When you're determined to survive, you leave nothing to chance.' The warrior's survival *requires* that he purchase weapons.

A warrior needs more than one or two ammunition magazines, and these cost $8–30 apiece – having ten magazines, each holding 20–30 rounds of ammunition, would not be exceptional. With these weapons, it's easy to fire a few hundred rounds of ammunition (at 10–30 cents a round) in an afternoon at the range. Each major weapon also has many accessories marketed by several competing firms. Flash-hiders attach to a rifle's muzzle to hide the light given off by guns when fired at night. Compensators, often combined with flash-hiders, direct gas discharges upwards so that gun barrels will not move upward when weapons are rapidly fired. Telescopic and other kinds special optics (costing $100–500) are considered necessary for a truly advanced assault rifle.

Until 1985 *SOF* also carried advertisements for special kits of gun parts that converted legal semi-automatic rifles into illegal fully automatic machine guns. (In 1985 the Bureau of Alcohol, Tobacco and Firearms began to enforce existing laws concerning weapons and weapons parts far more strenuously.[29]) Other ads offered kits to create 'silencers' or 'noise-suppressors' (to use the technically correct term). These devices are long tubes filled with washer-type rings or other buffering materials that allow the gases from weapons to expand slowly before reaching the general atmosphere, changing the gunfire 'crack' of gas expanding faster than sound into a more muffled, sub-sonic noise.

To complement the basic assault rifle come 'back-up' or supplemental weapons: military pistols ($350 for the Austrian Army Glock 17 to $650 for the US military's Baretta 92SB) holding 13–19 rounds of 9 mm ammunition, crossbows ($250–500, depending on whether they are equipped with telescopic sights) firing relatively silent arrows up to 75 yards, and huge, expensive 'survival knives' costing $75–300. Inexpensive weapons are usually disdained; state-of-the-art weapons signify competence and seriousness.

Besides weapons, warriors need two-way radios, binoculars, bullet-proof vests, various kinds of 'web' gear or 'assault vests' to carry all their equipment, and multiple-pistol holsters for hips,

shoulders and ankles. New models are marketed each year. All these consumer goods are advertised in *SOF*; one demographic study conducted in the late 1970s found that most *SOF* subscribers spend over $1000 a year on weapons and accessories. Through this consumption the paramilitary warrior can easily reach armament and accessory levels equal to most police SWAT teams and individual infantrymen in Western armies.

At the base of this array of weapons and accoutrements, the paramilitary warrior wears *camouflage uniforms*. 'Camouflage' normally means clothing or paint schemes or special devices that help a soldier, vehicle, plane or ship blend into the natural environment so that the person or object's silhouette will be diffused. But, in paramilitary culture, camouflage clothing has the exact opposite function. Camouflage doesn't hide anyone. To pass unnoticed in urban, suburban or rural areas requires dressing as local inhabitants do, in business suits, workman's clothes or casual wear. Wearing olive green or woodland or desert camouflage or SWAT black camouflage indicates that an individual identifies himself as a warrior.

Camouflage clothing also gives men a way to play with costumes, accessories and make-up without appearing effeminate. At a fantasy level, changing clothes means the warrior is no longer bound by the moral code governing civilian actions. To change clothes and put on make-up allows men to fantasise that they have become truly different from the ordinary, law-abiding men they normally are. In the minds of psychotics, this fantasy transition marks a real transition. One man in San Diego changed into camouflage clothes, took over a McDonald's restaurant and murdered twenty-six people with his Uzi 12-gauge riot shotgun and Browning 9 mm Hi-Power pistol (favourite paramilitary weapons). A number of similarly dressed and equipped killers have recently been reported in newspapers.

For more 'normal' men, wearing camouflage signifies a 'key-club' sign of membership of a social–political community of like-minded males who can recognise their common interests and beliefs by their common attire. For example, camouflage fatigues are the required dress at the annual *SOF* conventions in Las Vegas. Here several hundred men attend seminars on how to fight Russian tanks with small arms, hear speeches from famous anti-Communist leaders, and can examine the latest weapons at a huge exposition in the Sahara Hotel and Casino.

Until 1986 the most significant item offered in *SOF* was, literally, 'soldiers of fortune'. A typical classified ad read: 'MERC FOR HIRE: 43, anything, anywhere, work alone, short-term only. Bounty hunting. Will take commission job', followed by a first name and post-office box. A CBS *Sixty Minutes* news investigation in 1986 found that police in twenty states were investigating murders and other serious crimes linked to men hired through *SOF* ads. After CBS announced its findings, *SOF* discontinued taking such ads. In 1988 the magazine lost a 9.4 million dollar lawsuit filed.[30]

SOF has thus created an incredible combination of real counter-insurgency warfare, mercenaries and military units mixed with traditional American themes of cultural regeneration through violence and a warrior identity for men, ideological anti-Communism, a populist scepticism towards political leaders and consumerism. *SOF* claims that it has around 35,000 subscribers and news-stand sales of another 200,000 or so each month (apparently issues with war-movie covers do the best).

Since the mid-1980s, several competing magazines have entered the field. *Gung-Ho, Eagle* and *New Breed* followed the *SOF* format closely, but with less extensive world travelling; they do not have quite the same cosmopolitan air. *Vietnam Combat* simply tells adventure stories from Vietnam in a cheap newsprint format. *SWAT* and *Combat Handgunner* basically test combat pistols, revolvers, carbines and police shotguns and offer a vision of man as 'gun-fighter', while *American Survival Guide* concentrates on the consumer goods to fight and survive in a mythic post-disaster, post-limited-nuclear-war America where life resembles life on the old Western frontier. Not all of these magazines have been successful. Some fold, but new ones soon take their place.

Paramilitary culture's vision of permanent international war filled with constant personal combat for warriors finds its most openly violent exposition in pulp novels. Don Pendleton established the Mac Bolan series with Pinnacle Books (strictly a mass-market paperback house at the time) in 1969. The series opens with Army Serveant Mac Bolan returning home from Vietnam on an emergency leave to visit what is left of his family. Times had gone sour for the Bolans. Dad had heart trouble and lost his job. To support his family he got loans from the Mafia. The Mafia beat him severely when he couldn't pay, so little sister Cindy had to become a prostitute in a Mafia brothel. Dad found out, shot Cindy, his wife, his younger son and then himself. Only the son survived.

When Sergeant Bolan comes home and learns these terrible truths, he declares war on the Mafia and becomes 'The Executioner'. In the prologue to the first book Pendleton describes the character needed for a successful executioner:

Mac Bolan was not born to kill, as many of his comrades and superiors secretly believed. He was not a mechanically functioning killer-robot, as his sniper-team partners openly proclaimed. He was not even a cold-blooded and ruthless exterminator, as one leftist news correspondent tagged him. Mac was simply a man who could command himself. He was the personification of that ideal advanced by the army psychologist who screened and evaluated sniper-team candidates: 'A good sniper has to be a man who can kill methodically, unemotionally, and *personally*. *Personally* because it's an entirely different ball game when you can see even the color of your victim's eyes through the magnification of a sniper-scope, when you can see the look of surprise and fear when he realizes he's been shot. Most any good soldier can be a successful sniper *once* – it's the second or third time around, when the memories of personal killings are edged into the conscience, that the "soldiers" are separated from the "executioners".'[31]

Bolan slaughters his way across the United States in a 'warwagon' van for the first thirty-eight volumes in the series, each book a stop at a city where he kills dozens of Mafiosi and takes their illicit funds to finance more killings in other cities. Bolan dresses completely in black for his missions, wears a .44 Automag (a huge custom-built pistol) and a special silencer-equipped Baretta 9 mm that fires three-shot automatic bursts.

Pendleton graphically describes almost every shot and its impact on human flesh. In *The Executioner #30: Cleveland Pipeline*, 'The big silver hawgleg thundered its disgust with savage games. A chunk of Lenny's head skipped off across the water, trailing muck and crimson fluids behind it.' Later Bolan sends 'nine millimeters of sighing death splattering into that constricted throat, a warning cry caught there and pinched off in the dying gurgle'. He shoots another 'nine millimeters sighing ahead to clear the way, smacking the guy in at forehead center and punching the guy onto his back and sliding in his own fluids'.[32] Such descriptions always involve

a release of fluids; killing and death resemble ejaculations and orgasms.

Mac Bolan achieved extraordinary popularity in the 1970s with some print runs reaching 300,000 copies with over 75 per cent sales rates.[33] There were four issues a year. In the 1980s Harlequin Books, famous for its women's romance series, 'bought' Pendleton and the Mac Bolan character. Previously Bolan had been hunted by the FBI and local police forces, but received assistance from allies in unnamed special government agencies – the classic ambiguous relation with the government in paramilitary culture. In the new 'Golden Eagle' imprint series (Harlequin wants to keep a low profile with these books), Bolan is accepted by the government as an important warrior, is given a new name and fake biography – John Macklin Phoenix, Colonel, US Army, Retired – and is made the head of special anti-terrorist units based at 'Stony Farm'.

One unit is called 'Able Team' and the other is 'Phoenix Force'. The Phoenix programme in the Vietnam War was a US operation designed to capture or kill Vietcong political cadres living in South Vietnamese villages – thousands of Vietnamese were imprisoned or killed, many of them innocent civilians targeted because of personal grudges. Participating Vietnamese intelligence units had monthly quotas to meet. But the connotation here is very different. Phoenix implies a major paramilitary operation from Vietnam that did not suffer from the usual 'self-imposed restraints'. Bolan–Phoenix exemplifies the unrestrained warrior who can win victory and regenerate society.

Both Able Team and Phoenix Force have their own respective series, each published four times a year. The enemies they fight are nominally much broader than the organised crime network Mac Bolan contested. In their adventures the two commando teams, and the 'new' Bolan–Phoenix (who operates alone) battle with an interesting array of Iranians, Libyans and other Arabs, Central Americans, Africans, Asians, Russians and even Americans. Modern paramilitary warriors fight *everyone*.

Rarely are these enemies actual insurgents battling for social goals. Indeed, the figure of the evil 'terrorist' dominates the entire genre, not just Harlequin or 'Eagle' books. In paramilitary novels, terrorists are portrayed as the new foreign Other. They fight because they are overwhelmed with hate for the established order. Terrorists are shown as part of an evil urban world. They are portrayed as having great wealth. Leading male terrorists have

sexual access to many women followers and have complete control over other males in the terrorist hierarchy. Terrorists take great pleasure in disobeying society's rules. They are not afraid of possible death or capture; this absence of fear makes them more powerful and increases their pleasure.

The centre of evil control over the Third World and the threat to Western Europe and the United States is the Soviet Union. Within the Soviet Union, the dominant power is the KGB. All terrorists, subversives, drug-dealers and other criminal organisations are potentially linked together in the pulp-novel genre and all are subordinate to the KGB.

In one incredible novel, *Monimbo* by Robert Moss and Arnaud De Borchgrave (a respected mainstream author and editor of the *Washington Times*), the KGB plans to destroy the United States through internal revolt by radical black groups.[34] In the plan the Cuban government (portrayed as heavily involved in the international drug trade) manipulates right-wing Cuban exile groups in Miami to give drug-generated money to black radical leaders to promote terrorism and politically aimless insurrection. Also implicated are a feminist New Left network television correspondent and a Cuban diplomat who is really a KGB operative (they sleep together occasionally). Fortunately, a journalist whose wife and child are killed by these terrorists and who himself is wrongly framed for illicit sex decodes the plot and destroys the operation with the help of an Irish police detective in New York City.

Evil compounds evil in paramilitary culture; good, God-fearing, capitalist democracy where everyone is more or less 'middle-class' contrasts to the world of concentrated power, wealth, pleasure and evil projected upon all 'enemies'.

Currently at least thirty different 'action-adventure' series are being published; every major paperback publishing-house has several and in 1987 *SOF* initiated its own series. Each comes out four times a year with print runs between 60,000 and 120,000. Most feature Bolan-style individual heroes or commando teams who secretly work either for the US government or are autonomous 'mercenary' groups. Most series fight their battles in the 1970s and 1980s. All series name and describe every weapon, type of ammunition and accessory; most can be readily bought on the open market.

However, several adventures take place in Vietnam. War Dogs,

a commando group, 'fought on the edge of damnation in a place
called Vietnam'. They 'were the cutting edge – the bloody blade
of America's war machine in Vietnam. It was their job to attack
when others would run; to kill when others would hesitate; to
withstand torture when others would beg for mercy. They lived
for battle – and for them there could be no better death than to die
in combat.'[35] In no. 2 of the 'War Dogs' series, *M-16 Jury*, their
assignment is to kill a woman character modelled on Jane Fonda.
The squad succeeds in its mission after raping and torturing her.[36]

The Gunships command squad also lived in 'The Hell that was
Vietnam', but they have the additional problem of being *betrayed
by command*:

> John Hardin, Colonel in the U.S. Special Forces, knows a lot
> about the dirty side of war – his knowledge could be disastrous
> for his military superiors. He has to be silenced. And a hand-
> picked squad of mongrels and misfits are destined to die with
> him in the rotting swamps and festering paddy fields[37]

Such books differ from the hundreds of novels and memoirs
written by Vietnam veterans that try to address their experiences
critically.[38] Instead, the pulp series strip Vietnam of its history and
cast it as a kind of no man's land. The Vietnamese Communists
are portrayed just like the sexually perverted criminal terrorists in
the rest of the genre with the Russians (or occasionally the Chinese
Communists) secretly controlling everything.

The third historical setting for these pulp novels moves forward
to the future. America's leaders, having first lost their nerve during
the Vietnam War, fail again in the final confrontation with the
Soviet Union. A limited nuclear war destroys most American cities
and military forces, but leaves part of the countryside intact.
Russians invade and immediately take over. Post-nuclear America
means a return to the frontier. Men wear guns and constantly
shoot it out either with Russians or with Americans turned Russian
lackeys or with marauding motorcycle gangs ('roadrats') that pillage
towns, raping and killing as they go.

The Australian film *The Road Warrior* has strongly influenced
these books. Series such as 'The Survivalist' and 'Doomsday
Warrior' have in turn influenced the film world.[39] John Milius's
Red Dawn (1984) showed a small-town high-school football team
transform itself into a highly successful guerrilla group when

Russian and Nicaraguan paratroopers invade the United States after a limited nuclear war. ABC television's 1987 *Amerika* mini-series also showed Russian invasion of the United States and American guerrilla resistance.

Russian invasion does not mean that the United States finally collapses: on the contrary, Russian invasion *saves* America. Soviet nuclear attacks on large cities destroy the corrupt urban elite that has ruined America. Other wicked inhabitants of the cities, the white liberal professional–managerial class, and the blacks, Latinos and other racial and ethnic minorities, also perish. Hollywood movies, television, newspapers and other artefacts of urban culture (such as drugs and alcohol) can no longer influence people.

Moreover, with everyday life gone – and all the boredom of jobs, families, responsibilities and routines – the life of the warrior becomes the only life possible. The warrior is always at war and there is no hope of peace – war against the powerful foreign invader will go on indefinitely. Nor will the paramilitary warrior suffer under bureaucratically created 'self-imposed restraints'. Since the Russians have destroyed the Pentagon and the federal government, the war against the Russians and their American lackeys can utilise the warrior's full capabilities. All of the assault rifles, sniper rifles, pistols, ammunition and other supplies purchased before the Russian invasion are now transformed from what 'society' saw as a lunatic's obsession into the wise survivor's tools for building the new American nation.

Russian invasion thus *redeems* paramilitary culture, destroying its greatest enemies (the 'liberal' urban power structure) and affirming its insights into American weakness and Russian evil. The Russian invaders serve as enemy against which the American survivors can define themselves as a virtuous people building the new city on the hill. History becomes mythic prophecy; the future destroys the weak, corrupted and evil modern world, and returns to the virtuous past. The Russians are the new Indians.

Life on the new, post-nuclear frontier presents a series of difficult physical problems. Obtaining food, clothing, shelter and medicine takes much hard work. The new community of survivor guerrilla fighters is altruistic, idealistic, full of love and passionate sex, and is protected by male warriors and led by responsible male elders. All those who are virtuous live a life utilising their abilities and all are respected for their contributions. There is no class structure; all Americans are equal. Post-nuclear America becomes a paradise,

the old America of legend regenerated through a violent, cleansing fire.

Paramilitary culture has provided as a deep and broad *legitimation* of the US government's rapid escalation of military forces. If the Vietnam War was lost because of 'self-imposed restraints', then future victories require rapid mobilisation. The billions Congress appropriated for the Rapid Deployment Force in part came because it constituted the organisational embodiment of a powerful cultural myth. The US Army's Special Forces, Ranger Batallions, Delta Force and its 'secret' equivalents, Navy SEALs, Marine reconnaissance units and Air Force commando squadrons, have all benefited from paramilitary culture's idolisation of warrior heroes operating at the margins of large-scale bureaucracy.

Various local, state, and national police forces have also prospered from paramilitary culture. There have been few actual 'terrorist' events in the United States; extreme right-wing groups such as the Ku-Klux Klan, neo-Nazi organisations and anti-abortionists have conducted most of the attacks. Yet the image of left-wing radical terrorism, a major theme in paramilitary culture, has been used to justify a massive armaments escalation.

SWAT teams have expanded rapidly. When Ronald Reagan was Governor of California in the early 1970s his administration formed the California Specialized Training Institute (CSTI) at San Luis Obispo, California, headed by Colonel L. O. Giuffrida, Commandant. Commandant Giuffrida instructed his local police pupils on how to form SWAT teams and to engage in 'civil-disorder management'. Originally the objective was to form military-style tactical squads organised to seize and defend crucial communications and transportation points when large-scale domestic riots broke out. Such squads were supposed to hold these key areas until the National Guard arrived. Thousands of foreign and domestic police officers have been trained at the CSTI. When Reagan became President, Giuffrida became head of the Federal Emergency Management Agency and reorganised it as a centre for co-ordinating domestic counter-insurgency operations. One plan calls for the internment of 400,000 Latino immigrants, along with war protestors, if a Central American war should occur.[40]

The recent 'war on drugs' has also helped eradicate the distinctions between 'war' and 'peace' and 'foreign' and 'domestic'.

The Reagan administration has sent US army troops to Colombia on drug-eradication missions, engaged US Coast Guard and US Navy planes, helicopters and ships, and even used US Air Force AWACS radar command and control aircraft in attempts to control drug-smuggling. Inside the United States, Army National Guard units, complete with infra-red surveillance photography and helicopter-borne troops, have conducted military-style assaults on suspected marijuana fields.

Paramilitary culture also legitimates *state secrecy*. In novels and films the warrior's actions remain secret from the news media and general public. During the Reagan administration the Freedom of Information Act has been severely reduced in scope; most activities conducted by intelligence agencies are now exempt from the Act. The invasion of Grenada was conducted without the news media present. There was no large-scale public outrage at either the change in the Act or the censorship during the invasion.

Nowhere are the reciprocal relationships between the state and paramilitary culture more visible than in the testimony provided by Marine Lieutenant Colonel Oliver North during the congressional Iran–Contra hearings in July 1987. North proclaimed his right to lie and to deceive Congress as essential to achieve victory against the Sandanista revolution in Nicaragua. Indeed, North perfectly played the paramilitary warrior acting against craven 'self-imposed restraints' created by politicians. The popularity he won among the American public as a war hero can be attributed to his embodiment of contemporary myths.

In this way the garrison state and paramilitary culture reinforce one another. Paramilitary culture says that covert operations – meaning real foreign policy – must remain beyond public debate and above the law to achieve success. In turn, the absence of real information on foreign and military policies remains an absolute requirement for successfully propagating myths of extremely powerful heroes fighting and defeating demonic foes.

Yet the myth of regeneration through violence has its limits. *Platoon* (1987) challenged much modern paramilitary mythology; its Vietnam War does not seem at all winnable by unrestrained warriors. Instead it offers a vision of no battlefield victories, massacre of Vietnamese villagers, and deadly moral conflicts among American soldiers. Although the surviving American boy hero vanquishes his foe (another American) and emerges a man, he clearly does not seek another war. He would not 'do it all again' if

he had to. *Full Metal Jacket* (1987) found no redemption in war, either; the surviving Marines end their day of battle in Hue during the 1968 Tet Offensive with Walt Disney's theme song *Mickey Mouse* on their lips – certainly not an ode to combat glory and transcendent martial experience.

Nor was North's 'victory' during the televised Iran–Contra hearings an unequivocal success. Collective fantasies long nourished in American culture became more than a way of legitimating state actions; they formed the assumptions about the world and the political objectives for the Reagan administration's strategic doctrine and operating policies. Other nations and peoples have not played out their scripted roles in this vision; reality once again intrudes upon fantasy, just as it did in Vietnam with the collapse of war-movie magic. With the Iran–Contra affair, the failure of some of those policies has become public knowledge. Additional congressional investigations, criminal investigations by the Special Prosecutor, lawsuits and news-reporting will increase the domain of public knowledge – and perhaps open the space for a different kind of political and cultural regeneration.

NOTES

1. A. M. Schlesinger, Jr, *The Bitter Heritage* (Greenwich, Conn.: Fawcett, 1968) pp. 58–9.
2. Colonel Harry Summers, Jr, *On Strategy: A Critical Analysis of the Vietnam War* (Novato, Calif.: Presidio Press, 1982).
3. D. Middleton, 'Vietnam and the Military Mind', *New York Times Magazine*, 10 Jan 1982.
4. For an analysis of the US mode of warfare see James William Gibson, *The Perfect War: Technowar in Vietnam* (New York: Atlantic Monthly Press, 1986).
5. *The Pentagon Papers: The Senator Gravel Edition*, vol. 4 (Boston, Mass.: Beacon Press, 1972) p. 427; and Gibson, *The Perfect War*, pp. 93–154.
6. R. L. Samson, *The Economics of Insurgency in the Mekong Delta of Vietnam* (Cambridge, Mass.: Massachusetts Institute of Technology Press, 1970) pp. 54–67.
7. The Public Broadcasting Service's *Frontline* documentary series, 21 June 1983.
8. Taken from Seymour Melman's address to the Socialist Scholars Conference, New York, 1–2 Apr 1983, as cited in Alexander Cockburn and James Ridgway, 'Annals of the Age of Reagan', *Village Voice*, 25 Apr 1983.

9. M. T. Klare, *Beyond the Vietnam Syndrome: U.S. Interventionism in the 1980s* (Washington, DC: Institute for Policy Studies, 1981).
10. R. Slotkin, *Regeneration through Violence: The Mythology of the American Frontier, 1600–1860* (Middleton, Conn.: Wesleyan University Press, 1973) p. 7.
11. Ibid.
12. R. Fielding, *The American Newsreel 1911–1967* (Norman, Okla.: University of Oklahoma Press, 1972) p. 30.
13. E. Marri, *The Rise of Theodore Roosevelt* (New York: Coward, McCann and Geoghegan, 1979) p. 613.
14. H. N. Smith, *Virgin Land: The American West as Symbol and Myth* (New York: Vintage Books, 1950) p. 120.
15. K. Brownlow, *The War, the West, and the Wilderness* (New York: Alfred A. Knopf, 1979) p. 32.
16. R. Jewett and J. S. Lawrence, *The American Monomyth* (Garden City, NY: Anchor Press/Doubleday, 1977) p. xx.
17. For accounts of the relationships between Hollywood and the Defense Department, see L. H. Suid, *Guts and Glory: Great American Movies* (Reading, Mass.: Addison-Wesley, 1977); and J. Smith, *Looking Away: Hollywood and Vietnam* (New York: Charles Scribner's Sons, 1978).
18. One significant exception showing Second World War veterans having real difficulty adjusting to civilian life is *The Best Years of our Lives* (1946).
19. R. Kovic, *Born on the Fourth of July* (New York: McGraw-Hill, 1976) pp. 42–3.
20. P. Caputo, *Rumor of War* (New York: Holt, Rinehart and Winston, 1971) p. 14.
21. Quoted in R. J. Lifton, *Home from the War* (New York: Simon and Schuster, 1973) p. 32.
22. C. R. Anderson, *The Grunts* (San Rafael, Calif.: Presidio Press, 1976) p. 100. 'Grunts' are infantrymen; 'short-timers' are those whose tour of duty has only a short time to run; 'newbys' are new arrivals; and 'lifers' are regulars.
23. R. Evans and R. D. Novak, *Nixon in the White House: The Frustrations of Power* (New York: Random House, 1971) p. 252.
24. S. M. Hersh, *The Price of Power: Kissinger in the White House* (New York: Summit Books, 1983) p. 506.
25. O. Fallaci, *Interviews with History* (Boston, Mass.: Houghton Mifflin, 1977) pp. 45–6.
26. ABC television news, 23 Nov 1969.
27. I have been conducting interviews with the producers of paramilitary culture since September 1985, when I interviewed Robert Brown at the *Soldier of Fortune* convention in Las Vegas, Nevada. The assessment that the Iran hostage crisis strongly influenced the rise of paramilitary culture is one point agreed upon by most cultural producers.
28. For background information on Brown and US mercenaries, see *Covert Action Information Bulletin*, no. 22: 'Special: U.S. Links to Mercenaries' (Fall 1984).
29. Federal laws do not prohibit ownership of either fully automatic

machine guns or noise-suppressors. However, legal ownership requires a $200 tax plus extensive paperwork and the fee must be paid every time the weapon is sold. Some states do prohibit ownership of machine guns and silencers.

30. *The Dallas Morning News*, 5 Mar 1988. *SOF* has begun fund-raising to finance its appeal.

31. D. Pendleton, *The Executioner 1: War against the Mafia* (New York: Pinnacle Books, 1982) p. ix. This is the twenty-fifth print run with Pendleton's Introduction. The first edition ran in March 1969.

32. D. Pendleton, *The Executioner 30: Cleveland Pipeline* (New York: Pinnacle Books, 1977) pp. 18 and 129. The pornographic descriptions of killing resemble those found by Klaus Theweleit in his study of the German paramilitary groups formed after the First World War, the Freikorps. Many of the men involved desired 'the bloody mess'. See Theweleit, *Male Fantasies*, vol. 1: *Women, Floods, Bodies, History*, tr. Stephen Conway in collaboration with Erica Carter and Chris Turner (Minneapolis: University of Minnesota Press, 1987).

33. Interview with Andy Ettinger, Don Pendleton's original editor at Pinnacle, 17 Oct 1986.

34. R. Moss and A. De Borchgrave, *Monimbo* (New York: Pocket Books, 1984). Monimbo is a city in Nicaragua with a long tradition of supporting the Sandanista revolution. Lieutenant Colonel Oliver North once proposed that the Nicaraguan ship by the same name should be hijacked or sunk.

35. Front and back covers of Nik Uhernik, *War Dogs 2: M-16 Jury* (New York: Zebra Books, 1985).

36. Ibid.

37. Back cover of Jack Hamilton Teed, *Gunships 1: The Killing Zone* (New York: Zebra Books, 1981).

38. See Gibson, 'The Warrior's Knowledge: Social Stratification and the Book Corpus of Vietnam', *The Perfect War*, pp. 461–74.

39. Post-nuclear series include Jerry Ahern, *The Survivalist 1: Total War* (New York: Zebra Books, 1981); Ryder Stacy, *Doomsday Warrior 2: Red America* (New York: Zebra Books, 1984); and Richard Austin, *The Guardians 2: Trial by Fire* (New York: Berkeley, 1985).

40. For background to the Federal Emergency Management Agency see Keenen Peck, 'The Take-Charge Gang', *Progressive*, May 1985. The prison camps for Latino immigrants and war protestors are discussed by Daniel P. Sheehan in his affidavit filed for the Christic Institute as part of its lawsuit filed against many of the participants in the Iran–Contra covert-action network. The Christic Institute is charging the defendants under statutes in the Racketeer Influence and Corrupt Organization Act (1970). Copies of the affidavit can be obtained from the Christic Institute, 1324 North Capitol Street NW, Washington, DC 20002.

3

American Myths and the Impact of the Vietnam War: Revisionism in Foreign Policy and Popular Cinema in the 1980s

ROBERT J. McKEEVER

The central thesis of this essay is that the impact of the Vietnam War upon American politics and culture has been neither as profound nor as enduring as most writers on the subject have suggested. In the short term, of course, the war, in conjunction with other vital currents in American society in the 1960s and 1970s, engendered a severe dislocation in both domestic and international politics; and in popular culture the impact of the war was registered first as a deafening silence and then as an all-purpose reference point. Like many other students of the war, I hardly dreamed that within a few years of the war's end the dominant voices in both American politics and popular cinema would be loudly proclaiming not merely that the war had been honourable and even winnable, but also that the values underpinning American foreign policy before and during the Vietnam War were in need of forceful reassertion rather than questioning and modification. Today in Central America we have a measure of the extent to which this reactionary process has progressed, whilst in popular film the same trend, it will be argued here, has led to the renewed prominence on American cinema screens of a rejuvenated traditional male hero, first in non-Vietnam films such as *Star Wars*, *Rocky* and *Raiders of the Lost Ark*, and then, most recently, in a Vietnam context, in Sylvester Stallone's *Rambo: First Blood II*. Of course, this is not to argue that the American experience in Vietnam has had no long-term impact upon either cinematic representations of the male hero or US foreign policy: but, as we shall see later, the limited changes which have been wrought by the Vietnam War only serve to emphasise the current retreat into pre-Vietnam ideologies in the United States.

43

What, then, explains this almost obscenely rapid recuperation of the Vietnam War in American politics and cinema? The answer, I believe, lies in the fact that both US foreign policy and the popular fictional hero figure are so rooted in fundamental and controlling American myths that a successful and permanent challenge to them would necessitate the overthrow of the very myths themselves. And the implications of this are profound indeed, for national myths do not perform their prime function of uniting a people merely by offering a preferred version of the past: they also incorporate a utopian vision of the future. Consequently, to change national myths is not simply a question of reinterpreting history but rather amounts to a demand that the nation do no less than reinvent itself, in terms of values, culture and behaviour as well as in terms of history. Thus, it is contended here that, whilst the Vietnam War was a sufficiently traumatic experience to provoke a temporary crisis in American politics and popular cinema, it did not provide the major political and cultural earthquake that would have been necessary to produce long-term fundamental changes either in US foreign policy or in filmic representations of the male hero. Furthermore, since the tension between the Vietnam experience and controlling national myths could not be borne indefinitely, entailing as it did a paralysis of will and action, the time soon came when Vietnam, rather than the national myths, had to be reinvented.

Let me begin the detailed exposition of this thesis by recalling the arguments set out by Henry Steele Commager in his essay 'Myths and Realities in American Foreign Policy', published in 1968.[1] There Commager identified two myths which had powerfully shaped US foreign policy since independence: the myth of American uniqueness and the myth of the political, social and moral superiority of America. At first these myths justified isolationism, but as America's material interests expanded they 'rationalized Manifest Destiny, mission, imperialism and, in our own time, the imposition on the rest of the world of something that can be called . . . a Pax Americana'.[2]

As Commager points out, there is no contradiction in the argument that the same myths produced and justified both isolationism and a Pax Americana, for the myths themselves are 'rooted in a common attitude toward the Old World and in a common body of philosophical convictions about the character of the New World and the destiny of the American nation'.[3] Crucial here was

the well-established theme of Old World corruption and New World innocence, and this, combined with America's pre-Columbian historical and geographical isolation, created the myth that the United States was destined to be a new, different and superior society that would act as a model for the future social development of all nations.

Thus, the myths could easily encompass both the Monroe Doctrine and the so-called Great Aberration – namely, American imperialism and the acquisition of colonies in the Spanish–American War of 1898. As Commager reminds us, President McKinley's candid justification of the imposition of American rule on the Philippines fused 'duty' and self-interest in such ingenuous fashion that only a nation still held tight in the grip of its own myths could rely today on a similar fusion to justify its foreign interventions in such countries as Grenada and Nicaragua. What McKinley actually said was

> We could not turn the islands over to France and Germany, our commercial rivals – that would be bad business and discreditable. We could not give them back to Spain – that would be cowardly and dishonorable. We could not leave them to themselves – they were unfit for self-government. . . . There was nothing left for us to do but to take them all, and to educate the Filipinos, uplift them and Christianize them.[4]

By the end of the Second World War, two further elements had been added to this mythically based foreign policy: first, a belief in US military superiority which, although based in fact, served also to support mythic notions of American superiority; and, second, arising in part from the myths of innocence and uniqueness, a Manichean definition of US and Soviet morality and its policy corollary – namely, a bipolar view of international politics that defined virtually all political–military conflicts in the world as being primarily microcosms of the Cold War. The historian C. Vann Woodward observed this development with some disquiet:

> I have something of a leaning against the myths of the nation. . . . Unparalleled power, unprecedented wealth, unbridled self-righteousness, and the illusion of national innocence – it all struck me as an ominous combination full of potential dangers to the republic.[5]

It seems to me, then, that, when the United States undertook to create an independent, democratic, pro-American South Vietnam through force of American arms – and to do so in a blaze of media coverage and world attention – it set in motion, unwittingly perhaps, a rigorous testing of the viability of America's most important myths.

The myths of American innocence, uniqueness and superiority had, of course, just as far-reaching an impact on American culture as they had on foreign policy. They all have their part to play in the myth of the West – itself best viewed as a variant of the national myth – which in its turn gave rise to one of the most popular of literary and filmic genres, the Western. And it is in the Western that we find the quintessence of the figure with which we are concerned here – the traditional American fictional male hero. The qualities of this Western hero, particularly in popular film, are too well known to require detailed elaboration here: suffice it to say that, at his simplest, the hero is always at the centre of the narrative structure and, indeed, usually controls it; he is endowed with exceptional, almost superhuman, abilities in gun-play and other forms of violence; he is sexually potent, as evidenced by his great attractiveness to women, though he often rejects permanent relationships with women for the risk they constitute to his heroic will and abilities; and he is morally justified by both his personal triumph over his adversary and by the restoration to the community on whose behalf he acts of the moral and social order that was under threat. Above all, this hero is a supreme individualist capable of transcendent narrative action.

Of course, in more complex Westerns, such as John Ford's *The Searchers*, there can be considerable narrative and moral doubts about the hero, particularly when he embodies, rather than simply resolves, tensions between, for example, civilisation and wilderness, community and individual, white man and Indian. However, as my colleague Douglas Pye has argued, it was precisely the impact of the Vietnam War that brought to a climax the crisis of the Western hero in terms of both values and narrative function. In films such as *Little Big Man* and *Ulzana's Raid*, he identifies a new inflection of the genre which he calls the 'Vietnam Western'.[6]

When, after the end of the war, Hollywood was prepared to address America's experience in Vietnam more directly, this crisis of the action-movie genre and its representation of the hero was revealed explicitly as having roots in the Vietnam War. Andrew

Britton has emphasised this aspect of Hollywood's Vietnam films, which, he argues, are unable to cope with the narrative function of the hero in a context which provides no moral justification for his actions. Vietnam, says Britton, engendered a moral crisis in America, a crisis going right to the heart of the nation's value system, and,

> As the system and the hero were mutually guaranteeing, a crisis within the one endangers the intelligibility of the other. What are the consequences, then, for a narrative which preserved a hero-function, but posits in relation to him a situation ['Vietnam'] which is not only radically inexplicable, but which has also destabilized the structure of values which support and justify the hero's agency? The upshot of the contradiction is a hero whose activity [still deemed of value] remains 'tragically' unrealized; a hero who is passive – not acting, but acted on; or a hero whose assertion of agency appears as compulsive and psychotic.[7]

Britton is surely right to focus upon the crisis of the hero as the most significant manifestation of the Vietnam syndrome in American popular film. A brief discussion of two films, Michael Cimino's *The Deer Hunter* and Karel Reisz's *Dog Soldiers* (US title *Who'll Stop the Rain*), can illustrate this point. The heroes of both films – Michael and Ray, respectively – possess many of the qualities traditional in the male hero (although both characters are also constructed critically so that their mythic values and aspirations are offered to us for questioning and, perhaps, rejection). Before service in Vietnam, Michael is not only both part of and yet apart from a tight-knit group of buddies who drink and gamble but also, as the first hour of the film tells us, a daring and risk-taking driver and, above all, an expert and principled hunter of deer. In *Dog Soldiers*, Ray Hicks is shown not only as possessing the physical skills of a hero – in our first sight of him he demonstrates outstanding skills on the football field, as the other players slip and slide on the mud-covered pitch – but also as having some intellectual commitment to heroic individualism, gained through his reading of Nietzsche. One hardly doubts that he has the mental and physical resources to smuggle heroin from Vietnam to the United States, and in fact he accomplishes this task with ease.

Yet, despite these qualities and, indeed, subsequent heroic actions, both characters are ultimately defeated by forces beyond

their control. In *The Deer Hunter*, for example, Michael's escape
from his Vietnamese captors is achieved through a stunning
combination of will, ruse and gun-play, suggesting that transcen-
dent narrative action is still within the reach of the hero. Similarly,
in *Dog Soldiers* Ray easily deals with the first attempts of Antheil's
henchmen to recover the heroin: his combination of cunning and
strength, and his rejection of Marge's frightened plea for him to
hand over the heroin to Antheil, results in the almost comic
humiliation of Ray's assailants.

However, neither Michael nor Ray is subsequently able to control
events or outcomes. Of the two buddies whom Michael rescues
from Russian roulette, Steven is wounded and paralysed from the
waist down, condemned to live out his life in a wheelchair, and
Nick returns 'voluntarily' to Russian roulette and blows his brains
out, despite the fact that Michael is across the table urging him to
live; but, despite his proximity, Nick is now beyond the reach of
Michael's will. Furthermore, Michael himself has been severely
undermined by his experience in Vietnam, especially in the very
aspects of his character that gave him mythic status: thus, when
he returns to the mountains, he is able to hunt, but not kill, his
quarry.

Similarly, Ray finds that in spite of a series of 'heroic' escapes,
the same forces of corrupt government that have been watching
him since before he left Vietnam are slowly cornering him. Ray
himself, however, never seems to experience any doubt that he
will ultimately triumph – showing, perhaps, the naïveté of his faith
in Nietzsche; for, even as Antheil is closing in on his mountain
retreat, Ray assures a defeated Marge, 'We can win this one.' Once
again, Ray engineers an escape against all the odds, but he dies of
his wounds just as he is about to be rescued.

The basic point, then, is clear: traditional male heroic action has
lost its power of ultimate transcendence. The myth of the hero is
fatally undermined as the individual can no longer carry the day
against the larger forces at work in the world. However, at this
point I wish to take issue with Britton's emphasis on the moral
roots of this crisis. For it seems to me that historical analysis of the
reactions of the American public to the war suggests less a crisis
of morality leading to a crisis of action then precisely the reverse:
a crisis of action leading to a level of moral doubt. To put it another
way, for most Americans the trauma of Vietnam was the trauma
of defeat, a crisis of military action as an effective instrument of

foreign policy. Of course, this may have involved a crisis of values for some Americans – as it most certainly did for many anti-war protestors and intellectuals – but, for the majority of Americans, moral doubt about the Vietnam War was a secondary issue if, indeed, it was present at all. How else can one explain the fact that most of those who voted for Eugene McCarthy in the New Hampshire primary in 1968 were 'hawks' frustrated by the military stalemate in Vietnam, rather than 'doves' in the grip of a moral dilemma? And how else can one explain the election of Richard Nixon not once, but twice, during the war – the second time, after Nixon had expanded the war into Cambodia and dropped more bombs on Vietnam than Johnson had? Obviously no election is ever fought solely on the basis of one issue, but the 1972 election is most clearly read as an endorsement of both Nixon's values and his Vietnam policy and a concomitant rejection of those of McGovern. Similarly, opinion polls during the war indicate quite clearly that it was only after US ground troops had begun to be withdrawn from Vietnam that a majority of Americans supported such a policy,[8] thus confirming the usual trend in the United States for public opinion to fall in behind administration foreign policy.

It seems to me, then, that what led to the Vietnam syndrome in foreign policy and to the crisis of the hero in popular film was not so much a sentiment that America was morally flawed and therefore should hesitate to act, but rather the stunned realisation that the actions taken were ineffective in achieving success. For most Americans the Vietnam War exploded the myth of American invincibility rather than the myths of innocence or moral superiority. This seems to me to be the most plausible reading of Cimino's enigmatic ending to *The Deer Hunter*, when Michael, Steven and others from the community sing with feeling, although tentatively at first, *God Bless America*. Likewise in *Dog Soldiers*, there is little indication that Ray's ultimate failure stems from the lack of moral justification for his cause. Indeed, right from the start, Jon, Ray's partner in the heroin-smuggling, eschews such concerns in the light of his Vietnam experience, writing home to his wife, 'I have no more cheap morals to draw from all this death.' And, although at the end of the film Jon and Marge abandon the heroin to their pursuers and thereby escape, 'the film is unable to suggest where they are going or what they are going to do', as Britton says.[9]

At most, then, American popular cinema has registered a crisis of self-confidence, particularly in the realm of action, together with

some cynicism (*Go Tell the Spartans*) and horror at the excesses of war (*Apocalypse Now*). But this falls far short of demonstrating a major crisis of values *per se*. And the argument that these films can bear such an interpretation would be more convincing if analysis of American public opinion and politics suggested the existence of a major moral crisis. However, as I have indicated, that evidence suggests that the Vietnam syndrome was based primarily on a lack of success in action, thus undermining Americans' confidence in their military superiority, rather than on moral re-evaluation of America itself.

However, the clearest evidence supporting this interpretation is to be found in the developments in US foreign policy and popular film since the end of the war in 1975. Moreover, during this same period, political scientists and historians have offered their own pronouncements on this subject, often in the guise of determining the 'lessons' of Vietnam. This debate began, of course, long before the war itself ended, and as yet there seems little sign of a new foreign-policy consensus on how and when the US should intervene abroad.[10] However, whereas most of the early supporters of the war were political and military belligerents, like Nixon and Westmoreland, there is now a growing body of academics who take a revisionist position on the war. The first major step in this direction came with the publication of Gunter Lewy's *America in Vietnam* in 1978.[11] Whilst Lewy was critical of US policy failures, particularly the unwillingness to tackle adequately the political dimensions of the Vietnamese conflict, he also insisted that 'the sense of guilt created by the Vietnam war in the minds of many Americans is not warranted'.[12] The clear implication of this analysis would seem to be that US military intervention in Third World conflicts is both honourable and viable, provided the political aspects of the struggle are not ignored or misunderstood as they were in Vietnam.

However, Lewy's revisionism seems positively muted compared with that exhibited in a more recent work – Timothy J. Lomperis's *The War Everyone Lost . . . and Won* (1984). There is no scope here to unravel the sophistry of his argument, but Lomperis boldly avers that the United States in fact won the Vietnam War, even though, due mostly to journalistic bias and incompetence, it failed to appreciate it at the time. For, says Lomperis, the United States defeated the guerrilla insurgents at Tet and would have gone on to defeat the North Vietnamese regulars in the 1970s had it not

been for the media's erroneous interpretation of the Tet Offensive as an American defeat, thereby destroying the will of the American people to continue with the war. Thus, as Lomperis says, 'The United States . . . won a war it thought it lost, and lost by default what it could have won.'[13] Lomperis's book, then, may perhaps claim the dubious honour of being the first serious attempt to rewrite the outcome of the Vietnam War.

Of far greater consequence is the attempt by the Reagan administration to revise the history of America's involvement in Vietnam. For Reagan's foreign policy is underpinned not merely by the belief that the Vietnam War was both honourable and winnable but, more importantly, by the conviction that the setback in Vietnam was caused not by flaws in traditional American ideology and mythically based foreign policies but rather by the partial abandonment of that ideology by influential sectors of the American public. Thus, Reagan is presiding over nothing less than an attempt to revive in ever stronger form the very myths that were exposed as disastrous during the Vietnam War. This process is most clearly at work in current administration policy towards Nicaragua. In the first place, the conflict there is being depicted purely in Cold War terms, with the essential struggle defined as one between the United States and the Soviet Union. Reagan's Director of Communications, Patrick Buchanan, has said squarely, 'The strategic issue is a simple one. Who wants Central America more – the West or the Warsaw Pact?'[14] Secondly, the domino theory has been resurrected and used in the same emotive way as in the 1960s: take for example Reagan's own statement that, 'If we don't want to see the map of Central America covered in a sea of red, eventually lapping at our own borders, we must act now.'[15] Thirdly, US intervention in Nicaraguan affairs is defended not merely in terms of national self-interest, but also as offering Nicaraguans a chance of freedom, democracy and national independence: as a result, the Contras, in an intriguing combination of historical and contemporary myth-making, have been presented to the American public by President Reagan as 'the moral descendants of the men . . . at Valley Forge'.[16] Given that such a depiction defies, or rather ignores, all logic, history and empirical evidence, one can only assume that the President is intent upon a return to pre-Vietnam myths and policies, even if the 'loss' of Vietnam itself cannot be put right. After all, if the so-called Reagan Doctrine has any meaning at all, it is that the mere containment of Communism is

no longer sufficient in the 1980s; and those Marxist-inspired regimes which have come to power during America's post-Vietnam paralysis must be undermined and, if possible, overthrown. The conflict in Nicaragua, then, like that in Vietnam before it, has been invested by an American administration with a meaning far beyond that which it objectively merits, simply because Reagan has chosen to make it the symbol of America's foreign policy in the 1980s. And as one academic expert and former Reagan adviser has written,

> Nicaragua is the litmus test of the Reagan Doctrine. Nicaragua must not be seen simply as a familiar problem of a great power asserting control within its traditional sphere of influence. It must instead be seen as something much greater. That is why the administration is so insistent that its efforts on behalf of the Nicaraguan rebels cannot be allowed to fail. This is also why the simple logic of the administration's commitment in Nicaragua would require it eventually to intervene directly with U.S. forces rather than permit this commitment to fail.[17]

In many respects, then, Reagan intends Nicaragua to provide the United States with a replay of the war it lost in Vietnam and there can be little doubt that his intention is to win this time.

The quintessential reflection of this reactionary current in American popular film has been Sylvester Stallone's *Rambo: First Blood II* (1985). Although the most obvious concern of the film is the rehabilitation of the Vietnam veteran within American society, it is one clearly located within a political context that asserts a revisionist perspective on the war. Two themes from the film will serve to illustrate this point. First, Russian troops enter the narrative in such a way as to make clear that they constitute Rambo's – and America's – real enemy. No explanation of their presence is offered: it is simply asserted that they are there and, furthermore, that they command the Vietnamese troops. And, although the representation of both Russian and Vietnamese soldiers draws heavily upon Second World War stereotypes of Germans and Japanese, the higher status of the Russian characters is accentuated by the fact that they are more individuated than the Vietnamese.

Secondly, the film clearly places blame for America's defeat in Vietnam on politicians back home, rather than on the military. This is indicated from the outset when Colonel Trautman – later

to be identified by Rambo as 'The only man I trust' – tries to recruit Rambo for the mission. To Rambo's question, 'Do we get to win this time?' Trautman replies, 'This time it's up to you.' Furthermore, the film soon makes clear that the CIA is behind the cynical attempt to manipulate Rambo's mission so that it can mislead the public into thinking that there are no more missing Americans in Vietnam and that the war is therefore completely over. The CIA is represented in the film by Murdock, who oversees the mission. Rambo, who has been suspicious of Murdock from the start, clearly identifies him as 'the enemy at home' when, forced by his Russian torturers to radio a message back to his base, he blazes, 'Murdock, I'm coming to get you.'

Thus the film *Rambo* embodies both the revisionist view of the war as an essentially East–West struggle that can be defined in Manichean moral terms and the revisionist theory that a main cause of defeat in Vietnam was duplicity by civilians who failed to support the military. A significant absence in this area of the film's discourse is the role of the presidency, upon which no comment is made; this, at the very least, can be read as absolving presidents past and present from culpability on the issue.

However, in terms of the myths and conventions with which we began this discussion, what is most interesting about Rambo is not simply that the hero has been recuperated to the point where he can function and be morally affirmed within a recent and painful historical context, but that he is, moreover, a hero of a traditional kind, whose appearance, character and *modus operandi* strongly reflect aspects of the myth of the West and inflections of the Western genre. For example, Rambo's long hair, head-band and naked torso defy the image of modern military man. We are also told that he is of mixed Indian and German descent, which is an attempt, perhaps, to draw upon familiar stereotypes in order to justify Trautman's description of Rambo as a 'pure fighting machine'.

But it is in Rambo's *modus operandi* that we find the strongest echoes of the self-sufficient frontier individualist. For he distrusts and ultimately rejects the advanced technology of modern warfare in favour of the knife and bow-and-arrow. This is made clear on a number of occasions, such as when he becomes entangled in his technological equipment as he parachutes from the plane over Vietnam and has to cut himself free of it in order to survive; or, again, when on his return to base in Thailand his first action is to

destroy the highly sophisticated computer system over which Murdock presides. In a world of clear-cut moral choices, the film seems to suggest, a hero has no need of either sophisticated weaponry or sophisticated political argument: he needs only the skills of the frontier hero. Thus, most of the action scenes have Rambo killing through jungle cunning and his expertise with the knife and bow. By the time he uses exploding arrow tips and displays his mastery as a helicopter pilot, it is clear that such sophistications are merely adjuncts to his natural, dominant skills.

However, to argue that the figure of John Rambo draws heavily upon the myth of frontier individualism is not to say that he represents a simple return to the hero of the Western genre. For, while it is clear that, in significant ways, Rambo has evolved from the Western hero and is thus a product of the same fundamental myths and culture, the type has undergone certain changes as a result of Vietnam. The most obvious of these changes is the complete abandonment of what Cawelti called 'the cowboy hero's basic aversion to the grosser and dirtier forms of violence'.[18] Any notion of a code of honour when fighting the enemy would clearly be anachronistic and displaced in the context of Vietnam, and Rambo's only concern is winning at all costs in order that his country can behave honourably towards its own fighting-men. For Rambo, only victory can bring honour, and victory entails using all the methods used by the enemy. (An interesting comparison here can be made with *The Green Berets*, where, it is asserted, Americans and Vietnamese alike use lethally poisoned punji sticks, but only the Communists smear the tips in excrement.) Rambo, then, represents a return to the traditional hero, but is even more determined to do whatever is necessary to win; thus, where the Vietnam experience has wrought changes in the myths that it challenged, the result has been a mythic hero who resolves contradictions between extreme violence and morality in a more effective way than any hero before him.

It would seem clear, then, that the film *Rambo* and Reagan's foreign policy both offer Americans the opportunity to hark back to longstanding myths and to draw upon them both as inspiration for a reinterpretation of the Vietnam War and as justification for renewed American military intervention abroad. Of course, the immense popularity of Reagan and *Rambo* does not mean that the Vietnam syndrome has been overcome: congressional Democrats and public opinion have both shown considerable resistance to the

President's policy on Nicaragua; and it is significant that the analogy of Vietnam has figured prominently and quite specifically in this resistance – for example, when the House was asked to vote military aid to the Contras in March 1986, Tip O'Neill said, 'This is a Tonkin Gulf vote. . . . I see us getting into a war. That rag-tag army will go into Honduras, the Sandinistas will follow them and will be dragged into that fight. I see a quagmire down there, those hills and mountains.'[19] However, it is also clear that the Vietnam analogy has become a double-edged sword, available for manipulation by the administration as well as by its critics. Thus, Elliot Abrams, Reagan's Assistant Secretary for Inter-American Affairs, capitalised on fear of 'another Vietnam' when he suggested that aid was the only alternative for those who wanted to avoid military intervention in Nicaragua: otherwise, he said, 'You can use American military force, which is the last thing we wish to do, or you can surrender, which is, I would think, unacceptable.'[20] Moreover, the President's critics are motivated by pragmatic considerations rather than any belief that the United States is prohibited from taking military action on moral grounds. As one writer observed, during the debate on the June vote on aid to the Contras, 'Few Congressmen have dared to take a stand on the basic issue of whether the United States has the right to interfere in a far away country's internal affairs. Few have dared to say that Reagan is wrong.'[21]

Reagan's victory in that vote strongly suggests that the back of congressional resistance to military intervention in Nicaragua had been broken, only to be countered later by the fall-out from the Iran–Contra scandal. And the film analyst Susan Jeffords has argued that one purpose of recent films about Vietnam, especially *Rambo*, is to prepare public opinion for another Vietnam-type intervention elsewhere: as she put it,

> By producing a pseudo-closure and pseudo-victory to the war, these narratives do, in effect, 'close the book' on the Vietnam War. The story that has not ended is that of an American policy of anti-communism that took that country into that war initially and is being put forth now as a possible justification for another.[22]

The fact that cultural and political revisionism in US foreign policy has come so far and so fast since 1975 bears witness not merely to the American will to control what it sees as a hostile world environment, but also to the power of the myths that underpin

56 Vietnam Images: War and Representation

and justify perceptions and actions that only recently seemed to have been negated by the Vietnam War.

NOTES

1. H. S. Commager, 'Myths and Realities in American Foreign Policy', *The Defeat of America: Presidential Power and the National Character* (New York, 1974).
2. Ibid., p. 19.
3. Ibid., p. 20.
4. Ibid., pp. 37–8.
5. H. Mitchell, 'Historian C. Vann Woodward: the Education of a "Liberal"', *International Herald Tribune*, 29 May 1986.
6. D. Pye, 'Ulzana's Raid', *Movie*, nos 27–8 (Winter 1980–Spring 1981) 79.
7. A. Britton, 'Sideshows', *Movie*, nos 27–8 (Winter 1980–Spring 1981) 5.
8. J. E. Mueller, 'Trends in Popular Support for the Wars in Korea and Vietnam', *American Political Science Review*, 65, no. 2 (June 1971) 369.
9. Britton, in *Movie*, nos 27–8, p. 7.
10. See for example Ole R. Holsti and James N. Rosenau, *American Leadership in World Affairs: Vietnam and the Breakdown of Consensus* (Boston, Mass.: Allen and Unwin, 1984).
11. Gunter Lewy, *America in Vietnam* (New York: Oxford University Press, 1978).
12. Ibid., p. vii.
13. T. J. Lomperis, *The War Everyone Lost . . . and Won* (Baton Rouge: Louisiana State University Press, 1984) p. 176.
14. A. Brummer, 'Putting Patriotism behind the Contras', *Guardian*, 12 Mar 1986.
15. S. Hoggart, 'Rebel Rousers Seek Support to Help Bucks Fizz', *Observer*, 9 Mar 1986.
16. 'The Contra Crusade', *Newsweek*, 17 Mar 1986.
17. R. W. Tucker, 'The Reagan Doctrine – Ambitious Ends, Modest Means', *International Herald Tribune*, 12–13 Apr 1986.
18. J. G. Cawelti, *The Six-Gun Mystique* (Bowling Green, Ohio: Bowling Green State University, Popular Press) p. 60.
19. 'O'Neill Says Nicaragua Vote Recalls Vietnam Era', *International Herald Tribune*, 20 Mar 1986.
20. *New York Times* editorial repr. in *International Herald Tribune*, 9 Jan 1986.
21. Editorial in the *Guardian*, 27 June 1986.
22. S. Jeffords, 'The New Vietnam Films: Is the Movie Over?', *Journal of Popular Film and Television*, 13, no. 3 (Winter 1986) 187.

4

Black Music and the Vietnam War

MARY ELLISON

Black music is special in its close reflection of the ideas and needs of people who regard music as a powerful medium of communication and manifestation of talent. Throughout the 1960s and early 1970s, black music articulated and reflected the response of black Americans to the expansion of hostilities in Vietnam.

Vietnam was a war that crept up stealthily on black and white Americans. It took lives that no one supposed were endangered when President Kennedy sent men out to South East Asia as advisers rather than combatants. Yet John Kennedy was a president who had promised to aid the weak against the strong and committed himself to support black rights in America and human rights abroad. It seemed to be an era of rarefied idealism. That mood was sustained by the Shirelles' number-one hit (in the *Billboard* charts) in 1962: *Soldier Boy*.[1] Just as black Americans would rally round the American flag and enlist for a foreign war, the Shirelles supported whatever their soldier boy chose to do and would inevitably 'be true'. The time and the song were full of illusions.

These illusions continued to cloud responses to the war, which was apparently being waged to uphold the precarious power of a regime of uncertain popularity. Songs such as *Greetings (This is Uncle Sam)* by the Monitors in 1966 (VP 25032) and *Forget-Me-Not* by Martha and the Vandellas as late as 1968 (Gordy 7070) made responding affirmatively to the draft seem like a blow for freedom.

At the same time, it began to become obvious that this was not a simple or straightforward war in which black allegiance could be given without reservations. Vietnam had escalated to the status of a major war around 1965 – the very time when the frustration of black people at the unconscionable level of relative deprivation they were expected to endure had exploded into the Watts race riot. The brutality and disregard for human dignity that characterised American military action in Vietnam was echoed by

the ferocity with which black protestors were crushed – not only in Watts, but also in Detroit, Newark and Chicago over the next few years. In Vietnam black servicemen were victims of inordinate violence. Although their numerical strength in the armed forces in Vietnam floated around 11 per cent, they accounted for around 22 per cent of servicemen killed in combat each year. The Impressions' *This is my Country* (Curtom 1934), which rose up the pop charts in 1968, reflected the emergence of more ambivalent feelings about the war.

Blues singers were among the most articulate remonstrators against the war in Vietnam. Like all the best blues songs, those that were concerned with this impossible war were cast in singularly personal terms but were symbolic of a collective awareness. Blues singers have always spoken out as individuals while speaking for the community at large. Here, as so often before and after this war, they were not only casting their own cynical eyes over the situation but also voicing a more general mood. In the songs, as in the community, fear was less important than understanding, but that understanding led to widespread approval of fear as an appropriate emotion in dealing with Vietnam. As John Lee Hooker once said, 'We are here to pay our dues to the natural facts.'[2] He knew that his listeners would identify with his analysis of the situation and with his solution. He sang out an accurate consensus view before drifting individual thoughts had fully taken shape. In keeping with the long-established, time-saving tradition, Hooker sang unambivalently about *not* wanting to go to Vietnam. In *I Don't Wanna Go to Vietnam* he stressed that the troubles that really needed to be sorted and settled were those at home, not those in Vietnam:

> We got so much trouble at home, we don't need to go
> to Vietnam.
> Yeah, yeah, we got all of our troubles right here at home,
> Don't need to go to Vietnam.
> We oughta stay at home and settle our troubles to ourselves,
> I don't wanna go, don't wanna go to Vietnam.[3]

Many black soldiers denounced what the New Left historian Gabriel Kolko has termed 'the virtually unlimited violence and terrorism to which American foreign policy could resort' in this transcendent test of imperialist aspirations.[4] There was an increasing awareness that one aim of American intervention had initially

been to stem the advance of Communist or socialist revolution. For black soldiers to assist in this at the very time when Malcolm X and the Black Panthers were arguing that equality would only be achieved through a socialist revolution seemed ironic. By 1968 even Martin Luther King, one of the earliest and most vehement opponents of the war, was carrying a banner that said 'Power for Poor People'.

Malcolm X commented shortly before his death that what was happening was 'a global rebellion of the oppressed against the oppressor, the exploited against the exploiter'.[5] He explicitly condemned American intervention in Vietnam at its very outset. Huey Newton, leader of the Black Panthers, expressly condemned the war in Vietnam and Eldridge Cleaver said, 'While you are over there in Vietnam, the pigs are murdering our people, oppressing them, and the jails and prisons of America are filling up with political prisoners. . . . We appeal to you Brothers to come to the aid of your people. Either quit the army now, or start destroying it from the inside.'[6] To Cleaver anything else was treason against black people. To him the Panthers and the North Vietnamese were fighting the same battle for liberation.

The liberation philosophy of the Black Panthers was widely equated with the liberation movement of the North Vietnamese. The systematic way in which Panther leaders were massacred or dubiously imprisoned in Chicago and other Panther centres was seen to have parallels in the way in which the US Army crushed anti-colonialist, radical liberationist leaders in South Vietnam. Freddie Hubbard's *Sing me a Song of Songmy* forcibly stresses the irony of black soldiers aiding this exploitative anti-democratic process. The music hauntingly depicts the sorrow and the anger that are engendered by such an inappropriate course of action. Its powerful use of moody bass, stark trumpet, accusing saxophone and menacing cellos and violins enhances the sense of doom and disaster. The lyrics of *Black Soldier* stress the destructive force of a war that is bent on upholding the interests of a superpower rather than those of a struggling people. The crucifixion on a 'steel cross' is mourned and the lack of freedom of those black men who fight is seen as so fundamental that they are described as 'the night which has locked itself into darkness'.[7]

Martin Luther King not only questioned why the government claimed to be supporting democracy in Vietnam when it failed to uphold it in the American South, but also forecast that the war

against poverty in the United States would be lost in Vietnam. King led marches against the Vietnam War and denounced Americans' obsessive anti-Communism as positively dangerous. At Riverside Church, New York, on 4 April 1967 he said that, for the sake of both the 'suffering poor of Vietnam' and the 'poor of America who are paying the double price of smashed hopes at home and death and corruption in Vietnam', the madness of this war must cease. Known as 'A Time to Break Silence', this speech also declared that 'it should be incandescently clear that no one who has any concern for the integrity and life of America today can ignore the present war. If America's soul becomes totally poisoned, part of the autopsy must read Vietnam.'[8]

Martin Luther King's attitudes were symptomatic of those of the Civil Rights movement at large. As early as 1964, Civil Rights activists were comparing violence in Vietnam with the violence used against black people in Mississippi. In mid 1965 the death of a youth from McComb, Mississippi, led his classmates to distribute a leaflet saying that 'No Mississippi Negroes should be fighting in Vietnam for the white man's freedom, until all the Negro people are free in Mississippi.'[9] In 1966 the Southern Nonviolent Co-ordinating Committee (SNCC) called for withdrawal from Vietnam and termed the war a violation of international law.

To SNCC activist, poet and historian Julius Lester, Black Power was part of a worldwide movement for the liberation of oppressed peoples. He saw the struggle of the North Vietnamese against US imperialism as one of its most crucial manifestations. Yet there was a branch of the Black Power movement that was in favour of both capitalism and to a lesser extent the Vietnam War. The SNCC itself, however, was unambivalently anti-Vietnam. In January 1966 an SNCC press release denounced American interventionists as insincere in their claims that they were acting in the interests of the Vietnamese people. Stokely Carmichael urged black students to resist the draft. He also asserted that 'The VC [Vietcong] are showing us the best way to get it done.'[10] Black Americans, he said, could learn from the war how to defeat racism within America. Leon Thomas linked up with Rap Brown, a radical black activist prominent in the SNCC, on an album that gave powerful voice to their political ideology. In his anti-Vietnam song *Dam Nam (Ain't Goin to Vietnam)* – he attacked the techniques used in the war, as well as the war itself, as basically immoral:

He's gotta drop a napalm bomb
And never see the thing he's gonna kill.

You can do what you want to
But I won't be goin' to Vietnam.

It's a dirty mean war
And I won't be goin' to Vietnam.[11]

In 1969, a year or so before Marvin Gaye's *What's Going On?* reverberated through the charts and America's conscience, Ritchie Havens asked, 'What's going down?' – 'We say we love and we say we care yet we live our hate and we fight our wars and we burn our towns – what's going down?' It's not surprising that even children raised their voices in protest.[12] To some black Americans the external attempt to create an American 'colony' out of Vietnam had inherent similarities with the neo-colonialism black people in the United States had been subjected to since they were brought from Africa as a pool of unpaid, forced labour. Vietnam was seen as an essentially racist war in which there was as little respect for Asians as there had long been for the Afro-Americans.

Clyde Taylor, who edited the anthology *Vietnam and Black America*, summed up black attitudes towards the war: 'One attitude, then, towards the Vietnamese revolutionaries among resistant black people is "No Vietnamese ever called me nigger!" A more radical reaction is, "We are all in the same boat." The most radical response has been "We are allies."' This, says Clyde Taylor, makes obvious an awareness of a certain 'drift in American national consciousness'.[13] This was a time when the fibre of black resistance to American oppression was toughened and expanded to include human rights everywhere. Many prominent black Americans demonstrated the strength of this resistance. Julian Bond almost lost his seat – the first gained by a Southern black legislator in the twentieth century – in the Georgia House of Representatives because he spoke out against the draft. Muhammad Ali lost his heavyweight boxing championship title because he refused to fight in a racist war. Eartha Kitt may not have had a hit single that denounced Vietnam, but when invited to lunch on the White House lawn she spoke out vehemently against the war and the unnecessary loss of life it had caused. She was not invited to the White House again and her career was undoubtedly damaged.

When Jimi Hendrix sang his unique version of *The Star-Spangled Banner* at the Monterey Pop Festival, parts of his new interpretation and additional lyrics were devoted to attacking the American intervention in Vietnam. The Watts Prophets rapped on an album that had enormous 'ghetto' success in 1971,

> And my blood flows freely in Vietnam
>
> I'm tired of not getting mine
> Except of course in Vietnam
> Where every dead man
> Is a credit to his race.

In a closely similar vein Gil Scott Heron interrelates all the wasteful disregard for human life and dignity within the United States with that shown during the war in Vietnam:

> Brother served in Vietnam
> And found out no-one gives a damn
> Agent Orange fell on his camp (but everybody went deaf)
> Brother turned around on Uncle Sam
> Waiting for the axe to fall.[14]

To James Baldwin, it seemed as inevitable as it was reprehensible that a racist society would fight a racist and exploitative war, and poets such as Robert Hayden and S. E. Anderson attacked the genocide of black and yellow people in Vietnam.[15]

Vietnam and youth culture and black protest and the full flowering of soul music all came together in the mid 1960s. Social and political unrest found a new unity and solidarity in songs of general disaffection by black singers who were as disillusioned with Vietnam as with the failure of the American Dream. The Temptations' *Ball of Confusion* was as applicable to the Vietnam War as it was to the frustrations of ghetto life. They also sang the song that was a number-one hit for Edwin Starr in 1970.[16]

War, sung by Edwin Starr and written by Norman Whitfield and Barrat Strong, captured both sales and the popular imagination. It seemed to encapsulate universal truths that everyone could relate to. If ever a war had seemed to be worth 'absolutely nothing', it was the Vietnam War. Even those who thought it might be worth engaging in violence to seek black equality within the United States

saw the Asian holocaust as a redundant waste of life. It was not lost on black Americans that most of the lives wasted were yellow or black. Calling this war wasteful does not seem an exaggeration when it is remembered that over 1 million Vietnamese died and that 46,000 Americans were killed in combat. During the war 7 million tons of bombs were dropped – twice as many as on both Europe and Asia in the Second World War. Later in 1970 Edwin Starr made a further protest against the war with *Stop the War Now*, another successful single.[17]

Clarence Major, a black novelist and poet of great talent wrote of Vietnam's inordinate consumption of life – especially the lives of so many black soldiers:

> how come so many
> of us
> niggers
> are dying over there
> in that white
> man's war
> . . .
> two birds with one stone.[18]

In January 1969, 536,000 US troops were stationed in Vietnam, and about one in seven of all those enlisted were black. A much lower proportion, however, held officer rank. In the Army, for instance, 13.5 per cent of all enlisted men but only 3.4 per cent of officers were black. In the Marine Corps, 9.6 per cent of enlisted men were black, as against just 0.7 per cent of officers. In the Air Force the relative percentages were 11 and 1.7 per cent, and in the Navy 5.5 and 0.5 per cent. A disproportionate number of black men served on the front line. In 1966 alone 22.4 per cent of all army casualties were black. By 1970 black men were resisting the draft as determinedly as white. Junior Wells and J. B. Lenoir both sang versions of *Vietcong Blues* that denounced the war as senseless, pointless and utterly destructive.[19]

The most succinct statement about black soldiers' response to Vietnam came from Wallace Terry, *Time* correspondent in Vietnam and author of *Bloods*. He drew up a comprehensive questionnaire distributed to fellow black and white Americans in the battlefield. In 1970 he wrote that

Black Soldiers, schooled in the violent arts of guerilla war as
have no generation of blacks, are returning home from Southeast
Asia, fed up with dying in a war they believe is white man's
folly and determined to earn their share of American oppor-
tunities even if that means becoming Black Panthers or turning
to guns.[20]

Terry also found out that 45 per cent of black combat troops said
that they would join riots and take up arms to obtain the rights
they had so far been deprived of within the United States. On the
battleground, moderates had become militant. In 1967 and 1968
black soldiers were enthusiastic about the war, but by 1970
disillusionment was widespread and a black officer in Dong Tam
feared that 'we are probably building a recruitment base for militant
groups in America'. Most of the black soldiers thought that they
should not be fighting for the United States in Vietnam when there
was so much discrimination at home. Twice as many blacks as
whites believed they should not be interfering in an Asian war.
They also resented being pushed like cannon fodder into the front
line.[21]

These thoughts by Vietnam soldiers were given musical expres-
sion by Stevie Wonder in *Frontline* (RCA TMG 1289). The title sums
up the resentment felt by black soldiers over being too often placed
in the front line in the war and 'at the back of the line' in America.
The mindless violence is denounced and winning a purple heart
is negated by the endless fear of Agent Orange and a hopeless,
one-legged future.

In his survey of over 800 black and white servicemen in Vietnam,
Wallace Terry discovered that black soldiers – whether in the ranks
or officers – were far more opposed to the war than their white
compatriots. Bobby Bland was in Vietnam in its early phase but it
was still a horrific experience and he sang about waking up
screaming, dreaming he was back in the war.[22] When Luther
Allison was called up he could only view it as 'Bad News'.[23] A
black private from California risked eleven years in prison rather
than board a Vietnam-bound plane.

In Vietnam, black servicemen often refused to fight and *La Monde*
wrote that their clenched fists were held up in defiance of a war
that they rejected. The Navy regarded a substantial proportion of
its black fighters as undesirable because they opposed the war.
Black servicemen were also far more sympathetic than white to

student protests over Vietnam. Toby Hoffer, a black Marine, pointed out, 'The white man had his goddam Boston Tea Party, so why can't we have riots, and the white students their marches? Is there any difference? Check it.'[24]

In direct contrast to the early patriotic songs that supported American intervention were those that actually celebrated the Vietnamese victory and extolled the virtues of the North Vietnamese. The Last Poets saw Ho Chi Minh as an admirable leader – in their own subtle way – while Bernice Reagon, lead singer of Sweet Honey in the Rock, celebrated the victory of North Vietnam and socialism as a triumph for freedom in *There's a New World Coming*.[25] Many black servicemen did feel an affinity with the Vietnamese whose spirit remained uncrushed by the barbarous acts of the US government. They saw parallels with the way in which their own people had survived American violence.

Marvin Gaye was appalled by both the war and the American treatment of black people. He watched an extreme situation developing. 'Then the killings started – Jack Kennedy, Malcolm, Martin, Bobby – LBJ bought the Vietnam bullshit and everything got fucked.'[26] It was clear to him that the forces of repression – whether the FBI, the CIA or the Pentagon – were so extreme and irrational that they would kill the moderate Kennedy as well as the more radical Malcolm X and radicalised Martin Luther King. It was also clear that they would use and abuse black and white American lives in an unholy war of strategic expediency. 'What's Going On?' was the obvious question to ask, and Marvin Gaye asked it in a song and an album of such honest intensity and such intriguing complexity that whole new groups of politically unaware people began to look for answers.

Marvin Gaye made no pretence of the fact that he hated the government that would make black men fight and pay in taxes for a war that they did not believe in. At the very least, Gaye felt he had absolutely no quarrel with the North Vietnamese. More significantly, he felt the US government was being insensitively manipulative. When his brother Frankie came home from Vietnam and told him about the injustice and the atrocities, Marvin's adrenalin fused with his anger and he created a masterpiece. Using Frankie's account of his experiences on the South East Asian battlefields he wrote a work of inspired and troubling truthfulness. Frankie had been sickened by the unnecessary violence of this useless war and transmitted the revulsion and horror to Marvin.[27]

Although some of the songs in *What's Going On?* were written in conjunction with other writers, most of the lyrics as well as the tone and the feelings were essentially Gaye's own. He also produced the record and held out for its release against trenchant opposition from Motown. He had to refuse to record anything for Berry Gordy again if the record did not reach the public. But reach the public it did and the effect was astonishing. Jesse Jackson acclaimed Marvin Gaye as a great preacher and the critics recognised him as a profound and influential artist. The public loved the album enough to make it a long-term best-seller, and many people recognised that what they were listening to was not just great but politically radical soul music. Unlike James Brown, Marvin Gaye had never been patriotic, and here he linked the warnings against further waste of life in a tyrannical war with admonitions about the internal inequality and confusion that existed within the United States. He saw parallels between the abuse of power at home and the like abuse abroad, and these connections twined through the fabric of the songs on the album. Yet it was not a negative album: it was composed of music welded together far more by love than by hate. While war was rejected as 'the answer', love was unconditionally accepted and communication was suggested as a way of enhancing love and understanding and finding real solutions for the problems of racism and inequality both in the United States and in Vietnam. Gaye's plea to look to the future and save the children from the holocaust of war and the horror of poverty was illuminated with a hope that the United States could transcend its baser instincts and move towards a better existence. In *Inner City Blues* and the final short version of *What's Going On?* he makes obvious his greater respect for the use of violence to change the appalling conditions people have to face in American slums than for its redundant use in a war where people have no say in the conditions or political system under which the US government insists they live. *What's Happening, Brother?* is a sorrowful track mourning the lack of jobs and opportunities for all black Americans, including his brother who has just returned from the battlefield in Vietnam.

The intensity of the album hit black and white America in the gut. Here was someone articulating in sensuous tones, using a complex amalgam of jazz and blues as well as soul and pop, that both the Vietnam War and American racism at home were unacceptable, ungodly and had to be rejected. Peace and love were

extolled as the only sane alternatives and opinions were changed. This was a record that people listened to and were affected by.[28] In 1973 in Chicago *Save the Children* was recorded and filmed live as part of a movie that took the track as its title. The song seemed even more dark and despairing than it had on record in 1971. The 'sorrow' that 'filled' Gaye seemed to dominate this song that denounced 'such a bad way to live' and asked 'who is to blame?' The positive affirmation that life is to be lived seemed here filled with inescapable pain. Saving the children from the horrors of life in America and warfare abroad became a mission of desperate necessity.[29]

Far more straightforward was Freda Payne's anti-war hit single of 1971, *Bring the Boys Home* (Invictus 9002). By 1974 the country, black and white, was in tune with the Chilites and O. C. Smith when they pleaded for peace with *There Will Never be Any Peace Until God is Seated at the Conference Table* and the *La La Peace Song*.[30]

Once the war was over, black Vietnam veterans evaluated their experience with considerable cynicism. Ralph Hamilton pointed out that 'America was over there using words like "freedom" and "rights" and "democracy", things I didn't even have in this country. . . . Right then I made up my mind that when I got back to the "land of the free and the home of the brave" I was going to be free and brave.'[31] Throughout the war, black music had campaigned for freedom at home and abroad. Musicians were as aware as servicemen that the campaign would not end with the war. The war might be over but the struggle through song would go on.

NOTES

1. The Shirelles, *Golden Hour of the Shirelles Greatest Hits*, Golden Hour GH 824 (1973).
2. Quoted in L. Neal, 'The Ethos of the Blues', *Black Scholar*, Summer 1972, p. 47.
3. John Lee Hooker, *Simply the Truth*, Bluesway EMI SL10 280 (1969).
4. G. Kolko, *Main Currents in Modern American History* (New York: Harper, 1976) p. 364.
5. Quoted in M. Marable, *Race, Reform and Rebellion: The Second Reconstruction in Black America, 1945–1982* (London: Macmillan, 1984) p. 95.
6. E. Cleaver, 'To my Black Brothers in Vietnam', in M. Goodman (ed.),

68 *Vietnam Images: War and Representation*

The Movement toward a New America (Philadelphia: Pilgrim Press, 1970) p. 226.

7. Freddie Hubbard, *Sing me a Song of Songmy*, That's Jazz, Atlantic ATL 50235 (1971).
8. M. L. King, 'A Time to Break Silence', *Freedomways*, 7, no. 2 (1967) 106.
9. H. Zinn, *A People's History of the United States* (London: Longman, 1986) p. 475.
10. Goodman, *Movement*, p. 187.
11. Rap Brown and Leon Thomas, *Live*, Flying Dutchman FDS 136 (1970).
12. Ritchie Havens, *Just above my Hobby Horse's Head*, in *Richard P. Havens, 1983*, MCA, Verve SVLP 6014 (1969).
13. C. Taylor, 'Black Consciousness and the Vietnam War', *Black Scholar*, Oct 1973, p. 6.
14. The Watts Prophets, *Rappin' Black in a White World*, ACA 1971 (1971); Gil Scott Heron, 'Waiting for the Ace to Fall', *Real Eyes*, Arista AL 9540 (1980).
15. C. Taylor (ed.), *Vietnam and Black America: An Anthology of Protest and Resistance* (Garden City, NY: Anchor, 1973) pp. 101–2, 139, 143.
16. The Temptations, *Ball of Confusion* and *War*, in *The Temptations* EMI/Motown, STMX 6002.
17. Edwin Starr, *War*, Gordy 7101 (1970); Edwin Starr, *Stop the War Now*, Gordy 7104 (1970).
18. Junior Wells, etc., *Chicago/The Blues/Today*, vol. 1, Vanguard VSD 79216 (1972).
19. Goodman, *Movement*, p. 175.
20. W. Terry, *Bloods* (New York: Ballantine, 1984), and 'Bringing the War Home', *Black Scholar*, Nov 1970, p. 6.
21. Terry, in *Black Scholar*, Nov 1970, p. 9.
22. Bobby 'Blue' Bland, *Woke Up Screaming*, Ace CH41.
23. Luther Allison, *Bad News is Coming*, Vogue VS 407 523023.
24. Terry, in *Black Scholar*, Nov 1970, p. 11.
25. The Last Poets, *Delights of the Garden*, NBLP 7051; Bernice Reagon, *Give Your Hands to Struggle*, Paradon Records P1028.
26. D. Ritz, *Divided Soul: The Life of Marvin Gaye* (London: Grafton, 1986) p. 118.
27. Ibid., pp. 172, 187, 192.
28. Marvin Gaye, *What's Going On?*, Motown, STML 11190 (1971).
29. Marvin Gaye, *Save the Children*, Motown M800R (1973).
30. Chilites, *There Will Never be Any Peace (Until God is Seated at the Conference Table)*, Brunswick 55512 (1974); O. C. Smith, *La La Peace Song*, Columbia 10031 (1974).
31. T. Martin, 'The Black Vietnam Vet: Still Looking for Respect', *Ebony*, Apr 1986, p. 124.

5

Vietnam, Fine Art and the Culture Industry

JAMES AULICH

There is such a great discrepancy between art and the recent atrocities . . . that art is condemned to cynicism. Even when it addresses them, it tends to divert attention from them. . . . At present, all works of art including radical ones have a conservative tinge, for they help reinforce the existence of a separate domain of spirit and culture whose practical impotence and complicity with the principle of unmitigated disaster are painfully evident.[1]

Theodor Adorno's diagnosis of the state of the arts at the end of the 1960s is unduly determinist and pessimistic, but broadly accurate within the terms of the established institutions of art and the system of commercial and public galleries.

THE CULTURAL ESTABLISHMENT

During the 1960s the constituency of fine art expanded rapidly in line with a growth in higher education, and fine art opened itself to a young and prosperous audience. Its size would almost qualify it as a minor mass entertainment, yet it is more specialised and less democratic than any of the popular arts. Its language is often obscure in spite of its role as official culture, and fluency in this language assures the acquisition of social distinction. In other words, the audience is broadly restricted to urban, educated and 'deciding' classes, the majority of whom had no direct contact with the Vietnam War. Of the 20 million eligible for the draft during the war, 16 million did not go. Furthermore since the late 1950s American art had been proffered to the world as a model of

American freedom in a manner that by the end of the 1960s had led to a considerable sense of unease amongst the intellectual community. Barbara Rose, while not mentioning Vietnam directly, wrote, 'American art, the commodity lately found most useful in selling the American way of life, is as unwanted and as unexportable as our economic system.'[2] The artist's freedom was offered as positive evidence of liberty in a denial of the repressions of the state during a time of war and America's self-imposed role as world policeman. As a result many artists looked to the institutions of art as morally bankrupt and many strategies were developed to outflank them.

The relationship of the fine arts to the establishment is not simple. The artist, dependent upon institutional and private patronage and trading in unique objects, is something of an anachronism in an age of commodity consumerism. Largely independent of the ideological and market values necessary to the mass media, the artist appears to emerge as the embodiment of the free liberal individual. The artist's audience feeds off this image as an elitist and privileged group respondent to an archaic high-bourgeois ethic – indicative of the apparent survival of the individual in the face of much contemporary radical pessimism as to his or her status in the modern military–industrial state – and simultaneously provides a discourse apparently untouched by dominant commercial modes of communication. However, by dint of the social construction of the artist and his or her necessarily unique and liberal visions, critical positions are easily acculturated within what Leon Golub has called the 'gratuitous and disguisedly repressive freedom of the onrushing corporate state'.[3] The result is an artistic *avant-garde* that embodies nothing more radical than 'chic' and nothing revolutionary, desiring only status and prestige in the eyes of cognoscenti and collectors.

Since the end of the Second World War radicalism in the intellectual community had confined itself to aesthetics, aesthetics being much safer than politics. Indeed, under the banner of Clement Greenberg's formalist theory, the 'New American Painting' had become the 'natural' successor to the European Grand Tradition and had effectively put an end to European cultural supremacy in the West. In this new order subject matter was understood to be literary, illustrational and thoroughly anti-modern; nothing must threaten the autonomy of art as something belonging to the realm of pure spirit and free of ideology. Even

the reintroduction of figurative imagery in Pop Art had little initial effect, as it gained its legitimacy through a critical vocabulary concerned primarily with 'gesture', 'flatness' and the 'edge'. In sum, by the time of the Vietnam War the discourse of fine art had been so thoroughly acculturated that there was no available iconography of protest.

One of the first and most important fine-art images to dwell upon American military might was James Rosenquist's *F-111* (1965) (**plate 1**). As a mural-size picture it took up all of the available wall space when it was first exhibited at the Green Gallery, New York. In sheer scale it outdoes the epic proportions of the Abstract Expressionists and Barnett Newman's *Vir Heroicus Sublimicus* or Robert Motherwell's *Elegies to the Spanish Republic*. It compares, both in its challenge to the conventions of the easel picture and in its robust assertiveness, to Clement Greenberg's aesthetic of the New American Painting. The work was purchased by Robert Scull, a well-known collector of modern art, and loaned to the Metropolitan Museum of Art, where Henry Geldzahler, the Curator of the Modern Collection, later described Rosenquist as one of 'the major figures who have produced the vital sequence of moments that make the New York School the natural successor to the School of Paris'.[4] Rosenquist had trained as a billboard painter and his practice led him easily into the vanguard of the voguish Pop Art movement. His imagery is simple, direct and from a distance appears disinterested and anti-expressionistic. But Lucy Lippard, writing in 1965, could all too readily adapt the vocabulary of the dominant critical orthodoxy to its description. She found elements of the sublime, observed the painterliness of the brush-strokes and stressed the modern romantic myth of the artist as outsider – a myth vital to the ideal of the New Liberalism and the contemporary American artist – misreading the picture as 'devoted to a social theme . . . the artist's position in today's society'.[5] It is clear that the *F-111* was ascribed many of the qualities of Abstract Expressionism. In this way the New American Painting sought to sustain its cultural hegemony in the face of continual demands for novelty in the marketplace, even to the extent of abandoning its claims to an abstract and autonomous purity and facilitating the introduction of figurative imagery drawn from the communications industry.

The artist juxtaposes in a painted montage images of spaghetti, a hair-dryer, a small child, domestic wallpaper, cake, a tyre, an

H-bomb blast and a golfing umbrella, all unified by the giant F-111 that runs through the whole. The child is rosy, healthy and strikingly content. The bomb blast is juxtaposed with the protective umbrella. These elements, combined with the media source of the imagery and the style, which deliberately if ironically emulates a communications industry uncritical of American foreign policy, mediate the war and the sense of threat present in the image of the bomber. As Rosenquist commented, 'I like to bring things into unexpected immediacy as if someone thrust something right next to your face . . . and said "How do you like it?"' Individual objects are rendered 'so well that they might sell something, as if it had to be done by noon on contract'.[6]

Rosenquist's position was echoed by most established artists, who, if against the war, were steadfastly patriotic and defensive of the American way, loathe to criticise the ethical base of American technological achievement and market acumen. Robert Rauschenberg was perhaps the most typical in this respect. His reticence was mirrored in his *anonymous* financial contribution to *The Peace Tower*, his contradictory position demonstrated by his glorification of the American space programme in *Die Hard* (1963) and innovative use of the helicopter as an image of American imperialism in *Kite* (1964). The fine balance between technological optimism, expansionism and the putative benefits of the Pax Americana, on the one hand, and the 'troubling issue of military involvement by the US in the affairs of other nations',[7] on the other is clearly enacted in work that challenges the autonomy demanded by a dominant liberal aesthetic within establishment institutions. Indeed, the size and montage appearance of the *F-111* begins to stand for something aristocratic and absolutist as it represents imagery of American military supremacy and benign technological achievement. Effectively it affirms America's image of itself, and is difficult to read in the way Max Kozloff read it, as an 'indictment of US militarism'.[8] Rosenquist's 'vast emptiness of extravagance', spectacular, sensational, opportunistic and wildly naïve, abandons self-critical positions and expresses the desire to emasculate any sense of violence in the gloss of the colouristic display of a camp pop aesthetic. The whole emerges as a high-cultural legitimation and celebratory display of multinational corporatism and the war economy of the free market. It is difficult to forget that the painting was produced at the same time as the US Air Force was

embarking on Operation Flaming Dart and the bombing of North Vietnam.

STRATEGIES OF RESISTANCE

The legacy of the Cold War and the hold of market values were so strong that the expression of resistance within institutions of official art was effectively impossible, especially those isolated from calls of opposition from within some educational establishments. Throughout the war, the sculptor Mark di Suvero, for example, consistently refused to allow the exhibition of his work in America, for fear of compromise. In 1970 Irving Petlin warned of the dangers of the artist's position in relation to official culture and urged 'artists to withhold their work, deny its use to a government anxious to signal to the world that it represents a civilized culturally centred society while melting babies in Vietnam and gunning down kids all over the states. No.'[9] One incident occurred immediately following the Democratic National Convention in August 1968, when the dealer Richard L. Feigen organised the 'Richard J. Daley' exhibition:

> It was hastily arranged to replace a Claes Oldenberg exhibition in my gallery which Oldenberg postponed until the following Spring because he had been hit on the head by police during the Convention and was disinclined to celebrate Chicago at that moment. The Daley exhibition was also my idea to defuse a protest boycott which all artists were being called upon to honor for ten years – not to allow their work to be exhibited in Chicago as a protest. This was being arranged by several older New York artists. It was my position that Daley would not even know let along care about such a boycott, and that the only ones to suffer would be the artists' Chicago colleagues: better a statement than a non-statement. The only artist not to submit something was Josef Albers who told me he was 'not political'.[10]

The boycott as a means of protest was never fully exploited and Irving Petlin shows an unusual political forthrightness at a time when the anarchic and individualistic stances of the majority of artists led to a kind of apolitical silence.

Discontent found release in extra-artistic activities such as agitprop, demonstrations and petitions. Artists as a group were slow to respond, a tardiness indicative of their precarious position in a marketplace that encouraged the production of disengaged work and where only the smallest minority would ever gain sufficient international reputation to become 'independent'. The dominant and elitist ideological construction of the artist operated even amongst the protestors. 'An artist's work should be as clean as a hound's tooth of politics and social protest imagery. . . . Good art is never social work',[11] declared Abe Jay in support of the mirage of dehistoricised, autonomous art. Unsurprisingly, one of the first protest actions by artists took place outside of the domain of art and followed the example set by other professional groups such as doctors, teachers and physicists. It took the form of an advertisement in the *New York Times*, 'End your Silence', signed by 500 artists. The most impressive action was the Art Strike called by the Art Workers' Coalition on the First Moratorium Day, 5 October 1969, when 2000 artists protested on war-related issues and forced many galleries to close or curtail their activities.[12] Demonstrations of this nature are too numerous to list, but it is worth remarking that the targeting of centres of official culture such as the Guggenheim and Metropolitan Museums in New York echoed the activities of the Artists' Union during the 1930s. In both cases the artists were as concerned with their rights as much as the historically specific conditions of the Depression or Vietnam. In line with the Dadaists and Surrealists before them in Europe, they recognised the art institution as a vessel of dominant values and relied upon shock, surprise and literal demonstration in preference to the production of art objects which were liable to be appropriated so swiftly as to render any statement, propagandist or aesthetic, problematic. As such these activities did little more than add to the general cacophony of protest that characterised the liberal Left during the 1960s.

More effective challenges sprang from executive actions on behalf of groups of artists. Perhaps the most successful was *The Peace Tower* erected in the Bay Area of Los Angeles in 1966, where draft resistance was eventually to reach 34 per cent. Conceived by the Los Angeles Artists' Protest Committee, it aroused considerable public interest and was widely documented in the local press – significantly, after three months the owner of the site on which the Tower was erected refused to renew the lease and it was

dismantled. According to Therese Schwarz the major movers in the project were Irving Petlin, Lloyd Hamrol, Judy Geronwitz[13] and Mark di Suvero, who designed it. Monuments to war usually serve to reinforce feelings of national purpose and identity. *The Peace Tower* was more controversial, the eccentric balance of this brightly painted 50-foot-high steel tetrahedron serving to focus a little of the neurotic energy of a nation divided against itself while at the same time parodying the certainties of technological achievement and American pragmatism so often identified with contemporary Minimal styles. Most importantly, the Tower was produced and consumed outside the established institutions of official culture and civic respectability, and as an event shared by many people and reported in the press worked against the tradition of the private consumption of autonomous works of art.

A collective component around the base of the Tower consisting of contributions from 418 artists formed an important precedent for *The Collage of Indignation* at New York State University in 1967 and its repeat at the New York Cultural Center in 1971, when Lucy Lippard felt 'a return to slogans in an aesthetic context hardly expressed angers and outrages deeply felt'.[14] Many of the designs contributed by artists in these collective enterprises bore little stylistic relation to the work for which they were known in the marketplace. It seems the artist was yet again caught in an impossible situation, since on the one hand sloganising could not be perceived as art and on the other the aesthetic was a realm that possessed no vocabulary for the treatment of the political and was thoroughly permeated by ideologies implicated in the war. The contradiction is well illustrated by *Lace Curtain for Mayor Daley* (**plate 2**), Barnett Newman's contribution to the Feigen Gallery's 'group protest show' in Chicago.[15] In place of his normal colourfield abstractions he submitted a barbed-wire grid set in a heavy steel frame, spattered with blood-red paint. By making the work legible he ventured into a non-autonomous realm far from the rest of his work, which is deeply religious and Jewish but circumscribed by a dominant formalism often criticised for its corporate and inhuman connotations. Mark di Suvero, working outside the institutions of high art, did not have this problem: in the Tower he was able to produce a work possessing the expected characteristics of his *oeuvre*.

Work that ventured beyond the dominant discourse of art to make a social or political point tended to be consigned to critical

obscurity. Nancy Spero's Vietnam bomb pictures painted on paper between 1966 and 1970 received no widespread attention until the foundation of the AIR Gallery in the early 1970s, and then it was their feminist rather than their anti-war content that excited comment. The imagery is self-consciously anti-aesthetic, crudely articulated with a graffiti-like spontaneity. The pictures have a quality Donald Kuspit dubbed a 'psychological murkiness'. The style and the mutilations are reminiscent of American Indian picture-writing, and recall Red Horse's account of the Battle of Little Big Horn, another American defeat. Spero attempts to assert her outsider status as a woman and as an artist through deliberate circumvention of conventional forms of representation in art and the media. In *Helicopter, Pilot, Eagle, Victims Being Thrown from Aircraft* (1968) **(plate 3)** Spero engages the image of the helicopter, dual harbinger of death and resurrection – an image that through nightly television broadcasts had come to encapsulate the war in the popular imagination. Spero's husband, Leon Golub, wrote,

> The whirlybird becomes the Beast of the Apocalypse . . . destruction is literally in our living rooms via TV. All drops away, time, distance, the unthinkable. The malign fantasy and virtually insane imaginings of these paintings – the grotesqueries which form the delusions of the psychopathological.[16]

This picture, like *Female Bomb and Victims* (1966) **(plate 4)**, *Christ and Bomb* (1966) and *Bombs and Victims* (1966), has the clotted, spent fluidity of menstrual waste and recalls the masturbatory imagery of first-hand accounts of the My Lai massacre recorded by Robert Jay Lifton in *Home from the War: Vietnam Veterans Neither Victims nor Executioners*. These, like Spero's pictures, are characterised by the alienated absurdity of moral inversion within male codes of sacrifice, ordeal, glory and moral rightness. In Spero's work, violent omnipotence hovers over the splayed female victims; naked and exposed they affirm the 'masculinity' of the victor where the female, like the Vietnamese, is less than human and where rape is a form of revenge within the natural order. The imagery conveys the sort of brutalisation suffered by Second World War veteran Guy Sajer, who as soon as he saw naked flesh at the beginning of a sexual encounter 'braced . . . for a torrent of entrails'.[17] As indictments of male ideologies of war Spero's pictures are fragile and impermanent gestures conceived to challenge conventional

gallery and museum work. Her more recent work, such as *Vietnamese Woman* (1985), in which the figure of a Vietnamese in traditional clothes strides across the width of a 20 × 14-inch paper scroll, is more positive.

Like Spero, Leon Golub attempted to address the Vietnam war within the context of his *oeuvre* as a whole, rather than as an exceptional demonstration of sympathies divorced from the normal discourse of art. Golub founded, with others, the Ten Downtown in Chicago as an alternative to the commercial gallery system, and on his return from Paris in 1964 he immediately joined the Artists and Writers' Protest and established a pattern of active resistance. Again, like Spero, he received no widespread critical attention until the early 1970s, and during the war he seems to have exhibited his work mainly in centres of resistance, especially educational establishments.

Golub conceives of art as existing in a condition of dialectical tension as a product of the surplus energies of the state. The role of the artist as a representative of an older liberal individualist order is to struggle to turn those energies against the state. Themes of violence and masculinity had made up his subject matter on universal and mythological levels since the late 1940s. However, the terms of his gestural and large-scale canvas painting easily allowed the shift to a more specific iconography of the Vietnam War. On formal and stylistic grounds Golub's work addresses many of the aesthetic issues raised by the dominance of the New York School and its critical orthodoxies but seems to be a literal misreading of them. Golub's is not the broad, generous and vital gesturalism of Willem de Kooning or Jackson Pollock, but is more awkward, brutal and agonised; what is more, he abandons the all-over composition and recovers the figure from the ground to subject it to a process of tearing, ripping and scorching.

The *Gigantomachies*, painted over the period 1965–7, clearly make reference to classical reliefs of mythological and historical conflicts. But Golub's figures have none of the fluency of the continuous narratives of his distant models. They are naked and stumbling; they have lost their individuality and have all the qualities of the automaton. They enact the psychological processes of basic training, where the self is reduced to a set of reflex actions within the military organism. As Robert Jay Lifton recorded of one soldier, 'with Vietnam something went wrong for that young man. *This* war at *this* time did not, psychologically speaking, work for him.

If it occasionally afforded a glimpse of himself as a warrior-hero, he much more often felt himself a confused monster or blind helpless giant.'[18] In works such as *Napalm* (1969), Golub's iconography of naked figures, familiar from earlier generalised works such as *Burnt Man* (1961), is focused on the war through the title. With *Vietnam II* (1973) (**plate 5**) the meanings are anchored even more firmly and emphasised. The inclusion of recognisable imagery in the picture seems intended to evoke such events as the My Lai massacre. Direct and desolate, the picture draws on art-historical memories of Goya's *3 May 1808: The Execution of the Insurgents*, but in Golub's picture the helmeted anonymity of the soldiers is no longer answered by the defiant cry of a secular crucifixion, but instead is answered by the protective reflex of the victim as he throws his arm up in fear. There will be no salvation or resurrection in Golub's universe. As Jon Bird has pointed out, the Vietnamese are present but are cathartically separated from the American troops by a chasm of unarticulated 'modernist space'.[19] The picture refuses to supply a narrative in the nineteenth-century sense of the term, yet it strikes the mythic through its episodic and fragmented character. This is paradoxical in view of the style of representation, which, drawing on newspaper photographs and the documentary, encourages a voyeuristic response from the observer. There is a degree of aestheticisation in the decayed, scraped surfaces and the burnt and bubbled textures that mediate the subject matter with its stereotypical imagery of victor and vanquished. While horrific, it all appears perfectly natural, in tune with dominant male ideologies, and prefigures the recuperative spirit of the 1980s and films such as *Platoon* which attempt to tell it as it was.

More complex and in many respects more conservative is R. B. Kitaj's *Juan de la Cruz* (1967) (**plate 6**). Despite his dealer's highly capitalised and commercial operation at the Marlborough Gallery, London, Kitaj had a policy of selling as far as possible to public institutions such as museums rather than to private collectors. This policy was designed to ensure the maximum exposure of his work, and reflected his nostalgic ideal of the American Enlightenment and his perception of the museum as a centre of education, edification, entertainment and, most important of all, critical debate. Kitaj had been living in England since 1956, but in 1967 he was awarded a Visiting Professorship in Fine Art at the University of California, Berkeley. The picture dates from this period, when

he was spending time with poets such as Robert Duncan, who had been associated with the Free Speech Movement since its inception in 1964 and whose own private, individualistic and essentially anarchistic moral and ethical code was being forced into the public arena by the escalating pressure of events. Significantly, the picture was first exhibited at the Berkeley campus art museum. Kitaj had been aware of the critical condition of American social and political life for some time and had addressed it in his work. In this he shared the sentiments of his friend the poet Jonathan Williams, who as early as 1963 had written of the need for Americans abroad to stand up and be counted. The picture issues from contemporary accounts of the disproportionate number of black casualties amongst American ground forces. A 1966 report had revealed, for example, that a mentally qualified white male was 50 per cent more likely to fail his pre-induction physical than his black counterpart;[20] a phenomenon exaggerated because 'The Army was their [black Americans'] escape from the Newark ghetto. They wanted in not out.'[21] The artist drawing on his own experience in the American Forces of Occupation in Europe during the 1950s, has spoken of how the Army gave the black American a dignity and a meaningful role denied him in civilian life.[22] Indeed, *Juan de la Cruz* foregrounds the half-length figure of a black American Marine sergeant, supplemented by emblematic devices and attributes, against the interior of a helicopter in a manner reminiscent of an eighteenth-century portrait. In harmony with the form of the picture, Kitaj's reponse is humanistic and draws on a liberal-left tradition which finds one of its last resting-places in an ideal of the quest for knowledge divorced from the interests of multinational corporations.

The plurality and heterogeneity of that tradition is actively embodied in the structure of the picture, which embraces a stylistic, spatial and temporal diversity. Stylistically it ranges from the illustrational, in the portrait head, to the cartoon-like, in the more sexually explicit elements. Similarly, it is self-consciously ambiguous in the character of the line and the manipulation of colour as they shift from the descriptive and realist to the decorative and abstract. As in Golub's work, much of the meaning of the picture is anchored in the title, which here associates the fictional Sergeant Cross with St John of the Cross, Christian mystic poet, reformer and victim of persecution, and may also bring to mind according to the artist Roy Campbell, translator of St John's

devotional poems, traditionalist, Catholic, and Fascist supporter of Franco during the Spanish Civil War. Banked up behind the figure are representations of sadistic and sado-masochistic violence familiar from religious martyrology: the black American and the artist can be seen to be the secular counterparts of the saint. With their connotations of death and rebirth evocative of the vagaries of basic training, the obscene elements recall the graffiti-like imagery of Spero's pictures and parallel the use of sexual metaphor for power relations found in Norman Mailer's *An American Dream*. The killing and raping in the picture relate to the anxiety felt by Sergeant Cross as the war threatens his mortality and, in an inversion of the male codes of power, skill and worth, reassert masculinity in a denial of humanity symbolic of what many on the liberal Left felt to be the true position of America in Vietnam. At the same time the picture unconsciously draws attention to the skills American blacks were bringing back with them and feeds the fears of American whites. In the light of the stated aims of the Black Power movement, the connection with Roy Campbell casts the picture as a warning. Cross simultaneously becomes the embodiment of the totalitarian ambition of a repressed minority at home and of the totalitarian will of the state abroad. Charged with moral comment, the picture easily acquired the air of a museum piece, but, sceptical and fearful of official policy, the picture is not constructively critical of the ideological structures supportive of American military involvement in Vietnam and equivocates in the face of its potentially radical black subject matter.

ENGAGEMENT WITH THE MEDIA

Fine art is a minority pursuit, and far and away the most important and influential representations of the Vietnam War stemmed from the mass media, where, during the early years, the war was persistently constructed through newsreels and body counts in an attempt to justify Pentagon policy in Vietnam. For many Americans the reduction of the reality of war to statistics was expressive of an unwillingness to address the administration's true role in the war and to question its claim to be a defender of freedom and democracy rather than an offensive and potentially totalitarian defender of its own interests. Ed Kienholz treated the theme directly

in a piece titled *11th Hour Final* (1968) **(plate 7)**;[23] commissioned by the University of California at Berkeley, it finds inspiration in an advertisement for Hitler's 1938 people's radio, the *Volksempfänger* that was foisted on the German people as a means of ensuring propaganda penetration into the home. To Kienholz it offered a clear parallel to the nightly ordeal of the eleven o'clock final, the last news broadcast of the day, which was thoroughly permeated by a dominant ideology more interested in market returns than in human consequences. A concrete, tombstone television sits in the environment of a domestic sitting-room. On the bell-jar screen are the words 'THIS WEEK'S TOLL/AMERICAN DEAD 217/AMERICAN WOUNDED 563/ENEMY DEAD 435/ENEMY WOUNDED 1291'. At the bottom of the jar is the partially obscured head of a Vietnamese child. For the liberal Left the body count came to symbolise the moral and ethical bankruptcy of the war: 'counting the enemy dead can become both malignant obsession and compulsive falsification'.[24] This is a reading reinforced by the connection the artist makes with Hitler's Europe and the Final Solution, the eleventh hour, the hour before the last and the final descent into banality:

> The bodycount manages to distil the essence of the American numbing, brutalization, and illusion into a grotesque technicalization; there is something to count, a statistic for accomplishment. . . . The amount of killing – any killing – becomes the total measure of achievement.[25]

The British artist, Richard Hamilton, also responded to the Vietnam War through the media in the print *Kent State* (1970) **(plate 8)** but took a different course from Kienholz's work in form and institutional approach. It was produced as a reaction to the BBC news broadcast of amateur film taken on 4 May 1970 when National Guardsmen shot and killed four students at Kent State University, Ohio. As a response to a specific event reported in the media it bears comparison to the Art Workers' Coalition protest poster *Q. And Babies? A. And Babies* **(plate 22)** which makes use of a photograph of the My Lai massacre published in *Life*. Hamilton's image is characteristically less direct. The print is based on a photograph taken by the artist of a TV news broadcast. Transformed into a colour screenprint, it ran to the unusually large edition of 4000 copies at £15 each – as against the 50–120 copies at around £50 each that one would normally expect for such a production.

The intention was to try to free the image from an institutional context and extend the discourse of art into the arena of mass consumption – a longstanding and unfulfilled ambition of many artists associated with British Pop Art.

The most successful intervention of this kind, however, was the *Q./A.* poster: collectively and anonymously produced, it ran to an edition of 50,000 and was distributed free of charge. By this means it subverted the dominant conventions of the art object and the market system. Paradoxically, it was planned as a co-production with the Museum of Modern Art, New York, but the president of the museum's board of trustees vetoed the proposal. The Art Workers' Coalition challenged the decision by demonstrating in front of Picasso's *Guernica* (1937). A contemporary release read,

> The Museum's unprecedented decision to make known, as an institution, its commitment to humanity, has been denied it. Such lack of resolution casts doubts on the strength of the Museum's commitment to art itself, and can only be seen as bitter confirmation of this institutions and/or impotence.

The questions of artistic production and consumption were addressed in such a way as to be intolerable for the denizens of official culture, as Lucy Lippard points out in citing Hilton Kramer, who had 'the vivid impression of a moral issue which wiser and more experienced minds have long been content to leave totally unexamined'.[26] In fact, the relative success of the Art Workers' Coalition's intervention was more or less guaranteed by the museum's failure to co-operate: this rendered institutional appropriation of the art object impossible, and so left intact the wider redemptive and socially transforming ideals common to most modern art.

The Hamilton print, *Kent State*, drew attention to America's war at home. However, it is indicative that the victim it portrays, elevated to the status of martyr by both the media and the artist, is white, middle-class and educated. Michael Klein has suggested that at some point in the late 1960s the level of protest reached such a pitch that the dominant, market-oriented ideology withdrew its support for the war and began opposing it, in advance of other institutions of state and capital. This came about because of the extension of the draft to the middle and more articulate members of society, who were able to voice their discontent far more

effectively than sectors of society who had borne the brunt of the war for much longer. This is emphasised by the way the print was brought to the public. *Kent State* was exhibited with a commentary at the Studio Marconi, Milan, in 1971 and at the Whitworth Art Gallery, Manchester, in 1972 – far removed from the scene of the crime, as it were. The text conforms to contemporary conceptual modes and, while it might be ironic, dwells on Hamilton's interest in visual communication and effectively directs the observer's attention away from the evidence of the visual document and towards the technical sophistication of the media. 8-mm film had been converted into a radio beam for a satellite to pick up and bounce back to earth, where it was taped by the BBC and rebroadcast, then photographed by Hamilton, who finally translated it into screenprint. Victim became martyr and was taken out of history. The image inspired by moral outrage, stilted by irony and mediated by process served in the end, like Rosenquist's *F-111*, to extol the virtues of technology. In other words, the picture, participates in the ideological base of the conflict itself.

It might be said that during the period of the war all American art production was related in some way to the conflict in Vietnam, so pervasive was its influence on American domestic affairs. Yet the number of works relating to the conflict in specific and direct ways in terms of subject matter is relatively small, particularly when considered in light of the widespread personal involvement of artists as diverse as Robert Motherwell and Carl Andre. This was in part determined by the bedrock conservatism of the market, the audience, and the constrictions inevitably facing institutions responsible for America's cultural image abroad. However, institutions that were relatively free of the interests of corporate capitalism and the commercial system – especially institutions based on college campuses – found themselves with sufficient space to respond to work critical of official policy and media constructions of the war. On balance, though, artists' work did not fulfil the ambitions of a classical *avant-grade*, blazing a trail of radical thought through received orthodoxies, but performed a reinforcing function. The highly effective *Q. And Babies? A. And Babies*, for example, transformed an already critical and controversial piece of documentary photography into a poster in a spirit of affirmation of the disgust felt by the liberal Left. Most fine-art responses to the war were critical, but represented an older,

individualistic and liberal order that found the war intolerable in advance of the institutions of state and culture.

NOTES

1. T. Adorno, *Aesthetic Theory* (London: Routledge and Kegan Paul, 1986) p. 333.
2. B. Rose, 'The Politics of Art', *Artforum*, Mar 1969.
3. L. Golub, 'Utopia/Anti-Utopia: Surplus Freedom in the Corporate State', *Artforum*, May 1972.
4. H. Geldzahler, *New York Painting and Sculpture 1940–70* (London: Pall Mall Press, 1969) p. 15.
5. L. Lippard, 'James Rosenquist: Aspects of a Multiple Art', *Changing: Essays in Art Criticism* (New York: Dutton, 1971) p. 91.
6. Ibid., p. 91.
7. *Robert Rauschenberg Werke 1950–80*, exhibition catalogue (Berlin: Staatliche Kunsthalle, 1980) p. 328.
8. Quoted in Max Kozloff, 'American Painting during the Cold War', *Artforum*, May 1973.
9. Quoted in 'The Artist and Politics: A Symposium', *Artforum*, Sep 1970.
10. Letter to the author, 25 June 1987. See also T. Schwarz, 'The Politicization of the Avant Garde', parts 1, 2 and 3, in *Art in America*, Nov 1971, Mar 1972 and Mar 1973.
11. Quoted by Schwarz, in *Art in America*, Nov 1971, p. 97.
12. Schwarz, in *Art in America*, p. 97.
13. In her autobiography *Through the Flower* (New York: Anchor Books, 1977), with its strong feminist focus, Geronowitz, under the name 'Judy Chicago', fails to mention her involvement.
14. L. Lippard '(i) Some Political Posters and (ii) Some Questions they Raise about Art and Politics', *Get the Message: A Decade of Art for Social Change* (New York: Dutton, 1984) p. 29.
15. See Schwarz, in *Art in America*, Mar 72, pp. 70–5.
16. L. Golub, 'Utopia/Anti-Utopia, Surplus Freedom in the Corporate State' *Artforum*, May 1972, p. 52.
17. R. J. Lifton, *Home from the War: Vietnam Veterans Neither Victims nor Executioner* (London: Wildwood House, 1974) p. 271.
18. Ibid., p. 245.
19. *Leon Golub*, exhibition catalogue (London: Institute of Contemporary Arts, 1979) p. 17.
20. D. James, 'Presence of Discourse/Discourse of Presence. Representing Vietnam', *Wide Angle: A Film Quarterly of Theory, Criticism and Practice*, 7 no. 4 (1985).
21. William Broyles, *Bothus: Dims*, quoted in ibid.
22. *R. B. Kitaj*, film by Maya Productions for the Arts Council of Great Britain (1969).
23. He had treated the theme previously in a large portmanteau piece,

The Portable War Memorial (1965), where a hollow three-dimensional version of the press photograph of Marines raising the flag on Mount Suribachi speaks volumes of his suspicion of media representations.

24. Lifton, *Home from the War*, p. 64.
25. Ibid., p. 59.
26. Lippard, 'The Art Workers Coalition, Not a History', *Got the Message*, p. 14.

6

Flight Controls: The Social History of the Helicopter as a Symbol of Vietnam

ALASDAIR SPARK

One moment the world is serene, and in another the War is there.

Tim O'Brien[1]

No sound or image is as evocative of Vietnam as the helicopter. The two are synonymous, with the 'Huey' as familiar and as required in representations of the war as the six-gun in the Western (**plate 9**). This prevalence reflects the reality of affairs in the war, but it has tended to obscure the precise importance of the helicopter in determining aspects of the Vietnam experience for Americans, and hence the meanings inherent in its symbolic association with the war. As the archetypal symbol of Vietnam (for instance, on book and magazine covers), the helicopter has only one real competitor, the Vietnam Veterans Memorial in Washington. Unlike the memorial, it has a far more ambiguous and even subversive significance than mere evocation, as the following examination of its wartime social history and pedigree as a 'symbol in being' reveals. An important measure of this status is its continuing role in general post-war popular culture as a symbol of the threatening tendencies of technology and state control exposed by the Vietnam War.

VIETNAM (AIRMOBILE)

The Viet Cong are everywhere and nowhere, and so are we, everywhere and nowhere.

US pilot[2]

To appreciate the symbolism and iconography of the helicopter

requires an understanding of its relation to the war. Nothing else can place the same brackets around American intervention, from the first aviation companies sent to assist the South Vietnamese in 1961, to the frantic evacuation of Saigon in 1975, and the final scene of the jettisoning overboard of helicopters from the crowded flight-deck of the carrier *USS Blue Ridge*. As an official Army study notes, in a very real sense the helicopter made the Vietnam War possible:

> No other machine could have possibly accomplished the job . . . those scores of missions ranging from an insertion of a long range patrol to the vertical assault of an entire division; it alone could place artillery on the mountain tops and resupply these isolated bases; it alone could evacuate the wounded out of a chimney landing zone. . . .[3]

But in Vietnam this mere utility was overlaid with a distinctive American flavour, the mystique of the Air Cavalry. When William Gibson comments that the dumping overboard of helicopters in 1975 was 'as if an imaginary Western had turned into a horror show – the Cavalry was shooting its horses after being chased by the Indians back to the fort',[4] he strikes a chord which reaches back to the origins of helicopter Airmobility, General James Gavin's April 1954 *Harper's* article 'Cavalry, and I Don't Mean Horses!'[5] Gavin suggested that the then infant helicopter could bring freedom from the grinding frustrations evident in Korea, and likely in future limited wars. As *M*A*S*H* makes familiar, the United States did make limited use of helicopters in Korea, but Gavin's vision was of the deployment *en masse* of more powerful machines, 'organic' to units, replacing ground vehicles almost entirely in transport and for lightning assault – as Air Cavalry. This could permit, as Morton Halperin later put it: 'the highly mobile operations necessary . . . in the difficult military and geographical environments where limited wars are likely to take place. Military operations on land would assume much of the character of naval manoeuvres at sea.'[6]

It is therefore ironic that, unlike their Marine counterparts, Army advocates of Airmobility in the 1950s did not prosper in disputes with the Air Force, nor with their conservative superiors, who argued that the helicopter was too vulnerable. However, events took a new turn in 1961, as the enthusiasm of the Kennedy administration for counter-insurgency focused on the helicopter.

The French had already demonstrated its potential in Algeria, and in November 1961 Army (and later Marine) helicopter transport companies were despatched to assist the South Vietnamese Army (ARVN). Tentative airmobile operations began, and in 1962 Secretary of Defense MacNamara set up a review board (led by General Hamilton Howze) to examine the Army Airmobile concept, with the result that a test unit, the 11th Air Assault Test Division, was established the following year.[7] By then, Senator Henry Jackson was already enthusing that in Vietnam 'The sky is a highway without roadblocks. The helicopter frees the government forces from dependence on the poor road system and canals which are the usual arteries of communication.'[8] While a US adviser saw this as symbolic of failure, 'a tacit admission that we don't control the ground',[9] independence from the messy war on the ground (and, to echo Halperin, the 'peasant sea') was the precise appeal. The aim was not to hold terrain, and the rationale proved identical when in July 1965 the test division was hastily activated as the 1st Air Cavalry (Airmobile), and sent to Vietnam. In *Chickenhawk*, Robert Mason, Air Cavalry pilot in 1965, recalls that 'the major reason our leaders felt we could win where the French hadn't was our helicopters . . . our choppers would allow us to wander freely throughout Vietnam, hunting down the Viet Cong, undaunted by obstacles such as jungles, mountains, and blown out bridges'.[10] As a Marine officer put it in 1965, 'helicopters permit us to do in one or two days what used to take two weeks'.[11]

The aim of General William Westmoreland, the architect of American military strategy in Vietnam, was to locate and engage, to 'search and destroy' the main forces of the enemy (considered the major threat) deep in the interior and at the distant borders of South Vietnam. This was only possible by helicopter: otherwise, confined to small coastal enclaves, the Army would have found intervention far less acceptable. By the same token, airmobility permitted the deployment of ordinary and drafted soldiers to Vietnam. Two Army officers argued that, while it was extremely difficult to train large numbers of ordinary American soldiers in guerrilla warfare, 'the Army does not need to adopt guerrilla measures. Rather, the helicopter can be used, once the enemy is found, to re-supply US forces so rapidly that 20 men can be landed every minute.'[12] Hence, the helicopter seemed to do more than just solve the problems of countering insurgency: it appeared to transform the guerrilla equation, eradicating at a stroke previously

intractable problems of ambush, manpower and time which faced an America contemplating intervention. Westmoreland believed that without helicopters the United States would have required 1 million more men than the maximum 540,000 (working out at just one soldier per 460,000 square yards) eventually deployed – clearly unacceptable to the Johnson administration. Airmobility proved a seductive strategy for civilian and military policy-makers alike, offering what seemed a radical technological solution to the problem of matching guerrilla mobility and versatility. The attitude is epitomised in General William DePuy's comment that 'The VC [Vietcong] needs ten days to transfer three battalions. We manage five battalions in a day.'[13]

The helicopter became the American touchstone, symbolising a transcendent American power incarnate in metal – the Vietcong were aware of it, and awarded high honours to soldiers who downed ships. The American vision was summed up in the caption to a photograph in *Army* in 1967:

The 'copter touches down only for seconds, the troops pour out, carrying their weapons, necessary explosives . . . but not much more. You need more ammunition? A medevac for a wounded man? Hot Chow? Water? A visit by Martha Raye? It's all possible up forward, courtesy of Messrs. Bell, Boeing, and Sikorsky[14]

Martha Raye notwithstanding, in technology and mobility this was the ideal American way of war, and appropriately evoked *the* mythic American style of war. Contemporary and remembered accounts of the war are replete with comparisons to the American West, an association abetted, even sponsored, by the official policy of naming helicopters after Indian tribes, evoking the Indian wars – Sioux, Choctaw, Shawnee, Chickasaw, Mohave, Iroquois, Cayuse, Kiowa, Chinook, Tarhe, Cheyenne.[15] The policy predated Vietnam, but clearly was considered appropriate for the limited wars envisaged. The same resonance was true of the 'Cavalry' itself. During the war the press, fed by the Army, stressed a flamboyant lineage back to General Custer, as later maintained in Michael Herr's narration to the film *Apocalypse Now*: 'The 1st of the 9th was an old Cavalry unit which had cashed in its horses for choppers and gone tear-assing round Nam' But the history was fake. The evocatively named 1st Air Cavalry (Airmobile) had no link whatso-

ever with the ground-based 1st Cavalry, which in 1965 was serving on a rather different frontier in Korea. But, by administrative fiat, military planners created the cavalry mystique anew, transferring to the test unit the name, horse-head insignia, colours, history and crossed-sabre props clearly considered the symbolically appropriate heritage for the virgin elite.[16]

Helicopters did not exist in the numbers required for Vietnam: they had to be manufactured, or, in the case of the Huey Cobra, designed. By 1966 the Defense Department was taking 90 per cent of the $1300 million output of the US helicopter industry. Gloria Emerson itemises the species of helicopter:

> the UH-1 Huey, called a slick . . . which cost $300,000, the daintier LOH-6 [Loach] for observation which cost $100,000 . . . the Cobra gunship – cost $500,000; the CH-47 Chinook . . . which cost $1,500,000 and could lift 19,000 pounds of cargo or twenty-four injured men ; the CH-54 [Tarhe], the Flying Crane.[17]

In 1966 the First Air Cavalry alone had 434 helicopters, 16,000 men (pilots, air crew and infantry 'skytroopers'), and consumed 85,000 gallons of fuel per day.[18] Conventional line units, without the 'organic' helicopters of the Cavalry, were assigned to 110 independent Army and Marine aviation companies for transport and air support, provided by a further 1800 helicopters. Even so, there never seemed to be enough helicopters or pilots. In 1966 the Army upped pilot-training from 120 to 440 per month, but shortages persisted – hardly surprising given that, in 1967 alone, helicopters airlifted over 5 million troops, equivalent to 313 infantry divisions, and mounted 2.9 million sorties over 1.2 million hours – or, put another way, compressed 137 years of activity into one.[19]

Being such an omnipresent part of the war landscape created by America for itself in Vietnam, the helicopter was bound to be an important element of the war experience and so to furnish memoirs with common images and attitudes, and it is in this social history that the details of the larger symbolism of the helicopter are to be found. Yet it is notable that, while the helicopter is necessarily a frequent presence in memoirs, novels, films and general ephemera (comics, songs, and so on) relating to the war, fewer works than might be expected deal directly with the experiences of pilots and air crew. Pulp fiction about helicopter units (the 'Chopper' and 'Gunship' series) exists, but no particular genre of serious helicopter

memoir/fiction, comparable to the infantry novel. Worthy of note are short stories by Wayne Karlin and Steve Smith in *Free Fire Zone*; William Holland's *Let a Soldier Die*, a novel–memoir of the exploits of a gunship pilot; T. Jeff Williams' *The Glory Hole*, about a medevac crew; and Robert Mason's aforementioned *Chickenhawk*. William Eastlake's *The Bamboo Bed* and Coppola's film *Apocalypse Now* particularly exploit the symbolism of the helicopter.[20] The comparative rarity of such treatments can best be understood by examining the larger social history, but it is worth noting here that in film it has to be partly accounted for by practical difficulties. Duplicating the massed ranks of the war requires a very high budget and co-operation from those who have the helicopters – the US Army. This means gaining script approval, a problem which Francis Coppola only solved at great expense by hiring helicopters of the same type supplied to the Filipino Army by the United States. Most films instead make do with one or two helicopters (and it is interesting in what manner), while some low-budget efforts, such as *How Sleep the Brave* and *Tornado Strike Force*, are forced to use radio-control models. Recent films depicting combat remain unable to do the helicopter full justice: *Platoon* (also filmed in the Philippines) has very few, having foundered on the script co-operation issue, and director John Carpenter's attempts to finance a film of *Chickenhawk* have so far been unsuccessful.

HOT RODS AND COLD LZs

> *Every grunt and desk jockey from Ca Mau to Con Thien gave more than a cursory glance skywards at the thud of an approaching chopper clacking here, clicking there, all four corps were a zigzag of tracked chopper lines.*
>
> Tim Page[21]

In a war characterised by great variety in terrain, climate, types of privation and types of combat, the helicopter was a rare collective feature. The most evident sign of its omnipresence was the unmistakable slap–thud of the ubiquitous Huey, a noise which Michael Herr in *Despatches* called uniquely sharp and dull at the same time, the product of two huge rotor blades, 48 feet from tip

to tip and 21 inches wide. Noise was also a signal of the helicopter's authority in Vietnam, bringing fear to the enemy but to Americans a more complex reaction. For those attached to the helicopter – pilots and air crew – it signalled glamour and the pure thrill of flight, above the ground war. For soldiers, the beat of rotor blades imposed a rhythm (otherwise absent) upon the war, measured in cycles of waits at landing-zones (LZs), air assaults, medevacs, supply replenishments and withdrawals. As passengers, they were intimate with the 'ear-numbing roar of engines, the rush of rotors . . . the smells of grease and aviation fuel',[22] such that the association of helicopter and Vietnam was near-total, producing a profound dislocation elsewhere. Flying in a helicopter in America, James Rowe found that

> the sound of the blades, the vibration of the ship [was familiar] . . . only the countryside was out of place. I unconsciously searched below for the broad spreading paddies and criss-crossed canals . . . [and] felt a touch of panic as the buildings, expressways and rolling Texas hill country clashed violently with the image my mind was creating.[23]

A decade or more after the war, that same authority, threat, thrill and glamour could be conjured up by the sound of rotors. A veteran commented,

> Helicopters, any helicopter that goes by with the right pitch on those blades. Whenever I hear that . . . I just think, 'At any moment that thing's going to land. I'm going to see some blue smoke, or green smoke. . . . That thing is going to land, and pick me up, take me away. Who knows where.'[24]

For American soldiers, the fundamental authority of the helicopter lay precisely in this disturbing power to insert them into and extract them from the war (though the image of the 'nine-to-five' war is exaggerated). Serving with the Marines in 1965–6, Philip Caputo once noticed the graffito 'Happiness is a Cold LZ', and reckoned in *A Rumor of War* that Airmobility 'created emotional pressures far more intense than a conventional ground assault. It is the enclosed space, the noise, the speed, and above all the sense of total helplessness.'[25] Likewise, William Willson wrote in *The LBJ Brigade* of soldiers feeling 'helpless prisoners in this tin trap, and

plunging ahead we envision the end . . . a thousand ways of dying, we see them all'.[26] Denied the traditional security of the ground, Tim O'Brien noted 'how perfectly exposed you are. Nowhere to hide your head. You are in a fragile machine. No foxholes, no rocks, no gullies.' Soldiers soon learnt that helicopters were flimsy and vulnerable to concentrated and heavy-calibre ground fire. As Ron Glasser wrote in *365 Days*,

> most choppers are destroyed in the thirty feet between landing and taking off. The gooks could . . . put a few rounds into a chopper at 800 feet, but that might give the pilot enough time to get it down. So they wait until the chopper is too low to glide and too low to hover[27]

Denied the status symbol of an intercom, the eight to ten troops in the noisy rear of a Huey could only anticipate the approaching landing in ignorance. In the front, Mason recalled, pilots had clear priorities: in a hot landing 'a wounded aircrewman or great structural damage were the only reasons you could abort. If a grunt was wounded, you kept going.' Noticeably, many soldiers perceived the air crew who delivered them to the war as depersonalised hermetic parts of the helicopter, threateningly different from themselves (soldiers rarely travelled with the same crew twice in succession). In *The 13th Valley*, John Del Vecchio noted a gunner in 'flight suit and aviation helmet with the dark visor down . . . like an armed green astronaut'.[28] Similarly, in *Meditations in Green*, Stephen Wright describes a gunner: 'head surrounded by a huge bulbous helmet, face masked behind a sun visor . . . like a robot, or a man from the fumigation company'.[29]

Arrival, even at a cold LZ, brought only temporary relief, since heli-borne assaults by their very nature made the ground as alien as another planet. Soldiers might be anxious to leave the helicopter, but they were just as anxious to get back into their portable piece of America to escape. Disembarked in a jungle or paddy, Herr felt, 'it could be the coldest one in the world . . . watching the chopper you'd just come in on, taking off again'. As Caputo noted, 'when the helicopters flew off, a feeling of abandonment came over us . . . we were struck by the utter strangeness of this rank and rotted wilderness . . . marooned on a hostile shore from which there was no certainty of return'. On patrol the helicopter was the source of everything familiar and essential, from ammunition to medevacs,

to the 'things available in the rear area . . . pizza, fresh ice cream, cold beer'.[30] For the troops the truth was, 'you just didn't get it unless you carried it, or it could be kicked out of the door of the chopper'.[31] The helicopter in fact made soldiers feel more, not less, isolated, and the same inversion was manifest in other ways. Medevacs, while a morale-booster, were also a symbol of isolation, leaving, as Del Vecchio wrote, 'no trace of the dead or wounded . . . except for blood and . . . tissue' for those remaining in the jungle or paddy after the 'dust-off' chopper had gone.[32] Instead of allowing commanders personal contact with the troops, the helicopter in fact divided them from their officers, who made occasional appearances like visiting royalty. A company commander recalled a helicopter hierarchy whirring above him one hot day:

> The battalion commander and his operations officer were sitting in a helicopter at a thousand feet. The Brigade commander was at fifteen hundred feet. The Division commander was at twenty-five hundred feet. The Corps commander was at three thousand feet. And I swear to God, one day I was in a battle where COMUS MACV was at thirty-five hundred feet – all of them over the same battle.[33]

As a result, the helicopter provided a focus for soldiers' fears and folklore. Two legends predominate, the first of a helicopter atrocity, the throwing of Vietcong prisoners out of the helicopter, a story prevalent throughout the war. The Army investigated allegations and concluded that they were baseless, but anecdotal evidence is persistent. One soldier made a familiar claim: 'When we had to interrogate some of the prisoners, we used to take three gooks [Vietnamese] up in a helicopter about a thousand feet. . . . The first gook wouldn't talk . . . you push the guy out.'[34] The second tale concerns ghostly enemy helicopters seen or heard at night, or flying along the demilitarised zone. Like UFOs, unknown choppers were tracked on radar but never intercepted.[35] The North Vietnamese did operate helicopters, but that is not the point. The stories point to the troops' fears that the symbol and fact of American power had been appropriated by the enemy – as do parallel tales of a white GI in black pyjamas who had joined the Vietcong – and that they might themselves be the target of the helicopter, perhaps

as US soldiers were the surprise targets of enemy tanks at Lang Vei.

But the strongest fear of all was being stranded on the ground outside the American areas – of being forgotten, abandoned to Vietnam. Tim Page wrote of his fear when 'five of us correspondents were put down two clicks from the nearest friendlies by mistake. For an hour we stood there waving and shouting at every passing bird till I fished the signal out of my never-used Special Forces survival pack'[36] Abandonment is a central motif in memoirs, novels and other representations of Vietnam, from Eastlake's *The Bamboo Bed* to the recent missing-in-action cycle (see below), and almost always it has something to do with a helicopter. *The Deer Hunter* depicts a frantic struggle to board a helicopter, and an image already familiar to Americans of men hanging from the skids. In Stone's *Platoon*, it is notable that it is not enough for the 'good sergeant' Elias to be shot by Barnes: he has to be abandoned to Vietnam – and how else, but by helicopter? In fact helicopter crews made heroic efforts to evacuate wounded or soldiers in danger, and part of the combat structure of the war consisted of rescue of soldiers or downed air crew. But when gunfire was too hot (and in novels the destruction of the rescue chopper is a frequent motif) the result could be panic, as happened to troops of the ARVN 1st Division during the Laotian incursion in 1971. James Webb described real scenes at a besieged firebase in *Fields of Fire*:

> A Medevac helicopter made it through the enemy guns, landed . . . and was immediately swamped with frightened men. Sold-iers hung onto the outside of the helicopter when the insides were full. American crewmen cursed the panicking soldiers and kicked at them, knocking them off the helicopter railings, so they could depart.[37]

The power of such scenes was fully realised in front of the whole world in April 1975, in the final evacuation of Saigon ('Operation Frequent Wind'): the operation had necessarily to be conducted by helicopter, as American control of the ground in Vietnam had finally shrunk to nothing but rooftop LZs.

Nevertheless, for all this, soldiers also felt the thrill of flight, and sensed the appeal of the helicopter to air crew. William Willson recalled gliding over the jungle: 'as though on skis, we skim over

the quicksand of treetops, they stream below us like a highway at night, a blurred fascination of motion'.[38] Open (or absent) doors made flight more intense, a transcendence Herr called 'the rapture of the deep' and that was shared by Australian Neil Elliot: 'I like to hang near the door on a Huey. There is no door as such, just an open space above thousands of feet of sky. As the thing turns from side to side, it's like sitting in the door of an open bomb bay. Nothing but you and the earth – straight down.'[39] The thrill was sufficiently transcendent that even in assault, Caputo recalled, 'the experience was not entirely unpleasant. There was a strange exhilaration in our helplessness . . . the feeling, half fear and half excitement, that comes when you are in the grip of uncontrollable forces'.[40] A radio man put the appeal more simply: 'I loved flying in helicopters because you went fast. It's power, like having a Corvette.'[41] Soldiers were attracted by the glamour, and Mason often found grunts 'gathered around the machine. Some guys asked all sorts of technical questions. . . . Others would stand back and grin knowingly, as people do around race-track drivers.'[42]

A typical American iconography and masculine swagger developed among helicopter units. The seductive allure of the helicopter was manifest in the way pilots cultivated a swashbuckling 'Terry and the Pirates' or 'Flying Tigers' image: photographs show them confident and casual, moustached, with helmets, ray-ban aviator sunglasses, half-zipped flight suits, cowboy-style holsters and flak jackets. Pilots (and door gunners), were volunteers: in a Huey one day, a drafted Marine doctor recalled suddenly being struck by the realisation that he was 'inside a machine . . . maintained by kids who wanted to go to war. The pilot chose to fly in Vietnam, rather than changing tires or going to college.'[43] The helicopter rewarded such willing servants with a glamour, thrills and an *esprit de corps* absent in ordinary units. An Air America (the CIA's private airline) fixed-wing pilot described his helicopter colleagues thus: 'They were younger . . . had the wildest parties and were the biggest boozers and the real hotshot Charlie aviators. . . . The "rotor heads" were a clique and didn't mix much.'[44]

The primary enticement offered was flight itself, a transcendent exhilaration giving not just independence from the ground but total independence in the air: a soldier described a Loach as 'a rotary-winged hot rod [and] the guy flying it either had more guts than anyone else alive or had shit for brains . . . any lower and you might as well get out and walk'.[45] Helicopters could ascend

vertically, stop in mid-air, hover, pirouette and fly backward. Vulnerability to concentrated gunfire meant that helicopters followed contours, and 150 miles per hour seemed much faster when twenty-five feet off the ground – as pilots would often demonstrate to alarmed reporters. This required the skill and co-ordination described by William Holland as 'two hands, two feet, and single-minded concentration that through long practice finally became second nature, but could never be relaxed. Unlike other aircraft, a helicopter untended would not fly itself. It preferred to crash.'[46] Pilots learned to respect their craft as unforgiving creatures, offering only the slimmest safety margin – as many were lost to mechanical failure and accident as to the enemy. As Ron Glasser noted, exhilaration was tempered by the fact that 'once in the air they stay there, churning on through the sheer power of their engines. If anything happens to that power – and it doesn't take much' Life rested upon wingless machines which glided only in the most rudimentary fashion, and, shedding a rotor blade, fell unsupported out of the sky. But this vulnerability only underlined the helicopter's authority: not for nothing was the bolt securing the rotor blades colloquially known as the 'Jesus nut'.

There was a thrill darker than flight or *esprit de corps*: flying while being shot at – and firing back. The glamour elite of the war were the gunship pilots, in armed machines whose authority was total – 'aerial lawnmowers', as one soldier put it. Combat flying was by all accounts almost addictive, and although pilots feared it, few gave it up. Many were shot down half-a-dozen times. Captain Hugh Mills, a Cobra pilot who flew 3300 hours in 1019 combat missions, was downed sixteen times – almost certainly a record in air warfare. A crewman accurately described loaches, Huey Hogs, and Huey Cobras as 'never intended to carry troops or supplies, or letters. They were just these pieces of death machine that flew around, and that's all they did.'[47] Crews decorated their ships with shark's teeth and other insignia to identify their units, in a manner reminiscent of Second World War pilots. 'We had some colorful names: The Bounty Hunters, The Sting Ray, Light Fire Team, Magic Turban. We were Brutal Cannon.'[48] Shelby Stanton lists many others in *The American Order of Battle*. Cavalry call signs stressed the 'official' myth: 'The Saber Shakers', 'The Apache Headhunters', 'The Long Knives', 'The Flashing Sabres', 'The Yellow Scarves' and 'The Four Horsemen'. The thrill of the

gunships' firepower can be appreciated from a spectator's account of a Cobra attack:

All of a sudden, just out of nowhere, this guy is hovering over you. Once he tips the tail up and drops the nose, you know he's got four seconds. Then in four seconds, an unbelievable arsenal of destruction is brought forth. Firing these 2.75 millimeter rockets, after he drops 52 of them, he brings those 40 mike-mikes in. And he's still running two mini-guns. And they can roll. Roll in on the target. Come in at completely 90 degrees. At 200 miles an hour.[49]

Appropriately enough, other messages were addressed to those on the ground: 'Some of the more inventive crew chiefs would crawl under the helicopter and paint things on them like, "Be nice, or I'll kill you."'[50]

This is the image of the helicopter war parodied (though the image itself was in reality already a parody) in Coppola's *Apocalypse Now*, in the depiction of the 1st of the 9th, the most glamorous Cavalry unit of all. It is an exaggerated image which, while technically inaccurate, does convey the *esprit de corps*, exhilaration and thrill of combat felt by helicopter air crew. As such, the helicopter scenes in *Apocalypse Now* point to the character of air crews' experience, and to the reason for the relative absence of memoir or fiction based on their exploits.

An important element of their experience was speed – in both the velocity and sheer density of experience made possible by being, as Wayne Karlin put it, 'a loud noise and a green flash in the sky'.[51] Mobility provoked frequent, dizzying contrasts between front and rear, between Vietnam and transplanted portions of America – what William Shawcross called 'instant transitions between first world suburbia and third world death'.[52] This power is perhaps best indicated by the experience of James Rowe, a Green Beret captured by the Vietcong in 1963, who escaped in 1968 and was picked up by helicopter. After five years of starvation, within moments he was eating American fruit cake and peaches in the rear of the helicopter, and within half an hour was back at his old base. Picked up, Rowe marvelled

at the interior of the helicopter. The voices speaking English were like music. 'O Lord, please don't let me wake up and be

back in the forest. Please don't let this be a dream.' I looked out over the U Minh, feeling a strange detachment from reality. It had been so long, so long since I had seen the horizon. How many times had I looked up at aircraft, wishing I could be in them, flying above the mud, mosquitoes, and leeches: flying free above the confines of the trees, the green prison.[53]

A pilot recalled the mental equivalent of a cinematic 'jump-cut': 'One morning you're flying medevac and you'll see guys who haven't had a hot meal in four days. And [next] you're going to fly the general around [and he] brings you in to eat in an air conditioned room with a tablecloth and sterling silver'[54]

In human and in artistic terms this amounted to an extreme destructuring of narrative sense-making for air crew, placing the helicopter at the centre of an Aristotelian universe. History existed \ inside, not outside, the helicopter. Wayne Karlin wrote of the illusion of being 'suspended in space, while [below was] some moving assembly-like strip of ground that was drawing under the aircraft'.[55] Others constantly in the helicopter, such as journalists and photographers, found that frequent exposure collectivised Vietnam in the mind. To Herr, Vietnam became simply 'Helicopters and people jumping out of helicopters . . . Choppers rising straight out of small cleared jungle spaces, wobbling down onto city rooftops, cartons of rations and ammunition thrown off, dead and wounded loaded on'. Such generalised impressions go against the narrative grain of a century or more of conventional war fiction – namely, the traditional patrol or platoon focus, and the stream of events in battle. The formal military memoir (which infantry veterans do provide) could not hope to capture such fragmentation; Robert Mason succeeds in *Chickenhawk* because his memoir has a beginning in the American intervention in 1965 and an end in his own nervous breakdown. *Dispatches* – a memoir made possible by Bell Helicopters – was perhaps unlikely to come from a veteran. Herr wrote of the 'collective meta-chopper' that was 'helicopter' memory, the 'saver–destroyer, provider–waster, right hand–left hand, nimble, fluent, canny and human; hot steel, grease, jungle–saturated canvas webbing, sweat cooling and warming up again, cassette rock and roll in one ear and door-gun fire in the other, fuel, heat, vitality and death . . .'.[56]

By the same token, helicopter flight transcended the war, detaching air crew from the effect of their firepower. Coppola's

aim in the helicopter attack sequence was to show the audience that, like pilots, they too were 'capable of being thrilled at the prospect of sitting behind the stick of a helicopter and spraying a Vietnamese with machine guns'.[57] While flight detached air crew from the action of their weapons, and the same might be said of fighter-bomber air crew, perhaps contact with the reality of violence ought to have been heightened by the helicopter: for troop-carriers ('slicks'), in assaults; and, for gunships, in targets which were almost always human (not tanks or structures), opponents which were never other helicopters, and attacks which were not made from 20,000 but from 200 or even 20 feet. But, if helicopters had a symbiotic relationship to the war, air crew had a symbiotic relationship to helicopters. Glamour rooted in American myth, masculine *esprit*, exhilarating speed – being inside the symbol – were the rewards for men who at the extreme would abstract themselves from the war entirely, except as suppliers of the machines required for flight and of the raw statistics for the body count. A door gunner put it all into words: 'I loved it. . . . I was part of the elite. . . . Nobody screwed around with you. . . . We were the heroes. We got to fly the helicopter.'[58] This is surely the desired military equation in a modern limited war. As a gunship pilot in the Cavalry commented, 'we might talk about . . . technical things, flying, guns, maintenance, that kind of thing. But the moral issue of the war, no, we never discussed that at all.'[59]

As Coppola realised, the still darker side of detachment was sheer enthusiasm for the trajectories of slaughter; 'Airsports', a pilot told Herr, 'Nothing finer.'[60] There are many accounts of indiscriminate killing of those on the ground (and target practice on cattle) within 'free-fire zones' created for the roaming inquisitive helicopter. General John Donaldson, the only general court-martial-led in the war, was prosecuted for shooting civilians from his command helicopter – 'gook hunting'.[61] A gunship pilot testified on targets to the Dellums Committee,

> Anyone taking evasive action could be fired upon . . . we flew over . . . some people in a large rice paddy . . . they were obviously nervous, but didn't try to hide or anything. So we then hovered a few feet off the ground among them . . . they started to disperse, and we opened up[62]

This said, distance from the ground may in some cases have helped

preserve a sense of right and wrong: witness the action of Warrant Officer Hugh Thompson, who landed his loach in an attempt to rescue Vietnamese civilians – from American soldiers at My Lai.[63]

Here lies another reason for the comparative lack of memoirs and fiction. The helicopter made it easy to feel unequivocal about the war not ideologically but experientially, as a constant thrill ('pure sex', a spectator said to Herr). As a seductive piece of technology and an intermediary between men and the ground war, it was meant to function in this way. Many of Robert Mason's readjustment problems upon his return home came simply from losing the adrenalin 'high' of flight, not least in its tension with fear when under fire. The wistful comment of *Apocalypse Now*'s Colonel Kilgore, 'Some day, this war's gonna end', is surely only a darker expression of Mason's own regret. In the aftermath of Vietnam, pilot memoirs, if possible, were unlikely to be acceptable, being memoirs not simply of courage, but of glamour, *esprit* and excitement transcending the issues of the war. While *Chickenhawk* has been very successful (a Vietnam memoir for the 1980s), it is notable that it comes from a 'slick', not a gunship pilot, who would have a different confession to make – if any. A pilot who stayed in the Army, Robert Monelli, wrote, 'I would give my eyeteeth to go back. I didn't find combat difficult at all. It was a very intense activity. I must admit that after both tours I found normal conventional life a little dull. I have to admit, I missed it.'[64] A 'pure sex' novel or memoir of serious quality remains unwritten, and is perhaps unwritable. William Holland comes closest, but, while his hero is a gunship pilot, he has a moral dimension, wants to give up the role, but is so good at it that he is refused a transfer to a medevac unit. Even so, his loss of drive does not – cannot – result from the routine killing of the enemy, or even civilians; instead it comes from a mistake in the most meaningful extremity of helicopter symbolism – the directing of helicopter firepower upon Americans.

GROUND EFFECT

> *Machines like this make all the difference. How'd you like to fight a War against an Army that can be anywhere, anytime?*
>
> US pilot[65]

The helicopter, like the soldier, is a veteran of Vietnam. While previously it had a relatively innocuous place in the public mind, in air–sea rescue, or the crime-fighting of *Whirlybirds*, the helicopter is now overwhelmingly associated with Vietnam, at a more than subliminal level. As has been discussed, the two are synonymous, in fact and in image – from thousands of photographs and newscasts over a decade. Though they may not know its name, the Huey is as familiar a sight to Americans as a Boeing 747 or a Ford Mustang. Its very sound is instantly recognised. Similarly, the black-and-gold horsehead shoulder patch of the Cavalry (bar the Green Beret, the most well-known insignia to emerge from the war) signals Vietnam, and American soldiers wear it in military films as diverse as *Private Benjamin* and *Salvador*. Hence, the helicopter is a possessive symbol, instantly evoking its own war – for instance, in the first second or two of the title sequence of *The A-Team*, or in the Billy Joel song *Goodnight Saigon*. Likewise, in the opening scenes of Clint Eastwood's *Firefox* and in *Commando*, the sound (and then the sight) of the familiar green helicopter flashes the hero back into the past (it is a recognised symptom of post-traumatic stress disorder). Appropriately, the helicopter was the vehicle by which the American public re-entered Vietnam: in the dream sequence that opens *Apocalypse Now*, and in the first Vietnam scenes of *The Deer Hunter*. In both films, the mobility of the helicopter is echoed in the editing-technique, by jump-cuts in which first the sound, then the image of the helicopter moves the action to or within Vietnam. Both films also transport the audience instantly through associating ceiling fans with rotor blades, a metaphor which has now become common. Few films depict combat in Vietnam, but where it has briefly been attempted the helicopter is almost always present – in *Heroes*, *Dog Soldiers* (US title *Who'll Stop the Rain*), even *The Twilight Zone* – further reinforc-ing the association. Noise being cheap, the slap–thud of the approaching and receding helicopter often substitutes for the real thing, though in *Apocalypse Now* synthesised rotor blades (the sound of Herr's meta-chopper?) underscore the action.[66]

Such an association of sight and sound had other effects when the helicopter came home from Vietnam. As the war grew unpopu-lar, the soldier was depicted as contaminated by Vietnam, and in films, television series and popular fiction of the 1970s disturbed veterans stalk America, redeploying their military skills at home. As a human symbol of Vietnam, the veteran was transformed into

a domestic Vietcong (or, as Richard Berg nicely puts it, 'Vet Cong') on the loose in America's cities and forests. In a similar inversion, the helicopter returned home to make its target Americans in popular culture.[67] In reality, already during the war, the sight and sound of Army, police or National Guard Hueys at home had come to symbolise 'American' authority, directed against domestic subversives. An anti-war protestor, CS-gassed from the air at a demonstration, wrote, 'The Hueys shrieked in low, so low I might have downed one with a well-aimed rock . . . Huey, after Huey after Huey, Vietnam in Berkeley.'[68]

The symbolism was real, and not only in the minds of the demonstrators. Helicopters were used not only at Berkeley, but also during the march on the Pentagon in 1967 and the November 1968 march on Washington. With the example of Vietnam in mind, American authorities were quick to realise the helicopter's potential for surveillance and social control in the United States – during ghetto riots for example. The rationale was familiar: independence from the problems of the ground. Congressman James Scheuer recommended, 'In view of helicopter mobility and versatility . . . situations calling for large numbers of troops and policemen might be handled by heavy personnel-carrying helicopters. Our military experience demonstrates that men can [swiftly] be landed'[69] In the 1960s, US city police forces progressively equipped them-selves with helicopters for surveillance and quick reaction, and by 1973 and withdrawal from Vietnam, over 150 were in use, in sixty-three cities. Vietnam was at home, literally, since the same models of helicopter were used, the Hughes Loach in particular donning blue and becoming the 'Sky Knight'. With spotlight, observing camera and a megaphone issuing orders to those below, the helicopter henceforth became the technologically extended arm of state authority, and US citizens the target of its interest.

The helicopter had earlier played a part in 1960s popular culture. In almost all the James Bond films (particularly *You Only Live Twice* and *Diamonds are Forever*), and in lesser imitations such as the *Man from UNCLE*, the helicopter became the favoured transport of super-villains. The potential for crime was also explored in films such as *Sky Heist* and *The Hot Rock* (US title *How to Steal a Diamond in Four Easy Lessons*) – a member of Robert Mason's air crew evolved an essentially cinematic fantasy about robbing a bank in Las Vegas. But, under the influence of Vietnam, the dominant strand in helicopter depiction was not pilot- or even flight-focused. The

trend was established by Barry England's 1968 novel *Figures in a Landscape* (and the film based on it), in which the hunting helicopter is seen from the ground (the Vietcong viewpoint) by two prisoners of war on the run. The pilots do not really appear, and the machine is a persistent, malevolent personalised force in itself. England writes, 'the chopper ground back and forth over their heads, beating the message down, that he knew where they were, that he would never go away, that he would stay until they were broken'.[70] Such helicopters exist as autonomous agents of state authority, apparently pilotless or anonymously crewed, and their appearance is notable. In representations of Vietnam, in order to show that the Huey or Loach has gone to war, the doors are often removed, the occupants become visible, and soldiers scramble on and off. In contrast, the autonomous 'hermetic helicopter' is sleek and dark-canopied, self-contained and sealed, with no openings to the world, as if it were an alien spacecraft.

In this guise, the helicopter further symbolises Vietnam brought home in the threatening tendencies of technology and state control – the wire-taps, Pentagon Papers and Watergate lies bred by the war. An example is Peter Hyams' *Capricorn One*, one of a crop of post-Vietnam conspiracy thrillers which utilise the helicopter as a symbol of state authority. In the film, the US government fakes a Mars landing, rather than cancel the mission and lose face. Hyams was a newsreel cameraman in Vietnam, and, to judge from the film, the helicopter impressed itself upon him. The astronauts are held at a remote camp, but realise that the authorities will not allow them to survive. They escape, and in the major sequence of the film are hunted in the desert (helicopters are used on border patrol in New Mexico) by two green Loach helicopters, the scene featured on the movie poster. Throughout, the pilots are not shown behind their smoked-glass canopies, and there are almost no shots from inside the cockpit. These helicopters, which have a particularly insect-like appearance, exist as autonomous beings – an impression given most strongly in one particular shot, in which the searching helicopters hover, sniffing the wind, tilt toward each other as if in secret communion, and then suddenly spin and fly off in different directions. Only once, at a deserted filling-station where the hero hides, is a pilot seen – and then in the alien flight suit and black-visored helmet noted by so many soldiers in Vietnam. The helicopters are finally crashed in a duel with an antique, low-tech and thoroughly human-piloted crop-dusting biplane.

The helicopter is similarly deployed in other conspiracy thrillers of the 1970s and 1980s. In Stanley Kramer's *The Domino Principle*, an assassin (a Vietnam veteran) is manipulated by a conspiracy into shooting the President from a hovering Huey: the President waves to it, sure it cannot mean *him* harm. In Steven Spielberg's *Close Encounters of the Third Kind* Hueys police the perimeter, provide transport to the landing-site of the alien spacecraft, and deport those drawn there but not welcomed by the government, gassing those who resist. John Carpenter's helicopters in *Starman* are also agents of government authority, but with even greater vigour. The hunt for the stranded extra-terrestrial is masterminded from a green helicopter, and his spacecraft is taken away to be examined slung beneath it. At the end of the film, in scenes combining *Apocalypse Now* with *Close Encounters*, a squadron of Air Cavalry strafe the alien as he waits for his mother ship. In Carpenter's earlier *Escape from New York* (1979) the government has turned Manhattan Island into a walled penal colony, the perimeter of which is maintained by armed black helicopters which spotlight and shoot escapers, and in which guards make forays into the barbarous interior of the city.

The evident connection with science fiction is interesting. In *Close Encounters* (echoed in Bill Forsyth's *Local Hero*) a helicopter uses spotlights to masquerade as a flying-saucer. The resemblance to a spacecraft has been noted, and extra-terrestrial contact might be presumed the biggest secret a government would wish to hide. This hints at the reality that helicopter flight does offer a perspective otherwise impossible for humans – a British television series, *Bird's Eye View*, was based on this premise. Indeed, this is the essence of the use of the helicopter as a camera platform, and the fluid (gyro-stabilised) tracking shot from close-up to long-shot is now familiar. Three typical examples are the pull-back from a close-up of Clint Eastwood atop the chimney mountain in *The Eiger Sanction*, revealing the actuality of the scene; the progressive detachment from the characters at the climax of *Easy Rider* or *The Electric Horseman*; and the opening shot of *The Sound of Music*, as the camera takes a closer and closer interest in one individual. This Olympian perspective and the helicopter's authority and autonomous character clearly suggest that it is a deity in the modern technological pantheon. A recent example is a commercial on European television in which a man is awakened by a ghostly helicopter hovering (with a synthesised rotor beat) outside his

bedroom window, shining a spotlight down onto a mysterious new car which has materialised in his driveway.

Recently the helicopter has come to attention in two representations of Vietnam, the missing-in-action (MIA) genre of films, and the super-copters of the TV series *Airwolf* and the film *Blue Thunder*. In the recent cycle of MIA films, the (open-doored) helicopter often provides the transport back to Vietnam, and always salvation and escape from prison camp or hostile territory back to civilisation. It plays this role in the climax of *Missing in Action*, *Rambo: First Blood II*, *Uncommon Valor*, and episodes of *Magnum P. I.*, *Matt Houston* and *The A-Team*. But the major role of the helicopter is as the agent of abandonment. In *Rambo*, a Huey fails to rescue Rambo and the MIA he has freed – it is piloted by a mercenary ordered to abandon Rambo by his CIA boss, and painted a sinister black (later, when Rambo 'liberates' a Huey from the Vietnamese and escapes with the MIAs, it is the familiar olive green). The abandonment scene is best realised in the opening sequence of John Milius and Ted Kotcheff's *Uncommon Valor*, as a group of soldiers race for a helicopter, pursued by the enemy. Four fail to make it, and the camera dizzily rises with the helicopter from a close-up of their upraised arms to a long-shot of their capture. Symbolically, to be left behind in Vietnam, to be failed by America, to be missing in action, means to be abandoned by helicopter.

It is noteworthy that, while still a symbol of American technology, the helicopter is now challenged by enemy counterparts. In *Rambo* there is a duel between a Huey and a Mi24 Hind, the Soviet super-helicopter used in Afghanistan (ludicrously, the Huey wins). In fact, the 'Soviet' helicopter is a mock-up using a French Puma, neither type being familiar to American audiences. Another Hind mock-up appears in John Milius's *Red Dawn*, in which an inversion of Vietnam occurs and American guerrillas are hunted by an all-seeing Soviet craft – which the American guerrillas fail to shoot down. Interestingly, the antipathy to complicated technology expressed by the Rambo character does not extend to the helicopter, with his qualification as a pilot standing in sharp contrast to his primitivist fieldcraft. But the stress is on his qualification as a *helicopter* pilot, the message being that the helicopter is a good steed, a legitimate extension of self, part of a true union of man and machine.

Airwolf and John Badham's *Blue Thunder* both take their titles from imaginary super-copters, transcendent in their firepower,

their surveillance capabilities, their speed and aerobatics. Both helicopters appear to be hermetic non-human agencies with vast potential for harm, pure gunships equipped with advanced surveillance and bugging equipment (*Blue Thunder* begins with a statement that all the technology displayed in the film is real, though, as in *Airwolf*, the helicopter's capabilities are enhanced by speeded-up film and 'silent' rotors). The threatening potential is not used by criminals or a foreign enemy but by the US government itself. However, in both films the pilot acts to counteract the threat of such technology, and deploy it for good. In *Airwolf*, the Vietnam veteran pilot steals the super-copter and hides it in the desert, only making it available to the government for missions he personally believes are just. In *Blue Thunder*, the pilot steals the super-copter after using its capabilities to learn its secret, that it has been developed by subversive elements in the government to provoke civil disobedience. The need for pilot conscience emerges as the lesson of Vietnam for deployment of the helicopter (and especially the gunship): only thus can the threat of technology and machine autonomy be overcome. *Blue Thunder* makes this clear in its subplot: the pilot is the hero, but he is fallible. He has flashbacks to Vietnam, in contrast to the helicopter's official test pilot, a veteran of the Cavalry, the hero's former co-pilot and *alter ego*. The flashbacks are gradually revealed to concern the pilot's guilt at failing to prevent the co-pilot from carrying out the central atrocity of helicopter folklore – the throwing-out of a Vietcong prisoner. Defeating his *alter ego* in a helicopter duel, he finally destroys Blue Thunder by abandoning it in the path of an oncoming train.

In this as so many representations, the helicopter stands as the archetypal symbol of America in Vietnam. Without the military advantages it gave, the war, or at least large-scale American combat intervention, would have been scarcely possible. As a species of technology, the helicopter already had symbolic value for Americans, but in Vietnam the association with the American West, and the glamour and exhilaration of combat, reinforced the appeal. For American soldiers, more directly subject to its authority, the helicopter also evoked tension and the fear of abandonment, which has been a central motif in representations of the war. For those ultimately at the receiving end of the helicopter's attentions, the Vietnamese, the symbolic revenge upon America has been the helicopter's return home, to focus itself upon domestic America, as part of the legacy of Vietnam. Given that the helicopter has a

continuing utility in counter-insurgency, it remains an active symbol, and association produces a threatening and disorienting 'flashback' to a future Vietnam – as *Time* commented under a photograph of an American helicopter in Honduras. The same is evident in Hollywood's Latin American genre films, such as Costas Gavras's *Missing*, where the Huey acts as a symbol of dictatorial military authority, and of the American 'advisory' presence south of the border – a role it has in real life. Oliver Stone's *Salvador* makes the same point: the hero is shot by a helicopter, and there is scarcely a scene at the US Embassy which does not feature the distinctive clatter of Hueys overhead. As such, symbolism may be a defence against a future Vietnam. The 1986 video of Bruce Springsteen's *War!* begins with the sound of rotors and the grainy image of a Huey disgorging troops, watched on television by a father and teenage son. The final seconds dissolve back to archive footage of a medevac helicopter, while the beat of rotors grows louder. The camera pulls back, revealing a grieving father watching the television alone. Fundamentally, therefore, the helicopter is an uncompromisingly honest symbol, a machine veteran with a history that cannot be so easily rehabilitated (that is, forgiven *and* forgotten) and that, in sight and sound, connects past, present and perhaps future.

NOTES

1. T. O'Brien, *If I Die in a Combat Zone* (London: Granada, 1980) p. 104.
2. H. Portisch, *Eyewitness to Vietnam* (London: Bodley Head, 1963) p. 20.
3. Lt-Gen. J. Tolson, *Airmobility, 1961–71*, Vietnam Studies series (Washington, DC: Department of the Army, 1974) p. 104.
4. W. Gibson, *The Perfect War: Technowar in Vietnam* (New York: Atlantic Monthly Press, 1986) p. 3.
5. Gen. J. Gavin, 'Cavalry, and I Don't Mean Horses!', *Harper's*, Apr 1954, pp. 55–60.
6. M. Halperin, *Limited War in the Nuclear Age* (New York: Wiley, 1963) p. 165. Advocates of Airmobility did not especially stress the potential counter-insurgency role of the helicopter: emphasis was on limited war, and the 'atomic battlefield' concept. It is extremely doubtful that the extensive Airmobility demonstrated in Vietnam would have been possible, except in an insurgency, against a better-armed enemy. Given the sophistication of modern portable heat-seeking missiles, the Vietnam era may already seem to have been a golden age.
7. M. Hickey, *Out of the Sky* (London: Mills and Boon, 1979) pp. 206–18;

Gen. H. Howze, 'The Howze Board', *Army*, Feb–Apr 1974.

8. Senator Henry Jackson, quoted by Howze, in *Army*, Feb 1974.
9. M. Browne, *The New Face of War* (New York: Bobbs-Merrill, 1965) p. 56.
10. R. Mason, *Chickenhawk* (London: Corgi, 1985) p. 90. Mason was a 'slick' (troop-carrier) pilot. Returning from Vietnam in 1966, he became an instructor, but personal difficulties forced him to leave the Army. He was imprisoned for a petty marijuana-smuggling offence in 1981, during which time he wrote *Chickenhawk*.
11. *Vietnam*, Read in Series no. 1 (London: Eyre and Spottiswoode, 1965) p. 66.
12. Z. Bradford and F. Brown, 'The US Army in Transition', quoted in Cincinnatus, *Self-Destruction* (New York: W. W. Norton, 1981) p. 74.
13. F. Harvey, *Air War Vietnam* (New York: Bantam, 1967) p. 117. Harvey provides an interesting account of helicopter operations in Vietnam.
14. K. D. Mertel, 'The Agility of Airmobility', *Army*, May 1967, pp. 26–30.
15. For details see S. Stanton, *The American Order of Battle* (Washington, DC: US News Books, 1981). The term 'Huey' comes from the official model designation 'Utility Helicopter I', or UH-I, and was later legitimised in the name 'Huey Cobra'.
16. Hickey, *Out of the Sky*, p. 231. Given the constant rotation of air crew through the Cavalry, within a short period most of the division would have accepted the fake as real.
17. G. Emerson, *Winners and Losers*, 2nd edn (Harmondsworth: Penguin, 1985) p. 263.
18. Hickey, *Out of the Sky*, p. 231.
19. Tolson, *Airmobility*, p. 116.
20. W. Karlin, 'Medical Evac' and 'Extract', and S. Smith, 'First Light', in *Free Fire Zone* (New York: First Casualty Press/McGraw-Hill, 1973); W. Holland, *Let a Soldier Die* (London: Corgi, 1985); T. J. Williams, *The Glory Hole* (London: Corgi, 1977); W. Eastlake, *The Bamboo Bed* (New York: Avon, 1969). Other interesting accounts include R. Treskasgis, *Vietnam Diary* (New York: Holt, Rinehart, Winston, 1963); I. Kemp, *British GI in Vietnam* (London: Blake, 1969); W. Butterworth, *Order to Vietnam* (Boston, Mass.: Little, Brown, 1968); S. Smith, *American Boys* (New York: G. P. Putnam's Sons, 1975); J. and D. Groen, *Huey* (New York, Ballantine, 1984). I would welcome other references.
21. T. Page, *Tim Page's Nam* (London: Thames and Hudson, 1984) p. 17.
22. P. Caputo, *Del Corso's Gallery* (London: Sphere, 1984) p. 100.
23. J. Rowe, *Five Years to Freedom* (New York: Ballantine, 1984) p. 462.
24. In A. Santoli (ed.), *Everything We Had* (New York: Ballantine, 1982), p. 79.
25. P. Caputo, *A Rumor of War* (London: Arrow, 1977) p. 293.
26. W. Willson, *The LBJ Brigade* (London: Panther, 1967).
27. R. Glasser, *365 Days* (London: Longman, 1972) p. 197.
28. J. Del Vecchio, *The 13th Valley* (London: Sphere, 1982) p. 152.
29. S. Wright, *Meditations in Green* (London: Abacus, 1985) p. 253.

30. M. Baker (ed.), *Nam* (London: Abacus, 1983) pp. 83, 112, 138.
31. Veteran Joseph Anderson, in W. Terry (ed.), *Bloods* (New York: Random House, 1984) p. 229.
32. Del Vecchio, *The 13th Valley*, p. 403.
33. A. Santoli (ed.), *To Bear Any Burden* (London: Abacus, 1986).
34. Baker, *Nam*, p. 145. See also, among many others, Williams, *The Glory Hole*, p. 184; Terry, *Bloods*, pp. 27 and 225. For the Army side, see G. Lewy, *America in Vietnam* (London: Oxford University Press, 1978).
35. See for instance Herr, *Dispatches* (London: Picador, 1978) p. 95; D. Maurer, *The Dying Place* (London: Corgi, 1986) p. 141; and Del Vecchio, *The 13th Valley*, p. 303. Some speculation has it the helicopters were CIA.
36. Page, *Tim Page's Nam*, p. 21.
37. J. Webb, *Fields of Fire* (London: Granada, 1980) p. 402.
38. Willson, *The LBJ Brigade*, p. 48.
39. N. Elliot, *The Noisy American* (Sydney: New Century, 1967) p. 113.
40. Caputo, *A Rumor of War*, pp. 111–12.
41. Baker, *Nam*, p. 56.
42. Mason, *Chickenhawk*, p. 245.
43. J. Parrish, *Journal of a Plague Year* (London: André Deutsch, 1972) p. 97.
44. C. Robbins, *The Invisible Air Force* (London: Pan, 1981) p. 27. 2066 helicopters were lost to hostile action, and 2566 to non-hostile, but many were recovered and flew again. 668 pilots were killed in action, 401 through non-hostile causes. This rate was more than double that for fixed-wing aircraft. Figures from Stanton, *The American Order of Battle*, p. 346.
45. Rowe, *Five Years to Freedom*, p. 426.
46. W. Holland, *Let a Soldier Die* (London: Corgi, 1985) p. 49.
47. Glasser, *365 Days*, p. 196.
48. Baker, *Nam*, p. 103.
49. Veteran Stephen Howard, in Terry, *Bloods*, p. 125. *Bloods* also contains an account by a Cavalry veteran, Harold Bryant. For a pilot's account of helicopter operations, see Capt. J. McDowell, 'A Day in Tuy Hoa Valley with Gunships and Slicks', *Army*, Feb 1967.
50. Baker, *Nam*, p. 103.
51. Karlin, 'Extract', in *Free Fire Zone*, p. 180.
52. W. Shawcross, Introduction to *Tim Page's Nam*, p. 7.
53. Rowe, *Five Years to Freedom*, p. 440.
54. P. Starr, *Discarded Army* (New York: Charter House, 1973) p. 16.
55. Karlin, 'Extract', in *Free Fire Zone*, p. 182.
56. Herr, *Dispatches*, pp. 15 and 16.
57. Interview on *The South Bank Show*, London Weekend Television, 1979.
58. Baker, *Nam*, p. 161.
59. Emerson, *Winners and Losers*, p. 255. See also M. Mylander, *The Generals* (New York: Dial Press, 1974); and L. Baritz, *Backfire* (New York: William Morrow, 1985) pp. 301–2.
60. Herr, *Dispatches*, p. 56.
61. Citizens' Commission of Enquiry, Congressman Roland Dellums

Committee Hearings (New York: Vintage Books, 1972) p. 291.

62. Ibid., p. 283.
63. See S. Hersh, *Cover-Up* (New York: Random House, 1972) pp. 102–4.
64. R. Monelli, in *Newsweek*, 15 Apr 1985, p. 38.
65. Mason, *Chickenhawk*, p. 302.
66. Sound-editor Walter Murch produced the rotor beat by slowing down the noise of a chain hitting a paper bag. Coppola was forbidden access to sound recordings of military helicopters by the Department of Defense.
67. In *First Blood* and *Welcome Home Soldier Boys* the equation with Vietnam is drawn – a domestic 'Vietcong' now has to combat helicopters at home – and related domestic urban images such as the sniper leaning out of the helicopter are established. To be chased by a sniper in a helicopter has become standard in the repertoire of the modern American thriller, with perhaps the best realised depiction in Clint Eastwood's *The Gauntlet*.
68. Merrit Clifton, quoted in J. C. Pratt, *Vietnam Voices* (Harmondsworth: Penguin, 1985) p. 391.
69. Quoted in Ackroyd, Margolis, Rosenhead and Shalmer, *The Technology of Political Control*, 2nd edn (London: Pluto Press, 1980) p. 193.
70. B. England, *Figures in a Landscape* (London: Granada, 1970) p. 64.

7

Killingly Funny: US Posters of the Vietnam Era

DAVID KUNZLE

The American media's celebration of the twentieth anniversary of the end of the Vietnam War (which has not ended) tries to establish the war, if not as the 'noble enterprise' lauded by President Reagan, then at least as a well-intentioned effort that somehow went wrong. Films such as *Rambo*, and the media generally, rewrite the past in order to win the future. 'Do we get to win this time?' asks Rambo, setting forth on his mission to rescue from secret Vietnamese prisoner-of-war camps fictitious Americans presented as historical fact. So the US administration 'wins' in Grenada and fights to 'win back' Nicaragua, both countries supposed prisoners of Soviet Communism.

Academe has done its share to cover up the realities of the Vietnam War. My hope was that it would become an instrument to help prevent future Vietnams. Military academic official historians have been assigned to establish a definitive 'factual history' based on data to which only they have access. Their operation has been likened to that of some imaginary group of Nazi historians positing the German defeat in the Second World War as a tactical withdrawal – which leaves the official military historians, polite gentlemen by nature, nonplussed. There is also a poster so rude (**plate 20**).

An academic symposium related to our topic, called 'Vietnam Reconsidered: Lessons from a War', held at the University of Southern California in February 1983, gave such media giants as Harrison Salisbury of the *New York Times* the chance to defend the role of the mainstream press in the war. On that occasion I wrote a text (eliminated from the published version of the conference proceedings) which opened,

I hope this conference is not about to whitewash the crime of

112

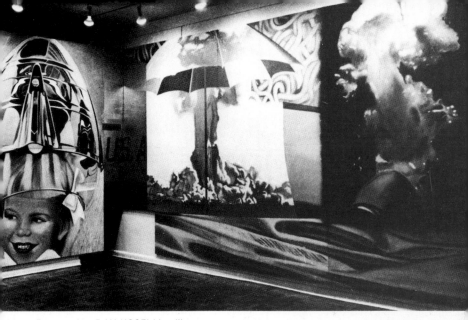

James Rosenquist, *F-111* (1965) (detail)

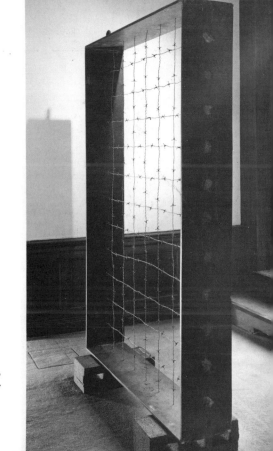

2. (*right*)
 Barnett Newman, *Lace
 Curtain for Mayor Daley*
 (1968)

3. Nancy Spero, *Helicopter, Pilot, Eagle, Victims being thrown from Aircraft* (1968)

4. Nancy Spero, *Female Bomb and Victims* (1966)

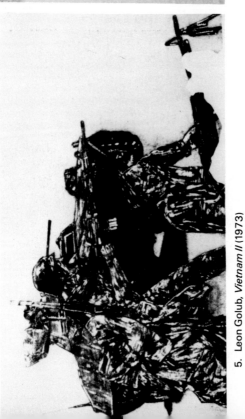

5. Leon Golub, *Vietnam II* (1973)

6. R. B. Kitaj, *Juan de la Cruz* (1967)

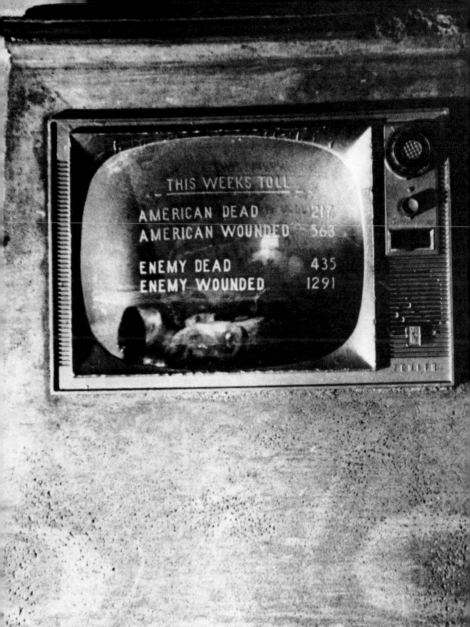

THIS WEEKS TOLL

AMERICAN DEAD 217
AMERICAN WOUNDED 563

ENEMY DEAD 435
ENEMY WOUNDED 1291

7. Ed Kienholz, *11th Hour Final* (1968)

8. (*above*) Richard Hamilton, *Kent State* (1970)

9. (*below*) *Dumping of Helicopter from LCC-19*

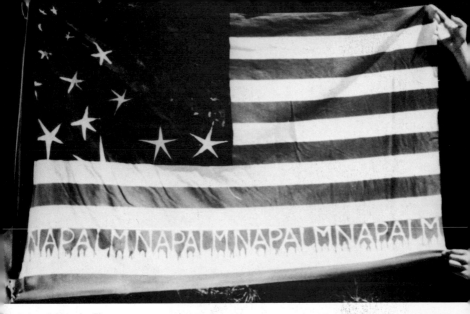

0. (*above*) *Napalm Flag*

11. (*right*) *Uncle Sam Wants You!*

13. *This is the spell of Chanel for the bath*

12. *This vacation visit beautiful Vietnam*

14. (*right*) Tomi Ungerer,
EAT

15. Robert Indiana, *EAT* (1966)

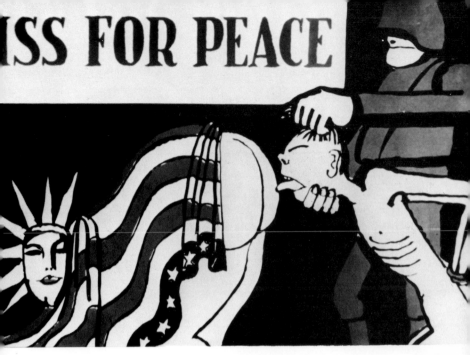

18. (*above*) Tomi Ungerer,
Kiss for peace

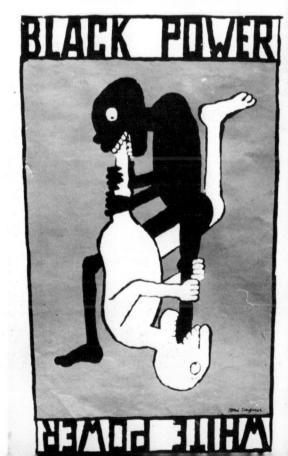

19. (*right*) Tomi Ungerer,
*Black Power, White
Power*

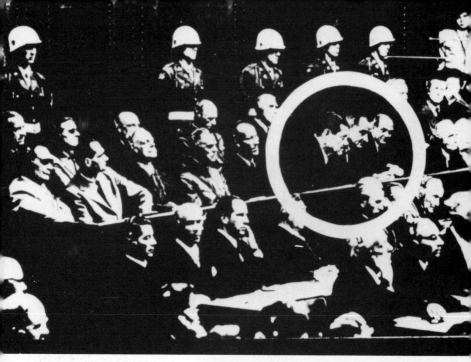

20. (*above*) *Nuremburg Trial*

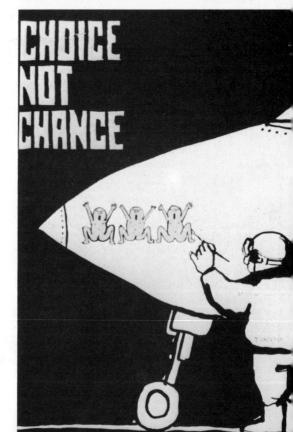

21. (*right*) Tomi Ungerer,
Choice not Chance

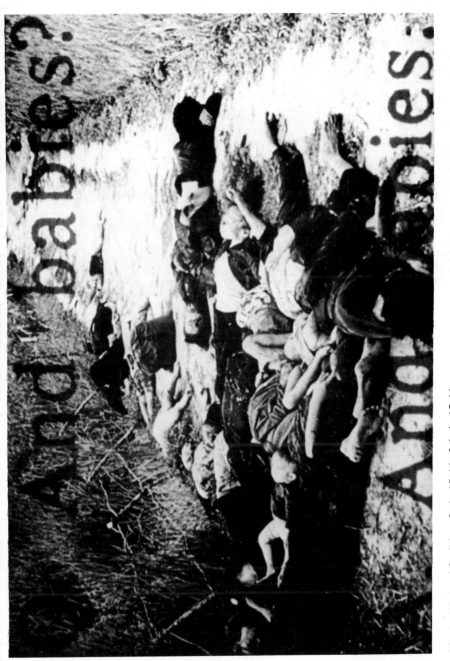

22. Art Workers' Coalition, *Q. And Babies? A. And Babies*

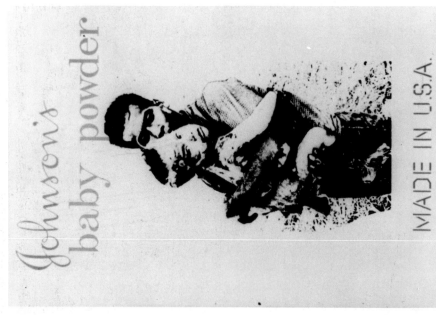

Johnson's baby powder

MADE IN U.S.A.

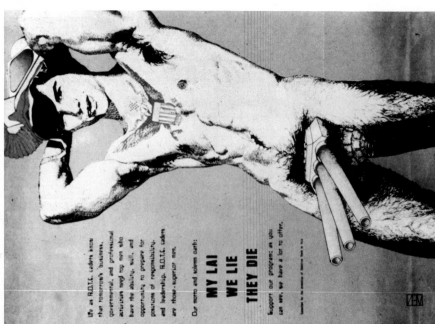

Life as R.O.T.C. cadets know
that tomorrow's business,
governmental, and professional
activities will top men who
have the ability, skill, and
opportunity to prepare for
positions of responsibility
and leadership. R.O.T.C. cadets
are those superior men.

Our motto and solemn oath:

MY LAI
WE LIE
THEY DIE

Support our program: as you
can see, we have a lot to offer.

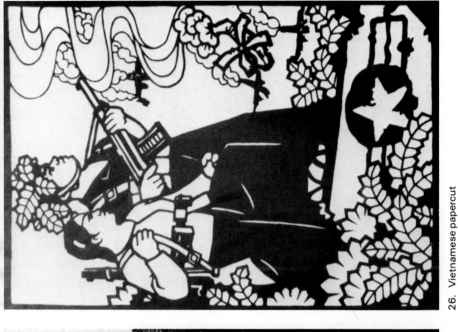

26. Vietnamese papercut

25. William Weege, *Napalm*, Happening Press

El Salvador

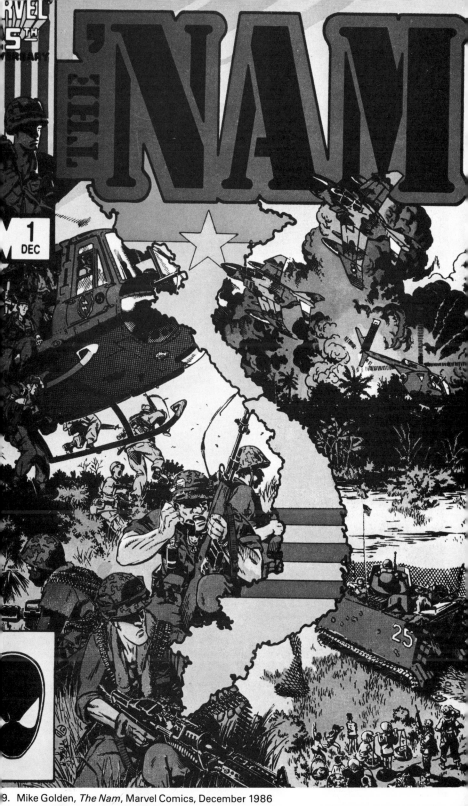

9. Mike Golden, *The Nam*, Marvel Comics, December 1986

30. (left) Mike Golden, *Savage Tales*, no. 1 (1985) p. 9

31. (above) R. Ledwell, *In-Country Nam*, no. 1 (1987) p. 7

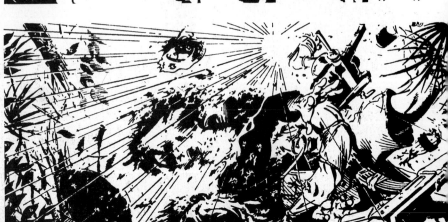

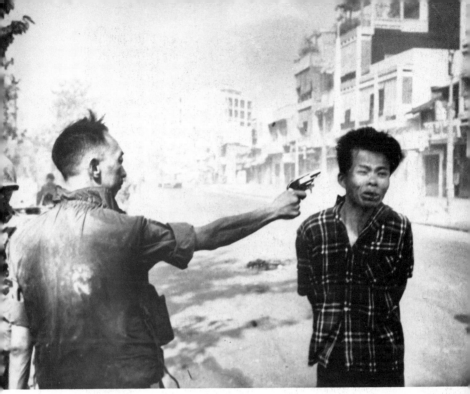

32. (*above*) Eddie Adams, *The Execution of a VC Suspect,* 1968

33. (*below*) Maya Lin, *Vietnam Veterans Memorial*

34. Fred Hart, *Vietnam Veterans Memorial*

the war. I hope that the prestigious USC and USC School of Journalism will not be party to the cover-up of the crime of the media in covering up the crime of the war.[1] I hope we will be reminded that the war against Vietnam is not over; it continues on the economic and diplomatic levels, and by military proxies. I hope that the lessons of the War and of the Conference is to stop the US war in Central America, which is a continuation of the war in Asia, by similar methods, and according to similar policies.

The truth about the war has been brought home to us by Vietnam veterans, some of whom are here to testify today. They knew truths the newspapers and TV refused to print.

But there were also at the time 'alternative' print media, an 'underground' press which dared to speak out. A vital part of its output was the popular political poster, a new phenomenon in the United States. Enduring testimony that the Vietnam War was indeed a crime, one of the worst in history, perhaps the worst since Hitler's, is to be found in the posters of protest which constitute the major graphic and visual document of the anti-war movement during the late 1960s and early 1970s. These posters are cries of denunciation, outrage and bitter mockery against those who launched the war, and the way they conducted it. The posters also summon up compassion for those who suffered it abroad, and they celebrate those who protested against it at home.

The sheer scale and diversity of the poster-of-protest phenomenon was extraordinary: an estimated 20,000–40,000 different dissident political posters were produced between 1965 and 1973.[2] While attempts have been made to collect, conserve and even exhibit them,[3] the relative neglect they have suffered is no accident, for they sit uneasily with the national conscience. This efflorescence of poster imagery is all the more remarkable in that it necessarily bypassed the sponsorship of official government agencies and academic or educational institutions (including art schools) such as stood behind the great poster campaigns of this century. The posters are typically American in their spirit of private enterprise, the work of innumerable individual professional and occasional artists, most of whom do not sign their names, and innumerable small *ad hoc* organisations generated by the broad spectrum of left, pacifist and anti-war concern which underpinned the movement. They are the most authentic *popular* graphic expression of US

history, the product of the moment when the US *people* for the first time since the Civil War made a decisive intervention in their history.

The politics of the poster of protest were as heterogeneous, eclectic, impassioned, spontaneous, and sometimes naïve, as the posters themselves, confused and limited as the movement was. Like the movement, the poster of protest helped generate currents which flowed around, through and beyond the great single objective of getting US troops and the war machines out of Vietnam. It opposed not only the war in Vietnam but also the war at home which was unleashed against protesters in universities and city streets across the country. It condemned not only the killing in Asia, but also the hounding, beating, repression and occasional killing of activists at home – students, workers, organisers, women and ethnic minorities, especially blacks. And from the moment the war in Vietnam began to ebb (1972–3), the posters took up other major social issues, such as pollution, ecology, nuclear power and weaponry, feminism: 'a [semi] self-conscious entity lay dead, or rather, dispersed into a hundred Hydra-heads chewing separately at as many places in the fabric of American life'.[4]

The posters were distributed by political groups, at and for demonstrations, on campuses, and through small commercial 'counter-culture' or 'head' shops, many of them predicated as much upon drugs, rock and sensuality as upon the new political activism. Stylistically, the poster of protest drew on the San Francisco rock poster, drug-related, orientalising psychedelic art, and sensualising neo-Art Nouveau. Always eclectic, it drew on surrealism, expressionism and Picasso's *Guernica*.

The posters' audience overlapped with that of the hippie and love generation, which was largely white and middle-class. But it was not price which excluded the poorer and working classes from the poster phenomenon. A large beautifully coloured offset-lithographic poster could cost as little as $2. The less educated classes in the United States were not in the habit of buying contemporary posters; nor were (are) they very politically aware.

When the draft, which had always battened upon the poor, the unemployed and the under-educated, hit the college campuses, a very different segment of the population was galvanised into resistance. Repudiation of the Selective Service System ('Selective Slavery System', 'SS System') became the purpose of many posters. As the US flag and personal draft cards were physically and

ceremonially destroyed, the traditional 'patriotic' symbols were graphically desecrated or transvalued. The US flag was deftly transformed into the statistics of genocide, prison bars, exploding matchsticks, bandit masks, bombing-raids, the bleeding from napalm, and so on (**plate 10**). Not coincidentally, Old Glory had recently been aestheticised and politically anaesthetised by Pop artists, in the new vanguard art movement of the decade. Another large group of posters worked variations on the notorious Uncle Sam recruiter figure created by James Montgomery Flagg in 1917, in an attempt to exorcise that gargoyle which had stared down so balefully from the cathedrals of militarism (**plate 11**).

The media view of the war in Vietnam as a kind of cinematic or touristic spectacle, where mass death went under the euphemism 'body count', was parodied by posters which tried, as it were, to 'unsell' the war by turning around the language and symbols of Madison Avenue (**plate 12**). The poster of protest became at times an indictment of the corrupt values of US consumerism, 'the American way of life' which US foreign policy was designed to defend and disseminate. A telling juxtaposition, which the inventor of the political photo-collage, John Heartfield, would have admired, contrasts two worlds: the consumerist 'beauty' of the United States, and the suffering it cost the Third World – specifically, after the bombing of the dikes in Vietnam, which caused flooding and drowning (**plate 13**).

These are just a few of the posters denouncing the war and its machinery. Their means and purpose are obvious enough. But I should like to pass on here to a more problematical type of poster, characterised by the work of an outstanding commercial artist and illustrator, Tomi Ungerer. For me, his poster *EAT* (**plate 14**), executed in 1967, at the height of the war and the protest movement, epitomises the wit and graphic ingenuity of the poster of protest at its best, and at the same time exposes perfectly the true nature of US purposes in the war.

It is indeed a clever and striking image, simple but allusive. We see the Statue of Liberty thrust down the throat of the Vietnamese by an anonymous but all-powerful arm heavily lettered 'EAT'. This kind of commercial injunction, long known from the brasher popular restaurant in the United States, had recently been incorporated as one of those all-American verbal symbols of an aggressive all consuming and devouring society, by the latest vanguard art movement, Pop Art (**plate 15**). Ungerer manifests how liberty,

US-style, is imposed upon an unwilling and apparently helpless foreigner, in a nakedly aggressive act assuming the guise of philanthropy: the provision of food, the first necessity of life. To even the most politically naïve, Ungerer's image exposes the belligerent purpose behind the philanthropic façade; to the more politically aware it questions the fundamental claim of US foreign and economic policy anywhere in the globe: that US-style 'liberty' – that is, the so-called free enterprise system – can produce a better internal economy, better living-conditions, more for everyone to eat, in the Third World. But in fact US military and economic policy in the Third World has resulted not only in less political liberty for most peoples there, but also in less food, as Frances Moore Lappe has amply shown. US policy has actually increased the gap between rich and poor nations, and rich and poor within a given Third World nation; it has produced actual starvation, another way to die, together with bombs, napalm and death squads who gouge out eyes and cut off genitals.

The Statue of Liberty, with its pedestal inscription 'give me your poor, your huddled masses, yearning to breathe free', was erected in the nineteenth century as a symbol of the welcome given uniquely by the United States of America to starving and oppressed peoples of the world.[5] This claim, whatever validity it may have had in the nineteenth century, has become a mockery in the late twentieth century, and the statue, itself, whose centenary was recently the occasion of much patriotic hoopla, has become for cartoonists a symbol of oppression abroad and at home, as is demonstrated by other posters of the Vietnam period, and a recent *Los Angeles Times* cartoon which was also turned into a poster, directed against Reagan's reinstatement of draft registration (**plate 16**).

Another component here, the forcing of edibles or liquids down a victim's throat, has a long history in the cartoon as an emblem of punishment or oppression; we think of Goya's anti-clerical *capriccio Swallow it, Dog* or Doré's cartoon from the *History of Holy Russia* of the French soldier ramming the defeat of 1812 down the throat of Tsar Nicholas at the time of the Crimean War (1854). I do not enter into other implications of the word 'eat', especially the sexual ones.

My admiration for this poster remained unalloyed until I took it, as part of a version of the Posters of Protest exhibition, to Cuba in 1973. When I proposed to hang it in a gallery in Havana, a

Cuban artist who was escorting me around demurred and objected politely to it, alone among the posters I had brought. I looked at it, for the first time, from another perspective, and realised that it was not exactly favourable to the Vietnamese, whose expected victory over the United States the Cubans had already celebrated in a poster series of their own (see below, and **plate 27**). The Ungerer poster was nevertheless hung on that occasion, but I would not hang it today without some disclaimer. The scales fell from my eyes. But the poster has become for me a useful teaching-device to demonstrate the difference between the heart of the liberal (pity the poor liberal – he has a double cross to bear, as Dario Fo says), always ready for a hearty laugh, but also imbued with potential or unwitting racism, moved to opportunist condemnation of a war because it is unwinnable, and tending to bleed only when his own side – his own sons – begin to suffer too, between 'bleeding heart liberalism' and the principled anti-imperialist attitude which, less humorous no doubt, condemns a war because it is wrong and immoral in the first place, and applauds the capacity of its victims to transcend their suffering and resist the oppressor.

It seems that earlier I was able to see only the top part of the poster, the arm and the Statue of Liberty; the figure below, as Ungerer drew it, was for me, as for the majority of anti-war Americans, an abstraction. Now I see the historical reality of Vietnam more clearly: resistance, struggle, victory. In other words, I am now able to see the war as it was seen by artists from nations politically committed to an anti-imperialist stance, as the Cubans saw it, as the Vietnamese themselves saw it – in, for example, the Vietnamese cartoon (**plate 17**) which reverses the situation Ungerer depicts: it is now Uncle Sam who, trying to swallow Vietnam, finds that he has bitten off more than he can chew.

Ungerer's poster is, in a word, not only potentially insulting to the Vietnamese, but also historically inaccurate, for the Vietnamese forcefully rejected what Ungerer shows them passively accepting. It is true, however, that the fact of Vietnamese victory, not ratified until 1975, was much more apparent in 1973, at the time of the exhibition in Cuba, than in 1970, the year the first US protest exhibition was prepared; and, one should add in some exoneration of Ungerer, than in 1967, the year he executed the poster, when the outcome of the war appeared, from any American point of view, as truly in doubt.

Let us look more closely at the head of the Vietnamese in the

poster. In so far as it is rendered according to the slant-eyed, button-nosed, yellow-coloured, comically exaggerated caricatural stereotype of the Asian, one may also accuse Ungerer of racism. Against this charge, one would argue that Ungerer, given his habitual humorous style, had no other means at his disposal to identify a Vietnamese – that, in so far as the caricatural styles of the modern era are designed to denigrate, all parties in a degraded or ridiculous situation will be denigrated. Disputes between individual politicians and contending political parties are usually seen in this way; similarly, cartoons depicting oppressor and oppressed victimise both. Maybe there are two enemies, or two parties equally at fault, collaborating in contemptible behaviour. Much cartooning, I believe, rests upon a mistaken assumption that conflict results from a kind of complicity between enemies – a 'let's agree to quarrel' – so that the cartoonist can say, 'A plague on both your houses'.[6]

The United States is the aggressor in Vietnam, says Ungerer, and its victim is helpless, pathetic, and perhaps absurd. But the difference between pathos and absurdity suddenly becomes important here, and in part a knotty question of style. Pathos elicits compassion, the desire to defend; absurdity is a form of denigration, a means of exorcising a perceived evil, apotropaic.

The enemy we fear we first reduce to impotence: this is the rule of satire generally, particularly nationalist and racist satire. The tendency of liberal humour to want it both ways, to deplore oppression *and* denigrate the victim, becomes quite transparent in another Ungerer poster–cartoon with similar components to *EAT*. This poster (**plate 18**) is arguably even more insulting to the Vietnamese than it is critical of the United States. Under the banner 'KISS FOR PEACE' a US soldier brutally forces a Vietnamese to kiss the bared posterior of the Statue of Liberty, who has bent over and drawn back her starred-and-striped drapery for the purpose. The obscenity latent in the *EAT* poster is now overt; so is the insult to the Vietnamese. We, the audience, become voyeurs of an action the artist has staged both for our enjoyment and for our derision.

The liberal view, which is typically that of the ethnocentric white, can reveal its racism outright. Witty as the design of Ungerer's poster dealing with the relation of white power to black power (**plate 19**) is, in its use of the idea of playing-card reversibility, it equates the power exerted by two racial blocs which are obviously not in any conceivable sense equal, and thus cannot be said to

have an equal capacity to devour each other. The poster records a moment in history, in 1968, when the Vietnam War, then at its apogee, had stimulated blacks to make new, militant demands for equality and justice under the law, demands voiced by black leaders as diverse as Malcolm X and Martin Luther King, and by white leaders such as Robert Kennedy – the very people who were being gunned down by racist exponents of white power. Worse, Ungerer does not merely equate black and white power; as an indication that he considers black power to represent a greater threat to whites than white power to blacks, he tells us which way the poster is to be hung and read by placing his signature at the bottom, and thus black power on top. The poster embodies the liberal fear that black demands are threatening to an implicitly preferable *status quo*, which is of course dominated by whites, and which is geared to what the poster conceals or denies, the destruction or suppression of black demands for equality.

There are many ways to protest against an injustice. When the injustice looms immense and intractable, conventional humorous modes seem inadequate. While humour vents repressed feeling, it can also trivialise the problem which caused the feeling, and divert the anger in it. Sometimes this process is a psychological necessity, and therapeutic, preventing the anger from tearing one apart, imploding. But the Vietnam War, like the Holocaust under Hitler – and comparisons of US with Nazi leaders have been made (cf. **plate 20**, a poster which puts President Johnson and his henchmen in the dock at Nuremberg in 1945) – appears as one of the monstrous crimes of history, for which conventional modes of humour are inappropriate.

Another poster, again by Ungerer (**plate 21**), shows a US bomber pilot recording his kills on the nose-cone of his plane, a tradition among military aviators. The poster shows the kills as those of Vietnamese infants, to the slogan 'CHOICE NOT CHANCE' (borrowed from a family-planning association) is certainly witty in a macabre way – cruelly witty, one might say. But it is hardly adequate to the reality of children getting killed by indiscriminate saturation bombing from 20,000 feet, and by US ground troops at close range, in massacres of which that committed at My Lai in 1968 is only the most publicised. For the likes of My Lai, a simple, relatively untouched documentary photograph is surely the more appropriate, and effective, protest (**plate 22**). I doubt that the Ungerer poster was very effective, except with connoisseurs of graphic wit.

It is also doubtful that many people even saw it at the time, whereas the photograph of the My Lai massacre, taken by an official Army photographer, acquired instant notoriety when it was run across two pages of *Life* magazine in 1970, and surely did much to move mainstream opinion against the war. The makers of the poster merely added the text 'And Babies? And Babies', taken from the transcript of the trial of Lieutenant Calley, the officer charged in a court martial with the murder of 106 Vietnamese civilians. Found guilty, he was placed under house arrest for a few months, but never even went to jail. Instead, he pulled fat fees for lectures nationwide, and posed as some kind of pacifist, in front of an anti-war poster.

I do not wish to inculpate Ungerer personally: he represents, I insist, a typical gut moral feeling, which was not in itself dishonourable, was shared broadly by liberal critics of the war, and was couched in a remarkable degree of graphic wit. As a postscript, I may add that if I have come to terms, by dint of an analysis such as this, with Ungerer's work, I am still nonplussed as to what to think – or feel – about a My Lai poster (**plate 23**) which uses quasi-pornographic imagery to protest against a war often described as obscene.[7]

Among the posters which eschew comic effects, there was naturally a preponderance of photo-documentation and photo-collage; among the most compelling are those emphasising the Vietnamese as so much tortured human flesh. A number try to convey the special physical damage and anguish of high-technology warfare, especially that caused by that appalling substance napalm (**plate 24**), now being used in El Salvador in an 'improved' version called white phosphorus. Artists have often faced the challenge of representing the rending of bodies and nerves. Goya and Picasso had their solutions. A quasi-surrealist collage (**plate 25**) offers a shocking blend of anatomical engraving (the science of death?), a nude photo from a 'girlie' magazine (erotic pleasures) over a background photograph of a child's real napalmed flesh.

Such posters still portray the Vietnamese as victim. A new type of poster, which one may call the 'poster of liberation', is emerging now to protest against the US war in Central America. This sees those struggling against oppression and imperialism not as passive sufferers, but as heroes, beautiful people confident of victory. Such posters correspond to a (quantitatively speaking) minor trend, whose full significance is only just beginning to emerge, in anti-

Vietnam War graphics. They coincide emotionally with the way the Vietnamese saw themselves in their struggle (**plate 26**) and the vision of the Cuban artist who idealised the struggle in a landscape which seems to embody the promise of Ho Chi Minh to build a Vietnam 'ten times more beautiful' (**plate 27**).

The war in Central America has brought forth a new wave of posters, of a different kind. They lack the humour and certain kinds of sophistication (or slickness) that characterised the Vietnam-era poster. They do not, on the whole, emphasise the atrocities committed by the US-surrogate troops, well known as these are. The emphasis is rather on the positive side – the achievements of the revolution in Nicaragua, the hopes of the improvement of life in the liberated zones of El Salvador, the aid programmes directed from the United States to the peoples of these two countries (**plate 28**). These posters spring out of hope, rather than guilt.

NOTES

1. Cf. Noam Chomsky and Edward Herman, *The Washington Connection and Third World Fascism*, vol. 1 of *The Political Economy of Human Rights* (Boston, Mass.: South End Press, 1979) pt 5.
2. This figure, based on a careful count and collation of certain private and public collections, derives from Michael Rossmann's privately circulated *Bulletin of the AOUON* [All of Us or None] *Archive*. I acknowledge his sharing of his writings, thoughts, enthusiasm and concern.
3. Cf. David Kunzle, *Posters of Protest*, exhibition catalogue. This exists in two versions: large (University of California, Santa Barbara) and small (New School for Social Research, New York), both 1971. There were other, minor shows subsequently, and versions of the exhibition were mounted abroad: at the Institute of Contemporary Arts, London; in Bologna, Santiago de Chile, and Havana, Cuba; and at the University of León, Nicaragua.
4. Rossmann, *Bulletin of the AOUON Archive*.
5. Its role in cementing Franco-American trade and capitalism, while displaying outwardly American philanthropism, has been exposed by Al Boime in 'Liberty: Inside Story of a Hollow Symbol', *In These Times*, 11–24 June 1986.
6. A notable exception here would be Gerald Scarfe, internationally known for his 'vicious' and often highly grotesque cartoons. He was represented at the conference by drawings wholly sympathetic to the Vietnamese and Vietnam, which he personally visited. The point, of course, is that he did not see the Vietnamese as in any sense enemies –

or even as alien; and that he no longer functioned, at this point, as a caricaturist.

7. See Lionel Rubinoff's political treatise, *Pornography of Power* (1968).

8

Literary Sense-Making: American Vietnam Fiction

WALTER HÖLBLING

Since 1941 the United States has been more-or-less continuously involved in a series of military conflicts around the world. The resulting public awareness of war has contributed to the production of an ever-growing number of fictional accounts that deal with war or war-like situations. One of the assumptions of this essay is that stories of war display essential cultural concepts, expectations and self-images more prominently than other kinds of fiction, as the extreme situation of war provides occasions for scrutinising and putting into words the individual and collective values in whose name the state demands that its citizens risk their lives for the common good. Thus, novels of war can be considered as fictional models of a nation's (or people's) 'storifying of experience', as acts of literary sense-making (or questioning) in response to historical problems of national importance.[1] The literary conventions employed by these texts in their attempt to understand a specific historical situation reveal specific cultural idiosyncrasies in plot patterns, motifs, symbol systems, and so on. If they have sufficient explanatory power, these models of literary sense-making persist as persuasive conventions, even in the face of political and historical change.[2]

Michael Herr says in *Dispatches* that 'war stories, after all, are stories about people' – stories, that is, like other stories, but about people in an extreme situation that is still (thank God) considered the exception rather than the rule. In this exceptional situation of war the state demands that its citizens (usually the younger ones) risk their lives for the common good – something that goes beyond the usual requirements for proving yourself a valuable member of the community. Such situations are traditionally an occasion for questioning the validity of those individual and collective values and self-concepts in whose name one might die prematurely, and

123

the whole matter is complicated by the perceptions of the enemy, which ignorance makes all the more alien and terrifying.

The Vietnam conflict is exceptional in at least three respects: (1) no war since the Civil War caused such a rift in American public opinion and led to such a massive and heated public debate for and against; (2) it was the first war the United States conclusively lost; and (3) never before did Americans think they knew so much about their military opponents, only to discover that they knew very little. Even if Frances Fitzgerald's critical stance in *Fire in the Lake* does appear somewhat harsh at times, many of her comments are born out by the language, concepts and general attitudes evident in the majority of fictions about the war. Denise Levertov's poem 'What Were They Like?' succinctly catches the inadequacy of the rather vague ideas Americans held about the country in which – and supposedly for which – they were fighting.

The outcome of this conflict has had far-reaching effects on US domestic, foreign and military policy, and the nation's self-image still seems to be in the process of recomposing itself from a broad spectrum of critical as well as revisionist public opinions. Just remember the kaleidoscope of articles, commentaries and speeches in 1985, on the occasion of the tenth anniversary of the fall of Saigon. In short, the overall impact of the Vietnam conflict on the United States not only justifies but demands that students of American Studies familiarise themselves with the fictional models responding to this unique historical experience.

Ideological positions are obviously important in this kind of fiction, as there were two camps – and little in between – from the beginning. Though there is not much in the way of explicit ideological argument in most of the novels, with the notable exception of John Briley's *The Traitors* (1967), it certainly makes some difference whether you focus your analyses around novels in the vein of *The Green Berets* or of *Bamboo Bed* or of *Close Quarters* or of *The 13th Valley*. To put into perspective the achievements of American fiction on Vietnam, it is necessary to have some knowledge not only of the political and socio-cultural background but also – maybe even more so – of the literary conventions of American war fiction as they developed up to the Second World War. What Paul Fussell, in an essay on First World War British literature, called 'cultural paradigms',[3] determine the fictional design, as does the familiar habit of conceiving of a new war in terms of the previous one. In relation to Vietnam, Second World War models

soon turned out to be inadequate, though this did not prevent a sizable group of authors from using them. Even so-called experimental fictions such as *Catch-22* and *Slaughterhouse-Five* were not easily assimilable to the new experience, as is shown by the ambitious failure of Eastlake's *Bamboo Bed*. The peculiar combination of massive high-tech destruction and guerrilla warfare in an exotic environment, along with the one-year rotation system and the increasingly doubtful political and moral premises of the involvement, made general public consent, as in the Second World War, impossible.

Here, perhaps, is the place to digress a little from the immediate topic and to focus on some of the 'cultural paradigms' developed in earlier American war narratives – particularly as the specific conditions of Vietnam stimulated American authors to look to the past for adequate fictional models. They turned to central American myths and self-concepts, originally embodied in the religiously motivated Indian-war narratives of the seventeenth and eighteenth centuries, then secularised in the pioneer stories of Western fiction, and nowadays happily and profitably thriving in the comic-strip and formula-story section of popular literature.[4] To understand the appeal of such models we have to go back to the original narratives and the way they responded to the 'American experience'. In the words of Richard Slotkin, 'The Indian wars proved to be the most acceptable metaphor for the American experience. To all of the complexities of that experience, it offered simplicity of dramatic contrast and direct confrontation of opposites.'[5] Slotkin considers the Indian narratives 'the first coherent myth-literature developed in America for American audiences' and argues that in the hands of eloquent preachers such as Increase Mather it became 'a primary vehicle for the American Puritan's mythology'.[6] Of the several components of this myth, the most important from our point of view are the *sense of mission*, the *conviction of being engaged in a just war* in a *unique historical situation*, and *racial warfare*.

The early settlers' sense of mission made partners of Bible and sword, as is shown by the following passage from John Underhill's *Newes from America* (1638):

Many were burnt in the fort, both men, women, and children. Others forced out . . . which our soldiers received and entertained with the sword. Down fell men, women, and children. . . . Great and doleful was the bloudy sight to the view of young

soldiers that never had been in war, to see so many souls lie gasping on the ground, so thick, in some places, that you could hardly pass along. . . . Sometimes the Scripture declareth women and children must perish with their parents. Sometime the case alters; but we will not dispute it now. We had sufficient light from the word of God for our proceedings.[7]

By the end of the eighteenth century, the struggle for souls had largely given way to the struggle for soil in the name of democracy and civilisation. This 'errand into the wilderness' retained from the earlier struggle the elements of racial warfare and the sense of the unique historical occasion, soon to become known as 'manifest destiny'. Underpinned by the symbol system of 'cultivating the wilderness' or 'the progress of civilisation', it justified the use of collective violence, as well as heroic individual actions by outstanding figures such as Daniel Boone, Davy Crockett and Kit Carson, in the gradual destruction of the aboriginal culture.

It is interesting to note that, just as official US histories never refer to the 300 or so years of war with the Indians *as* war (unless other nations were involved), so the engagement in Vietnam remained to the end a 'conflict', as a state of war was never officially declared. One could thus state, somewhat facetiously, that the two longest military engagements in US history – the Indian wars and the war in Vietnam – were, until recently, never acknowledged as what they in fact were, and one might be tempted to take a rather critical view of the myth of the Pax Americana, rather as Edmund Wilson does in his book *Patriotic Gore* (1962). Recent American historical writings such as Russell Weigley's *The American Way of War* (1977) and David Kennedy's *Over Here* (1980), a study of the socio-cultural context of the First World War, present a more realistic appraisal of the American past.

The literary legacy of the First World War was rich and proved adaptable to the experience of the next generation of authors, who, sooner than expected after the 'war to end all wars', were having one of their own. As Malcolm Cowley remarks, somewhat tongue-in-cheek,

One might say that a great many novels of the Second World War are based on Dos Passos for structure, since they have collective heroes in the Dos Passos fashion, and since he invented a series of structural devices for dealing with such heroes in

unified works of fiction. At the same time, they are based on Scott Fitzgerald for mood, on Steinbeck for humor, and on Hemingway for action and dialogue.[8]

Given the broad national consensus, in the Second World War, that war against the Nazis and Fascists in Europe and the Japanese imperialists in the Pacific was justified on political and moral grounds, it must be considered a sign of the intellectual honesty of those concerned that the fiction about this war voiced any criticisms at all. The general climate of the Cold War years was not very conducive to critical voices or texts, yet authors such as Norman Mailer and J. H. Burns, and, in a different vein, Irwin Shaw, Stefan Heym, Alfred Hays and John Hersey, are among those who, while supporting the war goals, point out the potentially dangerous effects on the victors. Not unexpectedly, they remain – like their predecessors after the First World War – an influential minority. Most American novels about the Second World War are conventional war stories imbued with the myths summarised by Ward Just in his book *Military Men*:

> Since American wars are never undertaken for imperialist gain (myth one), American soldiers always fight in a virtuous cause (myth two) for a just and goalless peace (myth three). . . . American wars are always defensive wars, undertaken slowly and reluctantly, the country a righteous giant finally goaded beyond endurance by foreign adventurers.[9]

To conclude this brief synopsis of 'cultural paradigms' and literary conventions,[10] the dominant perceptions of war in fiction and Hollywood films in the years before and during the Vietnam involvement were those of these myths.

Apart from their use of traditional concepts and conventional narrative techniques, war stories of the kind just outlined also share two other premises. One is a basically unchallenged belief in the leading role of the United States in a teleologically progressive history of mankind; the other is what might be called a 'realist' position concerning the relation of literature to historical events – i.e. the assumption that historical events are 'objective', that their chronological sequence is meaningful in and of itself, and that the task of fiction in relation to historical events is the *post factum* revelation of this meaning by various traditional literary techniques.

Against this understanding of literature as a more or less well-wrought, ancillary explanation of offical historical events, a small but distinct group of writers see the task of fiction not as the representation of familiar facts but as the creation of (literary) answers in response to, not in imitation of, events of national historical importance. To some extent all these writers share the assumption that meaning is created not by the mere chronological sequence of events but by the way those events are 'spoken of' – i.e. the order and sense we give to them according to our (culturally diverse) modes of conceptualising and contextualising. Inevitably this means that the meta-fictional dimension tends to dominate these authors' texts, which make the reader aware of how fictional discourse constitutes itself.

Robin Moore's *The Green Berets* (1965) is typical of the conventional war story. Its animated cartoon heroes have the same basic characteristics as the heroes of James Jones's gritty combat novels and share James Bond's explosive professional self-sufficiency. A well-blended concoction of macho American stereotypes serves up patriotism, adventure, secret-mission suspense and heroic individualism, with more than enough brutalising rhetoric to drive home *how* tough and professional these guys really are who successfully complete one dangerous mission after another on the new frontiers of democracy. Moving expertly in the dangerous limbo on the outer edge of civilised society, these supermen embody the heroic frontier man, the 'good gunman' as state marshal, the stubborn 'good detective', and their ilk. They fight for law and order in spite of their corrupt or weak superiors and the bungling military bureaucracy; and, if they seem much like the enemy in their use of deceit and brutality, they are usually more efficient, and the end justifies the means. Yet they are basically good comrades, with a soft spot for gentle women and helpless children. Moore dutifully differentiates between 'good good guys' and 'bad good guys', whose names usually suggest non-WASP ethnic groups and their supposed characteristics: Korn and Schmelzer have German names and Nazi tendencies; Ossidian, with an American name, is cruel and sly; men with Mexican or Italian names are passionate and crafty.

The Green Berets' enemies are 'Communists (C), black hordes, monkeys', or the Vietnamese in general – 'gooks', 'dinks', female 'slanteyes': inferior, sub-human creatures who are conceded to have human qualities only when dying in 'brilliant white pools of

napalm'. Then 'human torches cry their last'. There is no doubt that they will share the fate of their literary predecessors, the devilish 'injuns'. Strangely enough, the danger never ceases, though scores of black-pyjama'd fanatics are blown to kingdom come on the Berets' perfectly executed missions.

By his use of symbol systems based on a trivialised version of historical racial warfare, Moore demonstrates his fundamental failure (or unwillingness) to understand the real issues of the Vietnam conflict and reduces the representatives of a foreign culture to abstract embodiments of evil, the exotic and the inferior. In consequence, the American heroes become equally abstract, stereotyped agents of the 'good cause'. The success of Moore's book, which by 1975 had sold 3.2 million copies and is still selling (a new edition was published by Ballantine in 1983), was reflected in a movie version starring John Wayne, and shows that its perception of the American involvement in Vietnam as another just mission in the fight for democracy and freedom was shared by a statistically significant number of Americans. The more recent success of *Rambo: First Blood II*, of which Moore's novel is in some ways a forerunner, is evidence that this viewpoint is still widely held.

In what may be considered an inner-American counterpoint to Moore's well-written vision of American success, Norman Mailer in *Why are we in Vietnam?* (1967) employs a stylised sixties hipster idiom that suggests an extreme situation of a different kind. In order to render the anonymous information overload of a repressive post-industrial society geared to maximum performance, Mailer chooses a kind of electronic-stream-of-consciousness technique for his fictional psychoanalysis of the collective American unconscious. His comprehensive understanding of war – he once called 'form in general' the 'record of war' – indicates that for him 'war' is the life principle, understood as the dialectic interaction of opposing forces manifest in individual struggles, in cosmic events, in politics, and even in the artist's struggle for adequate literary form. In his attempt to express the irrationalities he sees as underlying the American involvement in Vietnam, Mailer employs a highly idiosyncratic form of genital–scatological symbolism which brings together contemporary concepts from Reich, Marcuse, N. O. Brown and McLuhan. The result is a generously four-letter-worded discourse, delivered by a protean 'narrative voice', that explodes a fair number of traditional American myths and self-images. And,

while one may argue about the validity of some of Mailer's criticism, there is little doubt that his novel provides a fascinating, if not very optimistic, fictional analysis of the complex struggle of American youth for an identity of their own in a decade that deprived them of the values held by their parents.

The loss of values and traditional symbol systems for sense-making is a trademark of much Vietnam fiction. The same is true of a good deal of 'faction' based on the war, especially that written after its end, such as Michael Herr's *Dispatches*. Herr, sharing his readers knowledge of the outcome of the Vietnam conflict, sets out not to glorify but to understand and tell the truth, according to his personal experience. His book is quite a contrast to Moore's, and, even allowing for the rather different perspectives and attitudes of the authors, it is obvious that the war Herr writes about is not the same one as Moore had in mind. In addition, the two texts provide ample ground for comparison of fictional strategies. Moore's book follows the success-story formula: all missions are carefully planned and smoothly executed in a sort of ideal war. The linear narrative discourse suggests definite beginnings, goals and ends – 'Mission completed, Sir!' – and it does not matter that no end is in sight. With Herr, we get no supermen but brave and occasionally quietly heroic soldiers who try to survive in a war that does not make sense. Employing collage and montage techniques that do not belong to the standard repertoire of media correspondents (except the 'new journalists'), *Dispatches* shows the formidable difficulties involved in writing traditional 'stories' about this war which was, as one reviewer put it, 'all circumference, had no center, and was therefore difficult to filter through unified plot and point of view' (E. Pochloda, in *The Nation*, no. 25 (1978) p. 344). The ordered reality that Moore's discourse presupposes does not exist in Herr's Vietnam:

> The spokesmen spoke in words that had no currency left as words, sentences with no hope of meaning in the sane world, and if much of it was sharply queried by the press, all of it got quoted. The press got all the facts (more or less), it got too many of them. But it never found a way to report meaningfully about death, which of course is really what it was all about. The most repulsive, transparent gropes for sanctity in the midst of the killing received serious treatment in the papers and on the air. The jargon of progress got blown into our heads like bullets,

and by the time you waded through all the Washington stories and all the Saigon stories, all the Other War stories and the corruption stories and the stories about brisk new gains in ARVN effectiveness, the suffering was somehow unimpressive. And after enough years of that, so many that it seemed to have been going on forever, you got to a point where you could sit there in the evening and listen to the man say that American casualties for the week had reached a six-week low, only eighty G.I.s had died in combat, and you'd feel like you'd just gotten a bargain.[11]

The problems implied here – a certain numbing indifference, the inability to decide which story to believe and how to tell it, the fact that war has become a habit – show the combined effects of information overload, moral uncertainty, and lack of motivation and of definite strategic goals. All of this leads to an entropy of meaning not unlike that exhibited in the works of contemporary fiction writers such as Pynchon, Barth, Barthelme and Vonnegut. The borderline between 'story' and 'history' blurs in direct relation to the extent to which official interpretations of reality and individual experience are moving apart, and the individual can no longer use common cultural symbol systems to explain events to himself and others.[12]

After Herr's excellent, if puzzled and puzzling, 'factual' account, let us turn to the novel which I think provides the most powerful literary expression so far of the specific characteristics of the US experience in Vietnam: Tim O'Brien's *Going after Cacciato*.[13] Its sensitive narrator–protagonist, Paul Berlin, is dropped into a world he thinks he knows from various secondary sources: his father's tales of the Second World War, movies and television series (*Iwo Jima*, *Hogan's Heroes*, *M*A*S*H*), daily media coverage, and supposedly true-to-life simulatory training in boot camp. His attempts to understand the reality of Vietnam by applying the rules of this media-created 'reality' fail abysmally and lead him to a terrifying awareness of his fundamental ignorance. A fellow soldier's 'death of fright' which Paul witnesses on his first patrol becomes, for him, the 'ultimate war story'. Like the key motifs in earlier war novels – Dresden in *Slaughterhouse-Five*, Snowden's death in *Catch-22*, Hennessy's death at the beginning of *The Naked and the Dead*, or the retreat from Caporetto in *A Farewell to Arms* – this experience makes the protagonist shockingly aware of his own precarious situation.

The figure of the sensitive and critical intellectual has been with American war fiction ever since Andrews in the Dos Passos novel *Three Soldiers*, but O'Brien introduces a number of new elements. In order to involve the reader in his protagonist's attempts at sense-making, i.e. his 'storifying of experience', he uses two clearly distinguishable modes of literary discourse. One renders Berlin's *memories* of the past events ('what happened'), the other his *imaginative* pursuit of Cacciato across Eurasia to Paris ('what might have happened'). The two levels interact and interfere with each other: while imaginatively leaving the dangerous world of war in his pseudo-legitimate pursuit of the deserter Cacciato, Berlin (mostly involuntarily) remembers – and finally comes to terms with – the horrors of war in an alien environment. O'Brien's innovation here lies in the way he uses his sophisticated 'dialog of discourses' to juxtapose the 'factual' and the 'fictional' modes of literary sense-making.[14] The discourse of Berlin's memory recalls the phenomenological style of the Hemmingway tradition and consciously places itself in the context of previous war fictions. Let me give an example of what I mean by this.

In one passage Paul remembers a firebreak during a patrol in hilly terrain that has been devastated by aerial bombardment – the caustic Doc Peret christens it the 'World's Greatest Lake Country'. Cacciato, the prototypical young innocent–ignorant American soldier, casts an improvised fishing-line into one of the bomb-craters filled with rainwater:

> He tied a paperclip to a length of string, baited it up with bits of ham, then attached a bobber fashioned out of an empty aerosol can labeled *Secret*. Cacciato moved down to the lip of the crater. He paused as if searching for proper waters, then flipped out the line. The bobber made a splashing sound.[15]

The obvious allusion here is to Hemingway's famous short story 'Big Two-Hearted River', where Nick Adams, back from the war, attempts to regain his bearings in the world by the familiar ritual of trout fishing. Also evident are the contrasts in style and semantic differences between Cacciato's acts and Nick's preparations for trout fishing.

For both, the ritual of fishing is meant to reconstitute their sense of personal identity, yet its respective forms and directions take quite different turns. Hemingway's Nick, symbolically placed with

the burned land around Seyney behind him and the swamp before him, is able to determine his position in the world – the river and the camp-site – by doing the right things, or rather by 'doing things right', and thus establishes a working relationship with his natural environment. Compared to this, the very material Cacciato uses for fishing – some string, a paperclip, a piece of canned ham, an empty aerosol can – signifies more than just a low grotesque version of Yankee ingenuity. In the world of the seventeen-year-old Cacciato, no piece of untouched nature is left between the burned land and the swamp; both have been fused in the lifeless wasteland of the 'World's Greatest Lake Country'. Interaction with such an environment to constitute one's identity must take a different form from Nick's parallel attempt; Cacciato's fishing becomes an ambiguous symbolic gesture. On the one hand an act of individual self-assertion, this clinging to a familiar ritual is on the other an expression of boyish helplessness and withdrawal into oneself. The situational inadequacy of the youth's behaviour makes it a striking image of his despair.

Opposed, and sometimes complementary, to the disturbing memories of despair and death, Paul Berlin's imaginative discourse creates an alternative reality on the occasion of a night watch. Berlin makes it clear that his imaginings are more than mere escapist daydreaming or pretending:

> Not a dream, but an idea. An idea to develop, to tinker with and build and sustain, to draw out as an artist draws out his visions. . . . It was a working out of the possibilities. It wasn't dreaming and it wasn't pretending. . . . It was a way of asking questions.[16]

While Berlin's memories contain all the horrors of war, his imaginings are full of the popular myths and stereotypes a twenty-year-old may come up with in his attempts to build 'a smooth arc from war to peace'. We see the 'story within stories' unfold before us, flounder along and, finally, shatter on the senselessness of war. With a sharp eye for the incongruences between popular myths and historical realities, O'Brien inverts the motif of the American Westward movement. 'Going West' does not lead Cacciato and his pursuers to untouched new continents but to Paris: the city where American independence was officially ratified in 1783; the city that served as the symbol of European culture in the First World War

and was celebrated by Americans in the Second; but in 1968 the city where negotiations for peace in Vietnam were bogged down around the notorious oval conference table. Paris as the literal 'vanishing point' of Cacciato's and Paul Berlin's imaginative journey – 'Imagination, like reality, has its limits' – is a sign that the American Westward movement has come full circle, and a reminder of the ironical fact that the United States, itself a former colony, took over from France as the colonising power in Indo China. At the end of the novel, Cacciato, the enigmatic symbol of innocence and ignorance, is missing in action. Thus O'Brien, while leaving open the possibility that Cacciato may still be alive, makes it clear that in relation to the American involvement in Vietnam traditional concepts of the 'just war', the 'unique historical mission' and the 'crusade for democracy' have lost their power of providing explanatory symbol systems. Now they are stories, overtaken by historical realities. Paul Berlin, while still unable to make sense of the war, has finally taken a significant step toward self-definition: his imaginative questioning of the realities of war has yielded no easy solutions, but a heightened awareness that helps him distinguish clearly between what happened and what might have happened. By such means O'Brien's novel manages to interrelate, as far as it is possible, main elements of the two major modes of writing about war, the 'factual' and the 'imaginative', that have been employed by American authors since the Second World War.

This is not achieved in John Del Vecchio's *The 13th Valley* (1982). Here is an example of the attempt to write a 'naturalist epic' about Vietnam, in the tradition of Dos Passos, Irwin Shaw, Mailer's *The Naked and the Dead* and James Jones's *The Thin Red Line*. The novel's merits are obvious, but even more so its final failure to grasp the special quality of the American experience in Vietnam. Intentionally or not, Del Vecchio uses two levels of discourse that are hermetically sealed off against each other. One is that of the traditional story of a patrol in enemy country, with all its ups and downs, details of army life, equipment, weapons and so on, and a (somewhat melodramatic) finale in which most of the main characters and half the company die heroically in fulfilment of their duty; of the major figures, only the Ishmael-like Chellini survives to tell the tale. None of the usual problems that Americans were facing in Vietnam exists on this level of the novel: US soldiers fight North Vietnamese regulars in an otherwise uninhabited mountain valley, so it's

soldiers against soldiers in a campaign that might have taken place in the Second World War or perhaps Korea.

All the real problems of Vietnam are mentioned in the second level of discourse – that of meditation and discussion, camp-fire talks and so forth. Here we learn about social, cultural, ethical, political and military problems – racial antagonism, anti-war protest, personal problems, and the like; but all this leaves the level of action curiously unaffected. In keeping these two discourses apart, Del Vecchio employs a kind of narrative immunisation strategy which allows him to avoid tackling the real issues of the American experience in Vietnam without leaving them out of the picture altogether.

In a way, this seems to exemplify a major trend in the United States ever since the Vietnam veterans, enraged by the national public welcome given to the returning Iranian hostages in 1980, came out of the closet. To me there are signs of an easy kind of revisionism which (not altogether unintentionally, I assume) links two completely different things. What I mean is that there is a tendency, in rehabilitating the Vietnam veterans, to present the war itself in a more positive light. Just to make my point clear: I am definitely *for* the long-overdue rehabilitation of the veterans, but would argue that they are being exploited and abused all over again if this is used to justify an unjustifiable war. (*Rambo: First Blood II* is a typical product of this trend.[17]) It seems that the painful truth that more than 50,000 young Americans died in a war which still defies explanation by standard American self-concepts is not easily acknowledged. There is a great temptation to confuse means and ends, and to sanction the Vietnam War by doing justice to those who had to fight it.

Let me conclude by summing up what I consider to be the main characteristics of the 'well-made novels' and more critical and questioning works on war in American fiction since the beginning of the US involvement in Vietnam. The Vietnam experience has not only influenced writings on that war, but has also, I believe, been highly significant for perceptive American writers (such as Heller, Vonnegut and Pynchon) dealing with the Second World War in novels published while the Vietnam War was in progress.

The mainstream consists of works written in the traditional mimetic modes, based on the assumption that war, as a specific historical event, takes its place in a (usually vaguely implied) teleological process of history, and that the task of fiction is to tell

'what it was really like' with the help of traditional literary techniques. Seen in this perspective, war is an exceptional historical situation interrupting an otherwise more or less civilised evolutionary progress toward a higher state of civilisation; indeed, it is explained by the need to defend this peaceful development against dangerous disturbances. In the novels that take this point of view we usually receive information about the characters' civilian lives before (and sometimes after) the war, follow them through basic training and into combat, learn about their problems and thoughts – all of this in the context of a linearly progressive narrative that feeds the reader's desire for mimetic illusion with (seemingly) realistic details of places, dates, the military hierarchy, technological equipment, battlefields, and so forth. It all adds up to the idea that the war – like the world as a whole – is explainable; actions and events follow the familiar pattern of cause and effect, and, if anything goes wrong, we know why. The fictional world is basically that of the nineteenth-century realist novel, where events proceed in linear sequence, if sometimes parallel in time, and are presented by means of a corresponding plot structure. We either follow the protagonists chronologically through the war years (James Webb, *Fields of Fire*) or, again chronologically, follow them through a specific campaign or mission (Josiah Bunting, *The Lionheads*; John Briley, *The Traitors*; Del Vecchio, *The 13th Valley*), which has a definite beginning and end corresponding to the sequence of events in time and space. Whether or not the novel is critical of the army or war goals is irrelevant to this dimension of the text, but it is manifest in the use the novel makes of patriotic imagery, characterisation, ideological rhetoric and (happy) endings.

The sense of an ending in war – and of closure in the narrative – implies that at least those who survive return to business as usual; it also suggests that the world of war is categorically different from the world of peace. Other rules of conduct apply, and one has to adjust, even if it may be difficult. A fair number of novels add distinctly Freudian overtones to the world of war, describing it as a space where men temporarily change (back) into fighting animals, rely on their instincts, and live out their aggressions and drives in words and in actions. The higher purpose of their relapse into a culturally anachronistic state is, of course, to ensure the continuing existence of that advanced cultural state from which they have temporarily descended. War is a regrettable yet necessary means of ensuring the progress of humankind. It is this basically optimistic

understanding of war as a concrete historical event limited in time and space and sanctioned by transcending goals that makes its horror, its irrationalities and the suffering it causes acceptable to the reader.

Unlike the mainstream novels, the innovative texts use war as a complex metaphor for our contemporary industrialised information society, in which traditional distinctions between 'peace' and 'war' are rapidly losing their validity. What were formerly thought of as acts of 'war-like' behaviour now appear to be variants of basic problem-solving strategies on a scale that ranges from individual verbal aggression to the collective use of violence organised and sanctioned by the state. As R. E. Canjar puts it in a recent article,

> War in short, is neither an emotional, moral, or political aberra-
> tion; it is the socialized production of violence and its monopoly
> use by the state. . . . Both corporate social life and corporate
> social death are materially produced by social means. It is for
> this reason that such phenomena as the military–industrial
> complex occur. It has less to do with conspiracies than
> it is a routine outcome of a production process in which the
> means, methods, labor, technology and organizations simul-
> taneously serve, and often fail to distinguish between, the
> production of life and the production of death.[18]

War in this sense is no longer a limited historical event but threatens to become a way of life; accordingly, in the more innovative war novels (and in related works such as Pynchon's *Gravity's Rainbow*), war is global and ever-present. Peace exists only temporarily in the shape of ideal spaces contrasting with the fictional world of war – Alaska, Sweden, Tralfamadore, Paris – and inevitably turns out to be but a projection of the narrator/protagonist's wishful thinking. The absence of peaceful spaces (and times) corresponds to the absence of a teleological concept of history in which war can be given a place and meaning, and within which the individual can understand himself and his actions as contributing to a collective goal definable in terms of commonly accepted symbol systems.

Such prerequisites for joint action are no longer functional in these texts. Meaning, if it exists at all, is constituted only in a highly individualised, sometimes hermetically solipsist, 'totality of

vision',[19] on both the textual and the meta-textual level. The advanced deconstruction of collectively or even intersubjectively valid codes produces a multitude of equally valid, idiosyncratic symbol systems and discourses. They resemble the pluralist structures in complex (post-)industrial societies, where a heightened sense of individuality corresponds to a reciprocal loss of collective agreement upon common goals. One result is a kaleidoscopic supply of information that leaves the individual with practically infinite options for sense-making or, viewed differently, with an entropy of meaning. The innovative authors translate this insight into the structure and discourse of their novels and point to the roots of violent aggression in our everyday patterns of communication and socialisation. The reader, involved in the texts by force of their continuous deferral of definite meaning, comes to realise that language is indeed, as John Hawkes once put it, 'the most powerful kind of actuality'.[20] On a more radical level, whatever kind of reality these texts present, the simple truth is impressed upon the reader that the very concept of 'reality' only exists because there is a perceiving and reflecting human consciousness. The literary discourse on war, creating fictional models of speechless confrontation, powerfully reminds us of the primal necessity to interact by signs rather than by wordless acts of destruction: far from being the 'motor of history', war threatens the very foundations of meaningful communication.

NOTES

1. The concept of the novel as a fictional 'answer' to central issues in contemporary society is inspired by N. Luhmann, *Soziologische Aufklärung: Aufsätze zur Theorie sozialer Systeme* (Cologne, 1970) esp. pp. 113–36. Cf. also W. Iser, *Der implizite Leser* (Munich: Fink, 1977), and R. Warning, *Rezeptions ästhetik* (Munich: Fink, 1975), for applications of Luhmann's theory of social systems to literary criticism.
2. P. Beidler, *American Literature and the Experience of Vietnam* (Athens, Ga: University of Georgia Press, 1982), considers 'literary sense-making' one of the central concerns in American fiction about Vietnam.
3. Fussell defines 'cultural paradigms' as 'systems of convention and expectation that largely determine which objective phenomena become part of the individual's experience – what people "make of things", how they fit their experience into the conceptual frames their culture has taught them to consider suitable for making sense of the world' –

P. Fussell, 'Der Einfluss kultureller Paradigmen auf die literarische Wiedergabe traumatischer Erfahrung', in K. Vondung (ed.), *Kriegserlebnis: der Erste Weltkrieg in der literarischen Gestaltung und symbolischen Deutung der Nationen* (Göttingen: Vandenhoek and Ruprecht, 1980) pp. 175–87. (Quotation from p. 175f., my translation.)

4. See J. Cawelti, *The Six-Gun Mystique* (Bowling Green, Ohio: Bowling Green State University, Popular Press, 1975).
5. R. Slotkin, *Regeneration through Violence: The Mythology of the American Frontier, 1600–1830* (Middletown, Conn.: Wesleyan University Press, 1973) p. 68.
6. Ibid., pp. 95 and 101.
7. Quoted ibid., p. 71.
8. M. Cowley, *The Literary Situation* (New York: Vintage Books, 1958) p. 41.
9. W. Just, *Military Men* (New York: Alfred A. Knopf, 1970) p. 7.
10. For a detailed account of the development of dominant American models in war fiction see W. Hölbling, *Fiktionen vom Krieg im neueren amerikanischen Roman* (Tübingen: Narr, 1987) esp. pp. 25–80.
11. M. Herr, *Dispatches* (New York: Avon Books, 1978) p. 229.
12. Cf. J. Peper, 'Postmodernismus: Unitary Sensibility', *Amerikastudien/American Studies*, 22, no. 1 (1977) 65–89, for a stringent analysis of this and related phenomena in contemporary fiction in the context of cultural theory; see also W. Hölbling, 'Out of Time and History: Loose Ends of the Mimetic Tradition in the Recent American Novel', *Indian Journal of American Studies* (forthcoming).
13. Tim O'Brien, *Going after Cacciato*, paperback edn (New York: Dell, 1980).
14. M. W. Raymond, 'Imagined Responses to Vietnam: Tim O'Brien's *Going after Cacciato*', *Critique*, 24, no. 2 (Winter 1983) 97–104, fails to account for the perspective provided by Paul Berlin's central narrative consciousness and treats the three levels of the narrative as separate narratives, without regard for their inter-referentiality. T. C. Herzog, '*Going after Cacciato*: The Soldier–Author–Character Seeking Control', *Critique*, 24, no. 2 (Winter 1983) 88–96, puts his focus very perceptively but sees the three levels merely chronologically as past, present, and future.
15. O'Brien, *Going after Cacciato*, p. 283.
16. Ibid., pp. 43–6.
17. The most recent American movie about Vietnam, *Platoon*, provides a much-needed counterpoint to *Rambo: First Blood II*; so far the most balanced of commercial movie releases on this topic, it seems to indicate that the American Vietnam trauma may begin to receive a different treatment from that of 'regeneration through (cinematic) violence'.
18. R. E. Canjar, 'The Modern Way of War, Society, and Peace', *American Quarterly*, 36, no. 3 (1984) 435, 437.
19. J. Enck, 'John Hawkes: An Interview' (dated 20 Mar 1964), in L. S. Dembo and Cyrena N. Pondrom (eds), *The Contemporary Writer:*

Interview with Sixteen Novelists and Poets (Madison: University of Wisconsin Press, 1972) p. 11.
20. Ibid., p. 16.

9

'After our War': John Balaban's Poetic Images of Vietnam

JEFFREY WALSH

Reading William Ehrhart's excellent 1985 anthology of Vietnam War poetry, *Carrying the Darkness: American Indo-China – the Poetry of the Vietnam War*, one is struck by an overall similarity of theme and style.[1] Poem after poem embodies common attitudes, shared cultural perspectives and what seems to be an identical use of language. The dominant viewpoint naturally enough is that of the soldier whose poems recall the time he spent in occupied Vietnam. A whole plethora of poems reiterate the traditional litanies of warfare: the rites of passage from callow recruit through combat and back to an uncaring United States. The war is portrayed as a terrible ordeal, a version of hell. Clearly many fine poems are included in Ehrhart's anthology, by such poets as Ehrhart himself, Walter McDonald, Gerald McCarthy, Basil T. Paquet and Jan Barry; their work exhibits great variety and difference, of course, and there is no monolithic 'school' of Vietnam War poetry.

Ehrhart's well-chosen selection of poems is likely to invite comparisons with poems written by American combatant poets of earlier wars, with Alan Seeger and Joyce Kilmer in the First World War, or Randall Jarrell, Richard Wilbur and Richard Eberhart during the Second. Although some of the themes are similar to those of earlier American war poets, such as Louis Simpson or Karl Shapiro, there are some striking differences, too. Perhaps the most profound difference in the poems about Vietnam is a deeply ideological one. Earlier poets claimed a moral underpinning and legitimation for their involvement in battle: Alan Seeger and Joyce Kilmer drew upon the tropes of American crusaders, defending Western culture; in the Second World War the fight against Nazism supplied a justification for death and wounding. In Randall Jarrell's famous poem 'A Camp in the Prussian Forest', for example, the GI is presented as the healing agent, cleansing the Nazi death

141

camp. It seems that earlier American war poets had a series of reference points: they encountered no identity crisis in portraying the occupying GI as a valued ally and liberator; they clearly believed they were fighting on the side that was morally right.

Without wishing to overdramatise the difference, it does seem clear that American poets who were combatants in Vietnam suffered an ethical disorientation related to the ideological confusion over the rights and wrongs of fighting the war. There is an absence of historical affirmation in the poems anthologised in *Carrying the Darkness*; poets do not seem to be able to make morally significant statements since they lack a sense of what may be called historical relativism, a positive means of comparing the history of Indo-China with their own national history.

Because most poems written about Vietnam lack this more objective historical sweep, the comparative faculty, the poets tend to rely upon a kind of committed experiential poetics which does not seem commensurate to the task of representing either the physical actualities of the conflict or the underlying moral and political values at issue. Such a limitation, it should be said, is not confined to poetry: in only a few works, such as Frances Fitzgerald's *Fire in the Lake* or the writings of John Pilger or the photographs of Philip Jones Griffith, are the historical realities of Vietnam adequately represented. There are no easy ways of explaining why the poetry of Vietnam veterans usually seems unable to confront the war's complexities; the reason for such limitations is probably obscurely related to the chasm of consciousness between occupying American soldier and Vietnamese citizen or soldier: history, culture, language, ideology stand between American poets and the Vietnamese 'other'.

In poetic terms this culture gap is exemplified in poem after poem either by the absence of Vietnamese, or by their depiction solely as passive victims, or by the poet's acknowledgement of incomprehension, as expressed succinctly in William Ehrhart's poem 'Guerrilla War':

> It's practically impossible
> to tell civilians
> from the Vietcong.
>
> Nobody wears uniforms

> They all talk
> the same language[2]

A more conceptual insight into this poetic problem is highlighted in Jan Barry's 'In the Footsteps of Genghis Khan' when he refers to his fellow Americans as invaders 'unencumbered by history'.[3]

Because the poet is unable to make sense of the 'otherness' of Vietnamese culture, such historical concerns are frequently missing from the poems in *Carrying the Darkness*. Vietnamese are usually present as passive victims, as napalmed girls or strafed farmers. The dominant poetic discourse expresses itself differently. Many poems, such as Robert Dana's 'At the Vietnam War Memorial, Washington, D.C.', are elegies for American dead; others, such as William Ehrhart's 'To Those Who Have Gone Home Tired', protest against the war in rhetorical anger; there are visionary poems such as Bruce Weigl's 'Monkey'. Perhaps the two most common genres, though, are poems which capitalise upon the argot and esoteric jargon of soldiers and those which reconstruct the conditions of battle. Two of the most celebrated Vietnam War poets, Michael Casey[4] and D. C. Berry, draw upon slang usage, typographical tricks, linguistic repositioning to replay the war's specific nature. Their poems, powerful as they sometimes are, often give the impression of being marred by gimmickry – the hip discourse and recondite utterance growing ultimately to be tiresome.

The primary way that poets treated the Vietnam conflict is through straightforwardly experiential poetry. Here the reader feels on familiar ground; the poem acts as a window on experience, reminding us somewhat of realist fiction. Authenticity is the motor here; the poem retraces the mystery of combat, faithfully re-creating it for the reader, whose position is constructed as that of an observer. Walter McDonald's impressive 'War Games' is a powerful example of such a sensibility: this poem dramatises the agony of being mortared and draws upon the conventional metaphor of combat as a game of chance.

> We never knew the color of scrip
> we lost, nor caring
> what was at stake in night games,
> not daring to think.
>
> When the all-clear siren wailed

we lifted our winnings from dust
and left through the reeking tunnel
into moonlight naked as day.[5]

Such lines have a clear familiar ring to them, and perhaps
communicate some faintly stifled heroic overtones. It is likely,
though, that the reader of Ehrhart's anthology will be ultimately
dissatisfied with this genre of poems and feel that they do not fully
enough treat the wider implications of the Vietnam War.

The contention of this essay is that the larger human meaning
of the American war in Vietnam, and later, Cambodia demands
for its poetic representation a sense of history and an awareness
of Vietnamese culture. Such a reflective intelligence and vision of
historical change and continuity, I believe, is found in the work of
at least one poet whose poetry is included in *Carrying the Darkness*,
John Balaban. By offering a close textual reading of Balaban's
poems I hope to demonstrate this more inclusive historical under-
standing at work.

John Balaban's Vietnam poems are built patiently brick by brick
upon close observation and demonstrate the poet's instinct for
witnessing the casual and the normal. 'The Guard at the Binh
Thuy Bridge' illustrates his ground tone by focusing on an
unspectacular moment of mundane inconsequence.[6] A soldier on
sentry duty rehearses firing his carbine, pretends to take aim at a
junk on which a woman passes by moistening her face in the
water. Nothing gory or particularly remarkable takes place and yet
the reader who is positioned as watcher responds actively to the
poem's key images, the nonchalant woman 'staring at lapping
water' and the river's lazy continuing motion – 'Idly the thick Rach
Binh Thuy slides by'. As always in Balaban's Vietnam poems, the
Asian river symbolises calm, continuity and the flow of unhurried
energy. Its rhythms are represented as the peaceful sign of life and
generation, its idle and healing motion indifferent to the conditions
of warfare.

The impressive 'Along the Mekong' similarly images the river
as organising life principle.[7] The narrator, Balaban himself, draws
upon his 'scientific turn of mind' to speculate upon the particular
effects of defoliants and chemicals. Reading an issue of *New Yorker*
he links the fate of the 'hare-lipped, tusk-toothed kids' he escorted
to surgery in Saigon with that of his own wife's pregnancy: 'what
dioxin, picloram, arsenic have knitted in my cells, in my wife

now carrying our first child'. The objective cast of the analysis here strengthens the poem's air of factual veracity. The war is encapsulated as an ecological disaster: drinking water is polluted, the food chain poisoned, the Vietnamese river contaminated by American science.

In the second section, 'River Market', observation is transcended by reflexivity. In a passage recalling the magnificent fish-market scene in Hemingway's *Across the River and into the Trees* the cluttered heaps of fish, fruit, vegetables, candles and so on borrow an allegorical significance beyond their naturalistic context. The narrator self-consciously alludes to the mode of poetic representation, arguing that the poet is not merely a reporter but an agent whose metaphors allow sophisticated connections to be made:

> Why, a reporter, or a cook, could write this poem
> if he had learned dictation. But what if I said,
> simply suggested, that all this blood fleck,
> muscle rot, earth root and earth leaf, scraps
> of glittery scales, fine white grains, fast talk,
> gut grime, crab claws, bright light, sweetest smells
> – Said: a human self; a mirror help up before.

This is an effective commentary on the production of meaning and subtly extends the biological–scientific locutions of the poem's opening.

Historical inclusiveness, an equal sympathy for American and Vietnamese alike, distinguishes Balaban's work. His poems are also characterised by a feeling for Vietnamese culture and custom and are thus not marred by an ethnocentric narrowness of perspective: he has no burden of personal guilt to escape, for example, and this openness permits a freedom of viewpoint and subject matter. Such a constructive and positive awareness is found in the compassionate opening of 'Mau Than', which is sub-titled 'A poem at Tet for To Lai Chanh'. The poem's speaker, Balaban himself, muses upon the old year's passing:

> Friend, the Old Man that was last year
> has had his teeth kicked in; in tears
> he spat back blood and bone, and died.[8]

The addressee of 'Mau Than' is a Vietnamese friend whose life has

been irrevocably ruined and whose plans to bring his bride from Saigon will never materialise. Subtly the human devastation is suggested through images of stone and dryness: To Lai Chanh's garden is stony, dry, unplanted, and the ever-present junks unload only rock.

The tone of emotional outrage in section two of 'Mau Than' is reinforced by the restrained and plangent voice. A series of staccato statements baldly emphasise the horrors:

> A year it was of barbarities
> each heaped on the other like stones
> on a man stoned to death.
> One counts the ear's on the GI's belt.
> Market meats come wrapped in wrappers
> displaying Viet Cong disemboweled.

The power of 'Mau Than', which is the finest poem written about the Vietnam War, derives from a tension between stark images of war and counter-metaphors of beauty and harmony. The terrible unanswered question of section two which resignedly asks how Americans, including officers, could take photographs of a girl 'whose/vagina was gouged out by mortar fragments' is superimposed on a civilisation and a landscape of unsurpassable loveliness. Section three articulates ruminatively this holistic potential; an organic scene of a man and wife fishing in a 'feathery drizzle' is a countervailing one to war. This process of unremarkable peasant labour is framed by a context of natural phenomena:

> Here at evening one might be as quiet
> as the rain blowing faintly off
> the eaves of a rice boat sliding home.

In Balaban's poems the war is never allowed to have the last word. One recalls Thomas Hardy's 'In Time of "The Breaking of Nations"', where a young man and woman, in similar manner, are envisioned as survivors. In Balaban's poem, as in Hardy's, the enduring value of the ordinary is affirmed as the true centre force of history.

It is a qualified optimism, of course, and in 'Opening Le Ba Khon's Dictionary' the ritualistic and the aesthetic are shown to be illusory and deceptive. Neither Andrew Marvell's fine literary

image of the human soul as 'clear Fountain of Eternal Day' nor
the hallowed dictionary of Le Ba Khon, neither the customary
reassurance of the Saigon zoo nor the Marvell-like moon 'caught
in willows by the pond', prevents the obscenities of warfare:

> At night police tortured men in the bear pits,
> one night a man held out the bag of his own guts,
> which streamed and weighed in his open hands,
> and offered them to a bear[9]

In this poem the civilities of the library remain divorced from the
barbaric act and art appears irrelevant since it cannot arrest the
current of inhumanity.

While most poetry written of the Vietnam War deploys what
may be called an American experiential axis, Balaban's poetry
conversely is predicated on a Vietnamese register and structure of
feeling. The resonances of many of his poems, and here perhaps
he recalls one of his famous predecessors, the Ezra Pound of
Cathay, depend upon an oriental utterance and image pattern.
Although on occasions this can yield to the seductions of 'Chino-
iserie' and may prettify oriental culture as in 'For Miss Tin at Hue',
it frequently contributes to the pleasure of reading the poet's work.
The opening lines of 'The Dragonfish' exemplify this celebration
of 'the other', a way of life almost at the opposite end of the
spectrum to that of contemporary American culture:

> Brown men shock the brown pools with nets.
> Fishing for mudfish, carp and ca loc,
> they step and stalk the banks; hurl;
> stand, then squat heronlike in the
> shadow-stretching, red evening dusk.[10]

Fishing is again celebrated as an activity highly resistant to aerial
warfare: the jet planes in the poem's text are marginalised,
interruptions of a momentary kind in a world of delta paddies,
tombs, ancestors, ghosts, pond fishing, ducks and 'blue morning-
glory'. The fishermen blend into their environment inoculated by
the timeless processes of their history against these new aerial
invaders. An old cur settled on the steps of a tomb signifies the
continuance of Vietnamese civilisation:

> In sheeting rain, a wet dog grins
> from a worn tomb's washing steps.
> The dog snuffles a hen's feather.
> It crackles old bones.

Poems such as 'The Dragonfish' symbolise the twin impulses of recovery and permanence.

There are basically two strands in John Balaban's portrayal of the Vietnam conflict: in this essay we have so far discussed the first of these preoccupations, the formal evocation and appreciation of Vietnamese institutions and lifestyles; it remains to consider the poet's other major concern, the impact of the war upon the United States, its legacies and influences both spiritually and culturally. A powerful short poem, 'Graveyard at Bald Eagle Ridge', prefigures Balaban's after-images of the Vietnam War. It expresses profound understanding of the suffering of Americans for their dead by foregrounding the bereavement of remote hill farmers who recall old American pioneers:

> Farmers hold dearly to their dead;
> their dead in childbirth, dead in war,
> dead with sickness, dead with age.[11]

The poem speaks of 'a sparse generation' and imagines the United States as a community of mourning.

Another mode of representing the war's continuing social effects upon America's collective psychology is exemplified by the visionary and surrealistic 'After our War'. This grimly ironic and wittily sardonic poem imagines the severed scraps of flesh such as 'tibias, skinflaps' returning under their own momentum to the United States. Here the forgotten bones and pieces of limbs attach themselves to people,

> So, now, one can sometimes see a friend or a
> famous man talking
> with an extra pair of lips glued and yammering on his
> cheek[12]

The humour, though, hints at madness, and the poem concludes with searching questions about the problematical nature of the post-war world:

Will the ancient tales still tell us new truths?
Will the myriad world surrender new metaphor?
After our war, how will love speak?

Presciently Balaban hints that the Vietnam War will be a storehouse
of new metaphor, a major determinant of contemporary American
consciousness. Such predictions have indeed been fulfilled.

Often Balaban's poetry written after the war returns imaginati-
vely to Vietnam for creative sustenance. Several poems, such as
'News Update' or 'Dead for Two Years, Erhart Arranges to Meet
Me In a Dream', recall dead comrades; others such as 'April
30, 1975', 'In Celebration of Spring' and 'Story', explore the
psychological and moral aftermath of the conflict. At other times
it is the people of Vietnam, its landscape and culture, that call the
poet back. In the range of such poetry Balaban maintains an even-
handedness, a consistency of sympathy and an intellectual alertness
that allow the war's influences upon both Vietnam and the United
States to be felt. It is this comprehensiveness of vision and freedom
from ethnocentrism that set his poetry apart; of course, his
translations from Vietnamese and his scholarship in the areas of
Vietnamese culture lend his poetry authority in this respect,
supplying it with a set of attitudes and cultural icons with which
appropriately to symbolise the wider repercussions of the struggle.

Several poems pay tribute to the heroism, endurance and
emotional resilience of Vietnamese citizens. A refugee who works
in southern California as a punch operator is the subject of 'For
Mrs Cam, Whose Name Means "Printed Silk"'. A contrast is drawn
between an idealised Vietnam, the 'Pass of Clouds' and 'Perfume
River, in Hue', and Mrs Cam's existence as a mother in the United
States. Interestingly the Asian river gives way in this poem to other
images of water – this time of tidal pools and the 'wide Pacific':
the sea serves as an image of survival, its creatures getting on, like
Mrs Cam, with the business of living:

> In tidal pools, the pipers wade
> on twiggy legs, stabbing for starfish
> with scissoring, poking, needle bills.[13]

'Thoughts before Dawn' which is dedicated to Mary Bui Thi
Khuy, one of Balaban's comrades in the hospital service in Vietnam
during the war, is a moving elegy to a young woman who selflessly
carried out her nursing duties under enormous pressure, retaining

her composure and intense self-discipline. A key to the strength of Balaban's poetry, its freedom from guilt, is provided in the second stanza of this poem, which recalls the poet's own medical tasks:

> We brought to better care the nearly lost,
> the boy burned by white phosphorus, chin
> glued to his chest; the scalped girl;
> the triple amputee from the road-mined bus;
> the kid without a jaw; the one with no nose.

(It is interesting to compare this passage with the poetry of Basil T. Paquet, a former medical orderly whose poems dwell almost pathologically on death and wounding.[14] Balaban's poem is more positive in recalling the constructive attempts made to clear up the mess.)

Whereas 'April 30, 1975', as its title implies, treats the immediate and personal impact of the cessation of hostilities and briefly contrasts a violent American culture with a gentler oriental one, 'In Celebration of Spring' offers a long-term, more reflective evaluation of the war's spiritual consequences. It calls on the Vietnam generation to commit themselves not to repeat the actions of their 'dead and disgraced' elders who got America into the war. The poem's central images are profoundly contrasting – of a dead Marine left behind and now rotting 'with a bullfrog for a face', of cratered Vietnamese homes and of wounded GIs walking lost and disoriented at home in an alien country. Juxtaposed against such paradigms of defeat is a magnificently lyrical evocation of a boy and a girl at play on a sunlit riverbank: natural energies complement their innate vitality. The running children symbolise America's powers of recovery, the nation's potential for a peaceful future,

> As she chases a frisbee spinning in sunlight,
> a girl's breasts bounce full and strong;
> a boy's stomach, as he turns, is flat and strong.[15]

Balaban's poetry eschews the now fashionable revisionism, and postulates recuperation through a spiritual process: 'we will be keepers of a garden'. The garden, we assume, is America.

Contemporary American culture, in its inflected revisions of the Vietnam War, dramatises ideology in operation; faced by such

contexts the poet's ability to envision the war which daily recedes further becomes more urgent and necessary. A similar problem faced Second World War poets – most notably Louis Simpson, who wrote memory poems of a pristine, childlike simplicity. One is reminded of Simpson's poems by some of John Balaban's attempts to reach back into the mind and recall Vietnam. In some poems, such as 'Dead for Two Years, Erhart Arranges to Meet me in a Dream', the dream's truth is articulated as a primary one yet it is smudged and imprecise. In others, such as 'Story', an anecdote or piece of factual information suddenly brings the war flooding back: in this poem a father casually remembers his son's spectacular death, thereby intensifying its significance.

> Nixon killed him.
> My son was a sweet kid, hated guns and violence
> and then, during that fucking war, he hijacked a plane
> and flew it to Cuba. He shot himself in Havana.[16]

In 'Story', taken from Balaban's most recent volume, *Blue Mountain*, 1985, the poet–narrator is figured at the conclusion of the poem in healing posture before the camp-fire.[17] He cradles in his hand a squashed mouse as if soothing and laying to rest all of the war's victims.

Memory in 'News Update' functions in an interesting way, and is ambiguously linked into the media processes where history is a commodity for mass consumption. As Michael Herr has most notably expressed in *Dispatches*, journalists and photographers occupy an authentically heroic role in the semiotics of the Vietnam War, taking on the aura of hipness and glamour. 'News Update' wrestles with this mosaic of truth and reportage–fiction: even the poet himself, who was covered with his friend Gitelson's leaking brains, who witnessed 'the human head/dropped on the dusty road' and watched 'nitrate fizzing on flesh' in the Burn Ward in Da Nang, is now 'written up' in the local paper because of a fist fight. He has himself become news.[18]

Throughout the poem there is an elision and confusion between the refugees who now have commodity value as 'page one' news and the 'dusty road' of historic Vietnam. To recall such legendary figures as Sean Flynn, who outrivals the movies, it is paradoxically necessary to adopt the imagery of the movies: 'One skims the memory like a moviola'. The bravery, tenderness, recklessness of

Dana Stone, Tim Page, Erhart and Marie-Laure de Decker are commingled with evocative stories such as that of the woman[19] who returned with a steel comb supposedly made from a melted-down American tank. The extraordinarily powerful effect of 'News Update' stems essentially from this mobility of tone, a fluid mixture of seriousness, irony and wit. Understating the war's tragedy, the poem pays tribute to those who participated in its myth-making, and yet it also reinforces this creation of folklore. Skilfully the temptation towards nostalgia is resisted through witty and collo-quial language, as when the Burn Ward is described as 'a half a garbage can that smelled like Burger King'. The poem's closing line, with its 'windy sighs' and 'ghostly laughter', leaves open Vietnam's abiding power to evoke the 'familiar faces' and 'the dusty road which called you all to death'. 'News Update' in its imaginative precision of recall, its informality and emotional resonance is wholly typical of Balaban's Vietnam poems. Fortunately he has continued to write memorable poems, most of which do not now directly mention the war.

NOTES

1. All quotations in this essay are taken from W. D. Ehrhart (ed.), *Carrying the Darkness* (New York: Avon Books, 1985).
2. Ibid., p. 93.
3. Ibid., p. 25.
4. See Michael Casey, *Obscenities* (New Haven, Conn., and London: Yale University Press, 1972).
5. *Carrying the Darkness*, p. 187.
6. Ibid., p. 7.
7. Ibid., pp. 7–9.
8. Ibid., pp. 9–11.
9. Ibid., p. 13.
10. Ibid., p. 14.
11. Ibid., p. 12.
12. Ibid., p. 16.
13. Ibid., p. 17.
14. See, for example, the impressive, 'Morning – a Death', ibid., pp. 218–19.
15. Ibid., p. 20.
16. Ibid., p. 23.
17. Ibid., p. 24.
18. Ibid., pp. 20–2.
19. Sandra Johnson, an American doctor.

10

History Lessons: *Platoon*

KATRINA PORTEOUS

Is there anyone out there who hasn't heard that Oliver Stone's semi-autobiographical *Platoon* (1986) is the first film to tell the 'truth' about the Vietnam War? Whilst it should be stressed that this is a thoroughly American account, paying no attention whatsoever to the Vietnamese perspective, it is certainly very strong in its depiction of particular authentic, and especially experiential, details. It creates a powerful impression of the impenetrable jungle, of the invisibility of the enemy, their indistinguishability from allies, and of the sheer chaos of a firefight; of the physical wretchedness and exhaustion of the 'grunts', their esoteric vocabulary, and of the disproportionate number of blacks, poor and ignorant among them. All this is so well done that the film offers a far more 'realistic' account of the American experience of Vietnam than the sweeping metaphors of *The Deer Hunter* and *Apocalypse Now*, or the idiocies of *Rambo: First Blood Part II*. Indeed, *Platoon* has more in common with oral histories of the war such as Mark Baker's *Nam* and Al Santoli's *Everything We Had*, and with memoirs written by American eye-witnesses and participants, such as Michael Herr's *Dispatches* and especially Philip Caputo's *A Rumor of War*, which in places it strongly resembles.[1] But what kind of insight does this perspective give it into a long, complex and changing conflict? Can any single 'truth' be told?

One thing that strikes you very forcibly is how conventional in terms of the movies and literature of past wars this film often seems. You have a series of events – a night patrol, an ambush, exploration of a booby-trapped Vietcong tunnel, an attack on a village, another ambush, and a set-piece battle with the North Vietnamese Army. Interwoven, there is the personal conflict of the stereotypical Sergeant Barnes (scar-faced, amoral and virtually indestructible) with the equally familiar Sergeant Elias (supernaturally graceful, almost messianic). Whilst they struggle against each other, a corresponding battle is waged within the soul of the

153

impressionable young hero, Chris Taylor, whose journey from innocence to experience forms the central theme of the film. So far, we could be anywhere.

But all this tells us several things about American perceptions of the Vietnam War. First, it suggests that, in some ways, it was like all other wars depicted in movies. Secondly, each event yields more specific information about how Americans behaved. We learn that some went to sleep on guard duty, got high, murdered civilians, hid from the enemy; that their morale was low; and that their leadership was incompetent, ruthless and brutal, subjecting them both accidentally and deliberately to air-strikes from their own side, using them as bait to lure out the North Vietnamese Army, promising them full support then failing to deliver. Thirdly, we discover from the conflict of Barnes and Elias, and from the underlying cultural opposition of 'juicers' (redneck drinkers) and 'heads' (laid-back dope smokers), that America 'did not fight the enemy. We fought ourselves.' Most of all, we learn that the central issue of the war for its American participants was not defending freedom but surviving, that what it was ultimately 'about' was losing innocence, discovering the 'enemy' within.

The relation of each of these suggestions to the reality of Vietnam is equivocal. In the first place, veterans' narratives suggest that, even at the time, the war was conceived in terms of particular conventions, often borrowed from Second World War movies, and that no clear distinction can therefore be drawn between what is 'conventional' and what is 'realistic'. Indeed, participants recall that the war frequently seemed profoundly unreal. Many veterans remember feeling as if they were involved in a film themselves. 'I loved to just sit in the ditch and watch people die . . . sitting back with my homemade cup of hot chocolate', writes one of Baker's anonymous contributors: 'It was like a big movie.'[2] This prevalent conception of the war often had disturbing implications; some felt they could do anything without censure. *Platoon* acknowledges this pervasive sense of illusion, Barnes repudiating it ('I *am* Reality') while Bunny, the stock sadist, subscribes to it: 'You got Audie Murphy here', he tells his partner in the climactic battle scene.

The traditional images of the movies and literature of past wars which *Platoon* restates – that war is madness and nightmare, the army a machine, its constituent parts less than human, slaves – were commonly invoked by American soldiers in Vietnam, not only because, as conventions, they were readily available, but also

because they were rooted in the particular realities of this conflict. The experience of night fighting, for example, of fragmentary guerrilla warfare with no clear lines defining success or failure, combatant or civilian; the fact that nowhere was safe, that American casualties primarily resulted from booby-traps and snipers rather than from direct confrontation (though the extent of the enemy's conventional forces was also often misjudged); all this, together with ignorance of Vietnamese culture and of the conflict's history, combined to create such confusion that the highly traditional representation of war as madness seemed entirely appropriate. Similarly, the massive superiority of American technology on the one hand, and, on the other, the impossible terrain, as formidable an enemy as the Vietcong and North Vietnamese Army together, seemed an incarnation of the conventionally conceived conflict between rationality and wilderness. 'The Puritan belief that Satan dwelt in Nature could have been born here', writes Herr.[3] From its assertion that 'Hell is the impossibility of reason' to its chaotic battle scenes and superbly evoked jungle, *Platoon* re-creates these conventions which were so integral to the experience. Yet, by this same authentic re-creation, it may perpetuate the tendency, common at the time, to obscure some of the peculiarities of the war behind a more traditional interpretation. Once again, 'convention' and 'realism' cannot be clearly distinguished.

The 'truth' of the second set of suggestions, dealing with American incompetence and brutality, is equally ambiguous: these too are conventions, though, unlike those of madness, nightmare and irrationality, they are specific to depictions of Vietnam. The film's central episode, the attack on the village, is based on two actual incidents which came to be regarded as symbols of the war at the time – the horrific massacre of civilians, including women and children, at My Lai in 1968, and the television report three years earlier which showed Marines using Zippo lighters to burn down houses in Cam Ne. Such atrocities really occurred; Caputo recalls how increasing frustration led to his own authorisation of an attack on a village, which resulted in his court martial.[4] But, whilst harassment of civilians certainly was extremely common, outright atrocity was by no means universal or as unique to this war as is sometimes suggested by the conventional portrayals which *Platoon* echoes.[5]

Similarly, whilst it is true that there was a great deal of incompetence in the organisation and leadership of the American

effort in Vietnam, once again, in rehearsing the standard clichés of the war, *Platoon* perhaps insists on this too heavily. The extent to which this aspect of American failure has been emphasised may to some extent reflect the shock felt by the world's greatest military power at its inability to defeat a small and apparently primitive enemy. The film's depiction of the Vietnamese – on the one hand as Third World peasants, fragile beside the hulking Americans; on the other, as a skilled enemy, at home and invisible in the jungle, concealing the formidable sophistication of their tunnels and underground hospital, and of their regular, as well as guerrilla, army – reflects both America's initial sense that victory would be easy, and one reason why it proved impossible.

At the same time, by packing into such a small space so much evidence both of American brutality and of the suffering of American soldiers at the hands of an often ruthless and incompetent command, the film effectively reinforces the prevalent mis-apprehension that what distinguished this conflict from other wars was that it was somehow uniquely terrible, a mis-understanding surely due to the fact that it was the first war to appear nightly in people's living-rooms. A further misconception is encouraged by the film's pace. According to most veterans, the war's principal characteristic was not action, but mind-numbing boredom:[6] not the stuff of which good movies are made.

The storyline, the conventional internecine feud ('this war ain't big enough for both of us'), likewise bears an equivocal relation to reality. Again, it represents some truth: as morale declined, 'fragging' of officers became more frequent, racial and class tensions increasingly destructive. But the message that Americans fought one another may be interpreted in many ways. As with the emphasis on US incompetence, it seems to suggest that the real issue in Vietnam was one of tactical mismanagement rather than of strategic miscalculation; like most of the opposition to the war at the time, the film asks no questions about American objectives, only about the way these were being, or could be, fulfilled. It indicates that what the United States gave with one hand it took back with the other – an argument which is certainly true on one level,[7] but which could even be construed as confirmation of the conservative claim that America lost the war simply because the military were prevented by opposition at home from fighting at full strength.

On the whole, *Platoon* maintains straightforwardly that the

United States was 'guilty' in Vietnam (without properly explaining how); but adds that the grunts, with a few exceptions, were not themselves to blame. In the vast majority of cases, this approach is justified. For most American soldiers, the choices by which 'guilt' or 'innocence' may be measured were strictly limited: you were drafted there, you obeyed orders. Chris Taylor is something of an anomaly, in that he volunteered. Still, this distinction between the country's guilt and the grunt's relative innocence is hard to maintain. This, of course, is partly the point, since the war must be shown to have compromised that innocence; but it also seems partly an unconscious implication of the film. There are times, as in Elias's death scene and in the film's closing sequence, for example, when *Platoon*'s evident pride in America's soldiers could even be interpreted as a disturbing glorification of their context, the war.

Many of the grunts' worst actions are deliberately qualified; very explicit motivation is provided for the attack on the village, and the film demonstrates the deep moral paradoxes of a conflict in which soldiers, some wearing crucifixes, burned down houses, then carried the children to safety. The conventions of war imagery on which it draws are carefully selected: there are significant silences. The John Wayne, cowboy, war-games and hunting metaphors so prevalent in veterans' accounts and in previous screen interpretations of Vietnam are all avoided, as is the stock representation of grunts as collectors of Vietnamese ears. Instead, images of the soldiers' internal struggles – concentration upon survival and, in Chris's case, moral transformation – predominate. The war is essentially reduced to psychological terms.

This is the real significance of *Platoon*'s claim that Americans fought each other in Vietnam, and of its central message that 'the first casualty of war is innocence'. This latter theme is another hoary old convention of war literature and movies through which experience was filtered by participants at the time. Every veteran's narrative tells of the odyssey from childlike naïveté to premature age and disillusionment with John Wayne morality. As Herr asks at one point in *Dispatches*, 'How do you feel when a nineteen-year-old kid tells you from the bottom of his heart that he's gotten too old for this kind of shit?'[8] But at the same time, whilst heroism comes to seem like madness to the war's participants, innocence as dangerous folly, still, in most of their narratives, elements of the old morality persist: war continues to be seen as the finest

proving-ground of manhood. *Platoon* confirms these clichés. It confronts us with a series of initiations, from the first revelation of the body bags which greet Chris on arrival, through his baptism by fire, his induction into the close bonds of brotherhood in the 'Underworld', and his 'blooding' at the Vietnamese village, to the climactic scene near the end, where he murders Barnes. His act inevitably recalls the earlier claim that 'the only thing that can kill Barnes . . . is Barnes', itself curiously reminiscent of Rambo's line, 'to win a war, you gotta become war'. We're left with the question, has Chris become like his enemy in order to destroy him?

Such a preoccupation with the journey from innocence to experience gives the film an undoubted authenticity, echoing as it does so many veterans' accounts. Yet at the same time it seriously compromises the claim that the film tells the 'truth'. By depicting the war primarily in psychological terms, complete with intimate camera work and emotional music, *Platoon* at once bestows on it an aura of tragic inevitability, and turns it into a metaphor for America's sins. Certainly, as has been suggested, the war *was* inevitable for the average, drafted grunt; many participants seem understandably to have stressed this fact in order to dissociate themselves from responsibility for actions which they had no choice but to perform, and for which they often felt an enormous burden of guilt. However, in a film that purports to tell the truth about the war, a purely psychological approach proves an inadequate solution to the larger question of America's guilt. It ignores the issue of political and military responsibility altogether. Above all, by dwelling, like many other veterans' accounts, on America's lost innocence, the film, like them, pays strikingly little attention to the far greater suffering of the Vietnamese, including those for whose freedom the United States ostensibly fought. It says nothing, either, about the political dimensions of their struggle. By these silences it perpetuates the kind of thinking, or lack of it, that made the war possible in the first place.

Platoon leaves viewers with a strong taste of how it felt to be dropped, ignorant and confused, into the jungles of Vietnam. This is in itself a considerable achievement. But, lacking the necessary irony or distance to put into perspective the conventions of war in general and of Vietnam in particular, it fails to provide an adequate critique of those conventions, through which the war was frequently perceived at the time. Its claims to reinstate history and reaffirm its lessons are therefore never fully realised. Though it is

an excellent subjective account of certain aspects of American experience in Vietnam, and a valuable antidote to *Rambo*, it provides no deeper historical insight than that of the grunts who stumbled across decaying corpses or fought amid the ruins of ancient temples and French colonial churches. In that sense, the first casualty of war remains, as the quotation originally stated, not innocence, but truth.

NOTES

1. M. Baker, *Nam* (London: Abacus, 1982); A. Santoli, *Everything We Had* (New York: Ballantine, 1982); M. Herr, *Dispatches* (London: Picador, 1978); P. Caputo, *A Rumor of War* (London: Arrow Books, 1978).
2. Baker, *Nam*, p. 58.
3. Herr, *Dispatches*, p. 80.
4. 'They had taught us to kill and had told us to kill, and now they were going to court-martial us for killing' (Caputo, *A Rumor of War*, p. 322).
5. 'I didn't know of anybody in my entire platoon that wanted to kill, who ever killed before' (Santoli, *Everything We Had*, p. 125). For Caputo, the point is not that American soldiers in Vietnam were particularly inclined towards atrocities, but that 'the war in general and U.S. military policies in particular were ultimately to blame' (*A Rumor of War*, p. 330). *Platoon* makes the same point, but its implications are not sufficiently elaborated.
6. 'Most of the work was boring menial labour' (Baker, *Nam*, p. 63, editorial comment).
7. 'It seemed like we'd do something real nasty and then we'd try to do something nice. It's like everything we did that was positive we cancelled out with a negative' (Santoli, *Everything We Had*, p. 49).
8. Herr, *Dispatches*, p. 21; cf. Caputo, *A Rumor of War*, p. xiii: 'in the span of months, [we] passed from boyhood through manhood to a premature middle age'.

11
'The Real Thing': New Images of Vietnam in American Comic Books

DAVID HUXLEY

Since 1980 there have been a wide range of texts in the field of American popular culture which have laid the groundwork for a recuperation of the Vietnam War. Many of these texts took the form of television series in which Vietnam was presented as part of the credentials which formed the background of heroes in violent professions – for example, *Magnum*, *Airwolf*, *The A-Team*. These were followed by comic books such as *Jon Sable, Freelance*, which used the idea of Vietnam in a very similar way. Gradually the influence of Vietnam moved from the background of some of these texts to the foreground, notably by the use of a recurring formula: the return-to-Vietnam or 'missing in action' story. A variation of this type of story has been used by all the examples mentioned above, and it also forms the basis of the second Rambo film, *Rambo: First Blood II*.

However it is in the field of American comic books that stories set specifically during the Vietnam War began to make a reappearance in 1985. Marvel comics' *Savage Tales*, no. 1, contained a seven-page story called 'The 5th to the 1st' about a battalion of Air Cavalry in Vietnam in 1967. *Savage Tales* is a comic 'magazine' aimed at an adult audience and is therefore published outside the control of the American comics code. The tradition that led to this kind of large-format adult comic, and the impact of the comics code on American comic, will be discussed later.

A closer inspection of one '5th to the 1st' story – 'The Sniper' (*Savage Tales*, no. 4) reveals some of the characteristics of the series. The basic plot of 'The Sniper' is this: the battalion, having failed to find an enemy supply route, goes to help some inexperienced Marines under attack. One of their pilots is shot and the helicopter carrying the story's narrator, Captain Young, crashes. While he is dazed his sergeant tracks down and kills the sniper who has had

the Marines pinned down. On returning to base the sergeant tells Young that the whole attack was the work of one young girl.

Although the story is written by Doug Murray, a Vietnam veteran, it still follows some of the formulas which occur in many other American war comics. First, the sergeant in 'The 5th to the 1st' is an archetypal figure in the tradition of *Sgt Rock*, one of DC comics' long-running publications. This sergeant is identified in the first story of the series as 'Rich Heidel . . . hell on wheels in the field – a drunken disaster in garrison'. Apart from the detail about his drinking (the reasons for which will be discussed later), Heidel fits perfectly into the precept that a sergeant must be the most effective member of the group. This apparently invincible sergeant-figure has dominated a large number of long-running American war comics.

Secondly, as an almost necessary comparative adjunct to the sergeant, the captain is less effective. Again, the initial story underlines this. The captain introduces himself as 'Roger Young . . . six months ago I was in college worrying about my grades and my girl'. His surname is perhaps meant to indicate his problem – he is too young to have all the requisite experience for his job. Although he is not necessarily ineffectual, there is no doubt that he is dependent on his sergeant, particularly for important tasks such as tracking down the sniper.

Finally, and perhaps most interestingly, the stories so far have continued the tradition in Vietnam comic books of pushing the enemy virtually out of sight. In 'The Sniper' there is only one appearance of the enemy sniper in six pages – and this is in the final frame, where he is almost hidden in a tree surrounded by foliage. Of course, some of these characteristics can be said to be reflections of the true situation in Vietnam. For example, the difficulty of tracing an elusive enemy was one of the features of the war. In comic-book fiction, however, these three devices: dependable sergeants, inexperienced or inefficient officers and peripheral Vietnamese appear with such regularity that they begin to appear ubiquitous. Furthermore, it is possible to break away successfully from all these formulas, as we shall see later.

On the other hand, 'The 5th to the 1st' does vary radically from standard American war comics in several ways. The most important of these differences stems from the freedom which is permitted when publishing outside the comics code. One of these freedoms is the ability to deal with problems such as the sergeant's drinking.

The kind of archetypal sergeant already discussed (Sergeant Rock, for instance) would presumably have been identified as a hard drinker already if this had been permissible within the code. More suprising is the admission of drug-taking: for example, in *Savage Tales*, no. 1, we are introduced to 'Paul Hogan and John Duff . . . these two experiment with consciousness-expanding drugs, but they get the job done'.

Such a semi-favourable comment on drugs of any kind rarely occurs outside the true 'underground' comic. Until 1971 reference of *any* kind to drugs (even in condemnation) was forbidden by the code. At present anti-drug stories are permitted, but the comment that drug-takers 'get the job done' would not be. Similar rules apply with regard to violence. In 'The Sniper' Captain Young is awakened by blood from the dead pilot dripping on his face. Such an explicit demonstration of the result of violence would be banned in a code comic.

'The 5th to the 1st' is drawn by Mike Golden, who uses a strong, clear 'cartooning' style which follows the tradition of American comic-book drawing. This style is unusual in its precision and clarity, which makes it effective for delineating machinery and landscape as well as figures. Golden's landscapes in particular give the *Savage Tales* stories a genuine sense of place that is missing from most other Vietnam stories – of any period. On the second page of 'The Sniper' one panel shows a helicopter flight passing over simply expressed jungle hills that evoke the beauty of the Vietnamese landscape. Perhaps even more remarkable are Golden's jungle 'interiors', in which distant foliage is rendered in a stylised, almost geometric pattern. It is a form of 'graphic equivalent', derived perhaps from a study of photographs of light breaking through dense foliage. It works perfectly.

To English eyes Golden's 'cartooned' figures can look strange in a comic of serious purpose. Facial features and figures are exaggerated enough to imply humorous intent in an English context because of the differing traditions of comic-drawing style in the two countries. Occasionally, however, this fine balance of exaggeration can slip, even in American terms. In the first story in the series we only see the Vietcong in three frames. In the third frame they are taken by surprise in an American ambush. Golden expresses the figures in a beautiful thin line, unlike the solid black which he uses on foreground figures – a device he uses to dramatic effect in this story in order to suggest depth and aerial perspective.

But with the face of the central Vietcong figure Golden moves from 'cartooning' into broad caricature. The huge, startled eyes of this figure seemed to have escaped from a humour comic, so that the image jars, particularly at a moment of extreme violence: the figure becomes a racial stereotype.

In fact the visual manifestation of extreme violence is an area where Golden's artwork would be seen to be inadequate, or rather, inappropriate. 'The 5th to the 1st' actually avoids very explicit violence, presumably through a kind of self-censorship. Of course it is true also that demonstrating the result of violence (for example, the incident of blood dripping on Captain Young's face) can sometimes be more effective than showing the violence itself. In 'The Sniper' we do not actually see anyone being shot. The second frame of Vietcong in the first story in the series **(plate 30)** illustrates the potential problems when Golden representes explicit violence. In this, two Vietcong are caught in a hail of gunfire. Golden expresses the force of the bullets in single broken lines, and the two figures in semi-silhouette have white holes torn through them where the bullets strike. It is the most violent image in a '5th to the 1st' story and, in many ways, tremendously effective. The problem is that it is also beautiful. It aestheticises the moment of violence in a way that is, presumably, unintended. It is difficult for a competent artist to avoid this duality in effect: to some extent there is similar danger inherent in all image-making of this kind. Even documentary war photography, channelled through the eye and compositional ability of a photographer, can sometimes make images of horror more palatable. But again, as we shall see later, it is possible to minimise this effect.

In December 1986 Marvel comics published the first issue of *The Nam*. The editorial explained, '*The Nam* is the real thing – or at least as close to the real thing as we can get in a newstand comic bearing the comics code seal. Every action, every fight is based on fact.' The letter columns of *Savage Tales* reveal that 'The 5th to the 1st' was a popular feature, so the move to a regular full-colour comic presumably made economic sense. But the previous examination of *Savage Tales* indicates that trying to produce a war comic within the code is fraught with problems. The censorship of the code makes the task of depicting the horror of war extremely difficult. Marvel are clearly aware of this and later in the same editorial they admit, 'Yes, we had to make some compromises. The real language used by soldiers in the field can be quite raw.' But sanitised

language is only one of its problems. The violence and acknowledgement of the role of drink and drugs which appears in 'The 5th to the 1st' will not appear in *The Nam*. Given that *The Nam* has made strenuous efforts to make every possible detail factually correct, it seems counter-productive to work in a format that imposes so many restrictions. The only justification for it is an economic one.

The Nam and 'The 5th to the 1st' are part of a long tradition of American war comics which have strived for absolute accuracy. The most illustrious of these predecessors were EC comics' *Frontline Combat* and *Two Fisted Tales*, which were edited, and sometimes designed, written and drawn, by Harvey Kurtzman from 1951 to 1954. Kurtzman's meticulous research and broad dynamic drawing made the best of these stories into terse and believable anti-war stories. They were produced before the introduction of the code in 1954, so they were published with the same freedom as *Savage Tales* and produced in a similar format. One strength of this format is that it presents several short stories per issue. This allows stories to be succinct and concentrated whilst avoiding the restrictions which continuing characters can impose. Kurtzman's characters, for example, are quite likely to be killed at the end of the story. One of his most famous and widely reproduced stories is 'The Big If' from *Frontline Combat*, no. 5 (1952). In this an American soldier in Korea is shown, fatally wounded, reflecting on how he came to be separated from the rest of his unit. In the final panel of the story the soldier collapses and dies, the victim of a shell-burst. The various choices which have led him to this tragic end constitute the 'Big If'.

The attack on comics by various critics which subsequently led to censorship did not concentrate in the main on war comics. Geoffrey Wagner, writing in 1954, did include them in his criticism. He wrote of a Battle Brady comic: 'Battle dotes on action. . . . Hooray for the Brooklyn Dodgers! he yells as he plunges his bayonet hilt-deep in yet another red. . . . It is all gorgeous carnage, topped off with a joke or two in dreadful taste.'[1] The comics code ended the 'gorgeous carnage' of which Wagner complained. Ironically, this carnage was replaced in later war comics by scenes in which bullets did not kill and the wounded did not bleed. And yet, in spite of this, the Americans were still the victors.

As part of their striving for factual reality, Marvel have also taken the decision to publish the stories for *The Nam* in 'real time'.

Thus, as each new issue is published, one month will have passed for the characters in the comic. Therefore the comic is intended to last for eight years, with an annual change in personnel as they are transported back to America. To understand what a radical departure this plan is from the standard scheme of time in American comics, and what this portends, it is useful to examine in more detail the more usual use of the concept of time in comics. Umberto Eco has analysed the use of narrative and timescale in Superman comics, and many of his conclusions are equally applicable to much popular fiction.[2] The main points of his analysis can be summarised thus.

1 The hero has incredible powers which make him almost invincible.
2 The narrative depends on the surprise value of each new situation or villain.
3 But each inevitable victory is an achievement locating the hero in a timescale, and thus aging (consuming) him.
4 The solution to this is to ignore timescale *in between* each adventure.
5 The hero therefore does not need to plan, and has no responsibility.
6 His appeal to readers is in a series of idiosyncrasies ('tics' or 'gestures').

In fact the basis of this model can be applied to most standard continuing war-hero characters. Eco concludes that the plot possibilities of this type of story are severely limited and what the reader is actually looking for is a reaffirmation of what he or she already knows about a character. Thus the repeated series of 'gestures' or idiosyncrasies (for example, James Bond's martinis, shaken not stirred, Hercule Poirot's vanity) are actually what makes a character popular, and the main function of the plot is to allow these 'gestures' to be displayed.

Eco argues that Superman will never perform a major act of global significance (or even marry), as this would 'consume' the character and place him in a 'real' timescale. From this it can be seen that, by using 'real time' publishing, *The Nam* represents a serious and unusual attempt to give comic-book characters a sense of reality. The continuing war hero in comics is generally a kind of sub-super-hero, even if he *claims* to be just an ordinary GI just

doing his job. The characters of *The Nam* are therefore a great rarity in a continuing series: they are central figures who are merely protagonists.

In *The Nam* Golden's design is as excellent as ever: the cover of the first issue (**plate 29**) is a *tour de force* incorporating two complicated scenes of action with a map of Vietnam. However there are two problems with the use of colour in *The Nam*. First, the cruder interior colour seems inappropriate to the imagery of war. This is true of the interior colour of most American comic books, which compare badly in this respect with the black-and-white interiors of *Savage Tales*. Indeed the coarseness of this kind of colouring, done by hand separation and using 'benday' dots for tone, was parodied by Roy Lichtenstein's paintings of comic-strip frames in the early 1960s. Because immense skill is required to reproduce naturalistic colour with limited means, colour in American comics is often 'expressionistic'. When this happens in *The Nam*, it demonstrates the second problem: on p. 14 of *The Nam*, no. 1, an ambush is coloured mainly in solid reds to highlight the moments of violence. Unfortunately this has the effect of obscuring the more delicate parts of Golden's linework, and it also lessens the depth and impact of the heavy black shadows which he has used. Similarly, colour can obscure the quality of the artwork when it is used in a more naturalistic manner. At the top of p. 8 in the same issue of *The Nam* a frame showing the infantry base is marred in this way. The tonal range available is insufficient, so that much of the sense of depth in the panel is broken down.

It is interesting to compare *The Nam* with another comic specifically set in the Vietnam War. This comic, *In-Country Nam*, which began publication in 1986, appears at first glance to be of the 'underground' variety: its cover is simply printed in only three colours and its artwork displays a crude naïveté not associated today with professional comics. The interior of *In-Country Nam*, printed in black and white with similar artwork, reinforces the latter impression. Overall it differs in tone from most underground comics of the late 1960s: rather than being obviously anti-war in intent it is, according to its own editorial, 'a gritty account o[f] the war in Vietnam with emphasis on small unit combat actions'.

In fact *In-Country Nam* is the product of a new movement which has radically affected the American comic-book industry in recent years. This is a movement of small unconnected publishers loosely known as the 'independents' who produce a wide range of material

normally published outside the comics code. The basic similarity between these publishers is that they aim their product at the ever-growing collectors market. Their comics have quite small print runs and are likely to cost over twice as much as the usual variety. The actual content of these comics varies to a marked degree: some reprint 'classic comics' of earlier periods; several carry on the anti-establishment tradition of 1960s underground comics; while others produce versions of standard newstand comics which are more *risqué* or violent but which are frequently executed with far less competent artwork.

In-Country Nam is published by the Survival Art Press, and its rear cover advertises another of its comics, *The Survivalist Chronicles*. The plot of this is described thus: 'From newly occupied Russian Alaska a paratroop drop by the Russians to survey the damage done by their nuclear bombs to the mainland of America.' Survival Art Press, therefore, appears to be part of a company which produces right-wing comics similar to some titles which were published during the Cold War.[3] This is in line with recent American 'red invasion' cinema films, whose history can be traced back to the status insecurities and isolationist tradition of the post-war Truman administration. A cursory examination of *In-Country Nam* seems to confirm this view. On p. 18, for example, after the North Vietnamese have suffered a defeat, a North Vietnamese colonel says to his major, 'Tell the popular front allies to continue their massed attacks with zeal – that will give us time to withdraw back into the safety of the mountains.'

Despite the fact that the story shows a clichéd, wily oriental officer willing to sacrifice his allies in order to save his own troops, it does at least *show* the North Vietnamese. Furthermore, in an earlier sequence we see the colonel and his major actually discussing tactics for a page and a half. Whatever the shortcomings in the characterisation of the Vietnamese, this kind of acknowledgement of the careful planning of the enemy and its effectiveness is unheard of in any Vietnam War comic book of any period. *In-Country Nam* also avoids the worst excesses of the stereotypical oriental officer, who is generally shown as some sort of sub-human sadist.

In-Country Nam, no. 1, avoids the standard jungle ambush narrative and concentrates on a major North Vietnamese attack aimed at securing a rice crop. Although a US battalion wins the ensuing battle, the final page explains, 'The rice was harvested

eventually, under the eyes of the ARVN forces, but still many tons of it made its way into the mountains' This almost throwaway line undercuts the whole narrative by showing that, for all their effort and apparent victory, the Americans have, in the end, lost the battle.

This is not to say that *In-Country Nam* offers an examination of the war which is novel or enlightened. R. Ledwell's drawing-style reveals that the comic may indeed have right-wing sympathies. At times the anatomy in the drawings and the brushwork used to express it is incredibly crude. Yet the style is reminiscent of one of America's most famous war-strip artists, Milton Caniff. Certain panels, such as the one showing an American colonel on p. 5 of the first issue, reflect Caniff's influence. Caniff's most famous strip, *Steve Canyon*, was 'seen in the Pentagon as a propaganda voice for the Air Force',[4] and one page from an earlier strip, *Terry and the Pirates*, was included in the Congressional Record in 1942 for this reason. The visual references to Caniff's work in *In-Country Nam* mean that it inevitably carries some of the strong pro-government overtones associated with his work. Other incidents in the narrative support this. On p. 14 of the first issue, at the height of the fighting, a North Vietnamese soldier is straddled by two rockets. Murph, an American soldier, comments, 'Holy shit, Jaw, did'ja see the look on that bastard's face?' Although this kind of gloating could be seen as a reflection of real attitudes among many American troops, the decision to publish that particular attitude does denote a specific ideological value judgement.

On the other hand, it could be argued that it is difficult to generalise about *In-Country Nam*. On p. 7 of the first issue there is a frame **(plate 31)** which parallels 'The 5th to the 1st' panel **(plate 30)** in which two Vietcong are shot. This frame also features two figures under attack, except that they are American troops. In terms of drawing-technique there are no comparison between Golden in 'The 5th to the 1st' (or *The Nam*) and Ledwell in *In-Country Nam*. Golden's composition, motifs and execution are all totally superior. Yet the frame by Ledwell, which has its foreground figure apparently disintegrating along one side, is somehow potently effective. It is crude rather than beautiful, but the final image appears to be a truer, and therefore more unpalatable, vision of violence than can be found in *The Nam*.

In-Country Nam contains very little characterisation of its two main characters. One, Jaw, gets a chance to complain about unfair

duties and at one point admits he is 'scared shitless'. The other, Murph, is frightened when trapped by enemy fire and it is he who gloats over the effect of the rockets on the enemy soldier. But these men fade in and out of the narrative and in fact do not appear at all in the last seven pages of the story. As an account of combat in Vietnam this lack of focus reduces the impact of the comic into that of an army manual. Yet as such it contains a truth about Vietnam. *In-Country Nam* expresses one view that is not particularly sympathetic to the Vietnamese, but it does make an attempt to be even-handed.

The styles of the main titles of *The Nam* and *In-Country Nam* are indicative of the difference between them. *The Nam* **(plate 29)** imitates army-style stencils, suggesting its intentions towards military realism. But the letters are smoothed out and elongated so that their rough edges are flattened – just as the narrative itself is. *In-Country Nam*'s main title is much less proficient, but its greater attempt to consider the enemy is indicated by the words 'In-Country', which is in oriental-style lettering.

The Nam, for all its efforts to achieve visual accuracy, particularly in matters involving small detail, has to tell some lies because of the decision to publish within the comics code. To conform to this, characters have to be 'frightened' instead of 'scared shitless'. Comics, such as *Savage Tales* and *In-Country Nam*, that have operated outside the code have been able, by contrast, to be more forthright and realistic in many respects. In particular, the '5th to the 1st' stories in *Savage Tales* had, within their chosen format, the potential for development of all kinds. *The Nam*, in spite of its striving to locate accurately every catch on every gun, is effectively sterilised, and for all its verisimilitude fails to add up to any cohesive truth.[5]

NOTES

1. G. Wagner, *Parade of Pleasure* (London: Verschoyle, 1954) p. 94.
2. U. Eco, 'The Myth of Superman', *Diacritics*, Spring 1971, pp. 14–22.
3. For example, *Atom Age Combat*, published by St John from 1952, and *World War III*, published by Ace from 1953.
4. G. Perry and A. Aldridge, *The Penguin Book of Comics* (Harmondsworth: Penguin, 1971).

5. It is worth adding that this opinion is not shared by many American comic-book readers, as *The Nam* has become the best-selling comic in America.

12

Image and Context: The Production and Reproduction of *The Execution of a VC Suspect* by Eddie Adams

ROBERT HAMILTON

One of the lasting images to emerge from the great mass of photographs of the Vietnam War is the picture of the execution of a Vietcong suspect taken by Associated Press photographer Eddie Adams on 1 February 1968 (**plate 32**). It now seems obligatory, when the war and photography are mentioned in the same context, to cite the Adams picture as an example of a photograph that changed the course of history, or showed the aimless brutality of war, or is simply a 'great' news photo. The image has become a receptacle into which the constantly shifting perceptions of Vietnam are placed. In consequence, the meaning of the photograph is not fixed or unitary but multiple and fluid according to the specific context in which it is used. In an episode of *Miami Vice* dealing in part with Vietnam, the camera pans slowly across Don Jonson's Vietnam memorabilia as the character remembers his experience of the war through the collection of objects spread out across his bed. The scene focuses our attention on the Adams photograph as the carrier of memory. The brutality of the war is framed and isolated against the designer violence of the programme. The photograph signifies Vietnam, but its signified is memory and nostalgia. One must ask, why this particular image? Why should the picture of the death of a nameless VC suspect on a Saigon street in 1968 be used in such a way in an American cop series eighteen years later? In reply, one might say that it has been used simply because it is a famous photograph, one that everyone will know and therefore will function symbolically, outside of the normal narrative strictures of the American cop genre, as a memory of the war. Or, at the level of the image, it has been used because of its visual power to convey brutality in terms of subject, composition and design, to privilege an 'unspeakable' element of

the visual over its discursive context. Neither of these replies is, I believe, adequate. In this essay I wish to ask, what were the procedures that were negotiated to produce the photograph's privileged position? How has the image been filtered into popular memory? To answer these questions and to understand the shifting position of the photograph in history, one must look to the multiple sites of its publication, attending to the multiplicity of its possible meanings and to the specificity of context in which the image functions. In 'The Determination of Newsphotographs',[1] Stuart Hall states that the newsphoto is a complexly structured sign in which meaning is made up of a number of different, interdependent levels of signification or codes. The levels range from technical, formal, compositional and expressive codes, through the identification of the subject and the manipulation of cropping and retouching, to the codes of layout and the anchorage of captions and headlines. I do not want to apply Hall's determinations in a rigorous or mechanical way; however, I shall refer to the appropriate codes where necessary in order to emphasise that a newsphoto is not merely the visual record of an event or a reflection of reality but the 'product of a social practice'.[2]

The photograph shows two principal figures. One, in uniform, is seen in profile with his right arm outstretched, holding a pistol close to the head of the other figure, who is in a frontal position and dressed in a checked shirt with hands behind his back. The photograph also includes two marginal figures and the shadow of a third; there are some buildings in the middle ground which run, from right to left, to a faded or unclear background. The two figures in the foreground stand out in tonal contrast to the faded background. (In some reproductions the photograph has been cropped and the outline of the main figures has been enhanced by retouching.) Form and expression indicate that a shot has been fired.[3] At this level or combination of levels of signification (technical, formal, expressive) the signified would appear to be 'a soldier or policeman shoots an unarmed civilian in the street'. This, of course, is not what is pictured in the photograph. Hall points out that the 'news effect' of a photograph depends on codes of identification: that is, the people and place are identified as specific people in a specific place which, connected to specific events, are deemed to have 'news value'. He states,

It is on the basis of these identifications that the photograph first

enters the domain of the news. This is the point, along the significatory scale, where the still photo intersects with the value of news production. All previous levels of signification now inform this 'news effect'.[4]

The correct denotation of the image thus depends on the identification of the people, place and events depicted. Other meanings are suppressed by identification, which also establishes 'news value', i.e. the usability of the photo in the context of news production.

During the Vietnamese New Year (Tet), on 30 January 1968, the Vietcong and elements of the North Vietnamese Army launched major attacks on over a hundred cities and army installations throughout South Vietnam in what became known as the Tet Offensive. To launch its attack on Saigon the Vietcong set up a command post in the An Quang Buddhist pagoda.[5] It was there, on 1 February, that South Vietnamese Marines captured a Vietcong suspect. The prisoner's only military identification was his possession of a pistol, usually the mark of a Vietcong officer. He wore a checked shirt and black shorts. He was marched down the street, arms tied behind his back, towards Brigadier General Nguyen Ngoc Loan, chief of the National Police. As the prisoner approached him, Loan drew his revolver and waved away the Marines. Without a word, the General raised his pistol to the prisoners' temple and pulled the trigger. The man fell to the ground, blood pouring from the fatal wound. These then are the specific people, place and events depicted in the photograph. At the level of identification, the signified is now 'Brig. Gen. Loan, chief of the National Police, executes a suspect, identified as a Vietcong officer, outside the An Quang Pagoda, Saigon.'

However, these facts alone do not necessarily indicate that the photograph of the incident has a usable news value. For example, Harold Evans, in his book *Pictures on a Page*, points out that Dickey Chapelle, a freelance photographer in Vietnam, had taken a similar picture in 1962 that was widely rejected by the press.[6] Evans does not suggest why the picture was rejected. In relation to this, I think there are several points to be considered.

First, the execution recorded by Adams was not simply an isolated, though unexpected, incident. The media's attention was heavily focused on Vietnam because of the Tet Offensive. The news value of the photograph must be seen within the wider

context of the story of Tet. (I shall return to this point later.) It should also be remembered that in 1962 American personnel in Vietnam numbered 11,300[7] in a supposed advisory capacity, as against 536,100[8] military personnel in a combat capacity in 1968, when there were also 637 accredited news correspondents in the country.[9] Vietnam was news.

Secondly, the image displays a 'dramatic' event. Peter Braestrup, in his book *Big Story*,[10] points out that not every day did newspapers get a picture in the actual moment of death. Adams' photograph is a rare, if not unique, image. Rarity and drama are conditions that would enhance the photograph's news value, relative to other conditions of production. This is not to imply that the value of the photograph lies in its formal structure. Our ability to read images in this 'direct' way is socially constructed and mediated by the history of the photographic culture in which we live.

Thirdly, there is the presence of the photographer and the apparatus that supports that presence. Adams, in one account of the incident, states, 'AP and NBC were next door to each other. We used to work together a lot. Because if a story moved on the wire, they knew they would get the story on TV. We heard this battle was taking place at the An Quang pagoda. So we all teamed up in one car.'[11] What I want to draw out from this account is (1) the apparatus that supported Adams' presence in Vietnam, namely Associated Press (AP), and (2) the presence of the NBC film crew, whose footage of the shooting enhanced the value of the Adams photograph. AP is a news agency that supplies reports and photographs to newspapers and magazines throughout the Western world. It is, therefore, economically dependent, in part, on extraordinary reports or photographs such as the Adams picture. AP is a system for distributing news, but it is also a gathering system. It must produce news that lies outside the gathering and distribution capacity of freelancers, or of newspapers and magazines who employ their own reporters and photographers. This is dependent on the speed at which it can send its representatives to stories that are just 'breaking' (this might explain NBC's reliance on the AP wire), and on a complex network of reporters and photographers who can be called upon to cover those events. As Tet broke, AP had the largest press contingent in Vietnam, employing some twenty people. In terms of the production of news value, Braestrup points out that

an AP or UPI [United Press International] story coming off the news tickers before anything else, heavily influenced big-league editors and producers on the 'tilt' of a given event, even if they later received contrary advice, or a contrary account from their own staffmen. Indeed, there were often complaints from newsmen abroad that nothing became news until AP picked it up.[12]

Adams' presence at the An Quang pagoda was, thus, dependent on this complex system. Furthermore, the processing, printing and worldwide distribution of the photograph was similarly dependent. As mentioned, the Adams picture was not the only visual representation of the event. One must consider the NBC film. The footage of the shooting was rushed to Tokyo to be processed, and was screened, via satellite, on the evening of 2 February on the nightly NBC news programme, *The Huntley–Brinkley Report.*[13] It was watched by approximately 20 million people. Although the film was shown slightly after publication of the photograph, there is a relation between the two representations of the same event. Still and moving pictures have different currency, but both function within the general realm of news production. It is not a case, as Harold Evans has argued, of the one being more memorable or powerful than the other. With reference to the Adams photograph he writes, 'In our mind's eye we can concentrate on a single image more easily than a sequence of images.'[14] One might argue the opposite: that in an age of moving images (television, film) a sequence of images will be more memorable because of its cultural dominance. I think that the real relationship is one of mutual dependence and reinforcement. A photograph is likely to be more newsworthy if supported by film footage, and *vice versa*.

It is, then, identification and the availability of systems to take advantage of it that qualify and quantify the news value of a photograph at the level of denotation. It is also the point at which levels of connotation come into play. Hall states that identification is where 'the connotive power of the image can be mobilized for the purpose of articulating "news value"'.[15] Connotation is the level at which second-order meanings are generated within the image. In the Adams photograph, these could be 'the brutality of war' or 'the South Vietnamese regime is unjust'. However, these 'free-floating' meanings are controlled by the anchorage of the caption that accompanies any news photo. Along with retouching and cropping, and the contextualisation of layout, the accom-

panying caption or headline will indicate preferred readings of the image and effect a closure of meaning rather than open out possible readings. This set of preferred meanings is ideological in that they conform to the dominant ideas, apprehensions and beliefs in a given society at a specific moment in history. It is therefore necessary to examine what were the preferred meanings or connotations of the image as it entered the social domain – that is, the newspapers of 2 February 1968.

The *New York Times* printed the photograph across four columns under the headline 'STREET CLASHES GO ON IN VIETNAM, FOE STILL HOLDS PARTS OF CITIES: JOHNSON PLEDGES NEVER TO YIELD'. The caption underneath the picture reads 'GUERRILLA DIES: Brig. Gen. Nguyen Ngoc Loan, National police chief, executes man identified as Vietcong terrorist in Saigon. Man wore civilian dress and had a pistol.' The photograph is given a privileged position at the top of the front page, signifying its news value, though the story behind it appears on an inner page. The caption is terse and unadorned: 'GUERRILLA DIES', followed by identification of the event. The victim, unquestioningly identified as a Vietcong terrorist, had been found armed and dressed in civilian clothes, thus suggesting both guilt and deviousness. His right to due process is all but elided; his death is simple, tough, but by implication, just. This preferred reading is reinforced in several ways. The picture appears directly under the line 'JOHNSON PLEDGES NEVER TO YIELD'. The report of the President's statement is run, in a single column, under the left side of the photograph, which shows Loan in firm profile, traditionally an image of strength; the headline under Loan reads 'A RESOLUTE STAND'. Under the right side of the photograph, there is the reported statement by General Westmoreland, the US military commander in Vietnam. The story is printed under the figure of the shot Vietcong suspect and headed 'ENEMY TOLL SOARS'. Although these headlines do not relate explicitly to the picture, their close proximity contextualises the image in terms of 'resoluteness': the execution can be seen as part of Johnson's pledge never to yield, a resolute stand by Loan, adding to the soaring death toll of the enemy. The brutality of the image can be read as a tough but necessary measure at the height of an all-out offensive by the enemy and not simply as the 'brutality of war'. Any possible accusations of brutality are further balanced by the printing of another AP photograph in two columns below the Adams picture and between the 'resolute stand' and 'enemy toll' stories. It shows

a South Vietnamese Army officer carrying the body of a dead child, said to be his own. The caption reads, 'HIS FAMILY SLAIN BY VIETCONG: A South Vietnamese officer carries the body of one of his children from his home. Terrorists overran the base of his unit in Saigon, beheaded an officer and killed women and children.' · The assumed guilt of the Vietcong suspect is further compounded by the atrocity photograph and caption, supporting the implied vindication of Loan's action.

The London *Daily Mirror* also reproduced the photograph on its front page, but with an account of the event as part of its lead story. The headline reads, 'VIETNAM VENGEANCE: and 3 of the 1000 reasons why it happened in Saigon yesterday'. The text dramatically tells the story of the 'cold-blooded' killing. Describing it as 'vengeance', it links the execution to a picture, printed to the left of and below the Adams photograph, of the bodies of a South Vietnamese Army captain and his family who were killed during the Tet Offensive. The paper declares that these 'bodies were three of the 1000 reasons' why 'the normal rules of justice and decency were disregarded'. In this way, the execution is seen as cold-blooded, lying outside the 'normal rules of justice', but it is justified and legitimised within the context of the '1000 reasons' (people whose deaths are attributed to the Vietcong), three of which are shown. An extreme example of the vindication of the execution came from the 'hawkish'[16] *New York Daily News*. In a leader on 3 February it stated, 'There are a couple of facts we should bear in mind . . . about the picture: (A) the executed Vietcong was out to kill as many people on our side of this war as he could, (B) so are all his surviving pals.'[17]

Outside the contextualisation of layout, text and comment, and the attendant vindication of the execution as a necessary response to Vietcong atrocities, the photograph and captioned reports were isolated from the main body of the story of the Tet Offensive. For example, in the same edition of the *New York Times* that printed the picture on the front page, it was reproduced also on p. 12, together with two other Adams photographs of the incident (before and after) and fuller captions. The sequence of photographs sets the execution within the context of the unexpected sequence of events. The caption headings reads (1) 'PRISONER', (2) 'EXECUTION', (3) 'DEATH'. The rest of p. 12 ran stories on the political and military responses of the Offensive. However, the execution is not mentioned in the main text and therefore appears as an isolated

incident removed from the 'big story' of Tet. The point I want to make here is that the photograph does not illustrate the text; the picture is not a photographic record of a key political or military event but an event in itself. The importance of the photograph is that the combination of the execution, the presence of the photographer and the recording of the precise moment of the bullet's impact produces, within the general news currency of Tet, an 'extraordinary' picture that was 'news value'.

The preferred meanings implied by the original use of the picture appear to be twofold. First, the photograph records an unexpected and isolated incident, and it is newsworthy because it depicts the moment of impact of the bullet as one man shoots another. As *Time* magazine, in its caption published with the photograph on 9 February, stated, it was 'a picture that will go into the history books'.[18] Secondly, the brutality of Loan's action is justified by this conviction that the prisoner was a Vietcong terrorist and thus implicated in the atrocities committed by the Vietcong. Furthermore, his action is an example of the resolute stand needed to defeat this major and yet unresolved attack by the enemy. Many newspapers, including the *New York Times*, and in London the *Daily Mirror*, *The Times* and the *Guardian*, ended their reports of the execution with a quote from General Loan. He was widely reported to have said after killing the prisoner, 'They killed many Americans and many of my people.' This statement effects an explanation, and a defence, of his action.

The Tet Offensive, although considered to be a military defeat for the Vietcong and North Vietnamese, is often represented as a major propaganda coup for the nationalist forces and a critical turning-point in Western public attitudes towards the war. The effect of the photograph has also been cited in this context. Eddie Adams has recently described the effect of his photograph as 'very detrimental – perfect propaganda for North Vietnam'.[19] This point, I think, is overstated. However, it does raise the question of the effect of the image. Was it 'detrimental'? Did it affect public opinion? Did it, as Harold Evans has stated, capture 'the instant when Western opinion about the Vietnam war shifts fundamentally'?[20] On the evidence suggested by the original publication of the photograph, the impact it might have had was contained and defused within the ideological framework of preferred meanings, cited above. Furthermore, its publication was not explicitly intended to show the aimless horror of the war.

Rather, as Peter Braestrup has suggested, the editorial decision to feature the photograph involved little or no ideology:

> In most places, one may assume, the decision to feature the Loan story stemmed simply from the oldest journalistic instincts: not every day do newspapers get a close-up picture of one man shooting another at 'the instant the bullet slammed into the victim's head, his features in a grimace' as the AP log noted.[21]

The effect of the image on public opinion is a complex matter and not as instantaneous as Evans suggests. The photograph was taken during the Tet Offensive, a period of intense journalistic coverage of Vietnam. Its possible effect on public attitudes cannot be removed from that context. Daniel Hallin, in his book *The Uncensored War*, states that Tet's impact on public opinion was 'more complex and less dramatic – though certainly not insignificant – than generally supposed'. Furthermore, 'the initial public response to Tet itself was to rally to the war effort: the number of people calling themselves hawks, for example, jumped from 56% to 61% in the immediate aftermath of the Tet attacks'.[22]

For those opposed to the war, the photograph might have provided further evidence of its violent and oppressive nature, fuelling doubts about America's involvement. For example, Robert Kennedy in a speech on 8 February stated,

> Nor does it serve the interests of America to fight this war as if moral standards could be subordinated to immediate necessities. Last week a Vietcong suspect was turned over to the Chief of the Vietnamese security services, who executed him on the spot – a flat violation of the Geneva Convention on the Rules of War.
>
> The photograph of the execution was on the front pages all around the world – leading our best and oldest friends to ask, more in sorrow than in anger, what has happened to America?[23]

Here Kennedy mobilises the image to question America's support for the South Vietnamese government in moral terms. The violation of the rules of war is not America's immorality but that of its ally. Kennedy suggests that it does not serve American interests to be associated – in sorrow – with the 'immediate necessities' of the execution. The wider question of the morality of America's military

intervention in the affairs of another state is simply not addressed, and seems not to have been provoked by the photograph. A more bitter and satirical use of the image was articulated by Ralph Steadman in his drawing *And Another 45,000 of this Baby Here*, in which a Pentagon general places an order for the gun used in the execution with an arms salesman. The general points to the Adams photograph, which is placed on a rising sales chart. Steadman utilises the photograph to satirise the immorality of the military–industrial connection. What I want to suggest here is that the photograph is not in itself, as has often been suggested, an explicit 'anti-war' image, but was mobilised to articulate a wide range of political, moral and ideological positions. Hawks and doves alike used the photograph as a platform for their own opinions about the war.

Following the immediate clamour of the 'scoop', the photograph was reprinted in the *New York Times* of 6 May 1969 on the occasion of the announcement of that year's Pulitzer Prize winners. Edward T. Adams won the prize for spot news photography. The photograph appears at the bottom of p. 34, following a biographical sketch of Adams at the top of column one. The picture is no longer front-page news and the specific circumstances of the execution are all but forgotten. In this context, the photograph emerges as a thing-in-itself, a 'memorable' image, a 'great' news photograph. The Pulitzer Prize, and the many awards subsequently won by Adams, guaranteed the image a place in the histories of news photography. In such histories the image can be attributed the unproblematic power of changing history or, as Evans states in his collection of twenty-five years of news photography, *Eyewitness*,[24] of changing in an instant the public perception of the war. In this way, while the image enters the domain of history, its effect is exaggerated and dehistoricised.

Other post-Tet reproductions of the Adams photograph are more problematic. Later in 1969, *Life* magazine used the photograph in its end-of-decade review, in an article entitled 'Martyrs and Murderers'.[25] Under the heading 'Two Images of Horror Evoked the Torment of Vietnam and Pierced the Conscience of America', it displayed the Adams photograph beside a larger photograph of the self-immolation of Quang Duc, taken in 1963 by Malcolm Browne, also of AP. While the wider implications of the image were contained during the reporting of Tet, which did not radically shift public opinion against the war, a gradual change did take

place later. Of the post-Tet period Daniel Hallin states,

> Winning . . . was no longer what counted. When Lyndon
> Johnson was preparing his March 31, 1968, address on the war,
> aides persuaded him to change the opening line from 'I want to
> talk to you of the war in Vietnam' to 'I want to talk to you of
> peace in Vietnam.' And from that point forward, the message
> Americans heard was . . . 'we are on our way out of Vietnam'.[26]

Unfortunately, for the next five years someone forgot to tell the
Vietnamese. The point here is that, as the ideological perception
of the war altered in the post-Tet period, the photograph came to
connote 'the torment of Vietnam' in the editorial eyes of a magazine
that had been 'the most consistent and enthusiastic supporter of
the war'.[27]

As the historical distance from the war grows, so do the number
of statements about the photograph and the range of contexts in
which it is reproduced (this one included). Recently Vietnam has
been the subject of much historical debate between the Left and
the Right of the historiographical divide. Eddie Adams has made
statements about his picture which, seen in the light of the current
debate, raise questions that have to be asked even if they remain
unanswered. In a collection of interviews published in 1985 Adams
stated,

> when I sent the film in, I didn't even say that it should be
> processed. I said, 'I think I've got some guy from the police
> shooting some Vietcong.' . . .
>
> I didn't know until a couple of days later when I started getting
> these playback reports from all over the world. The photo was
> all over the front pages.[28]

Adams' statement would appear to be at odds with Don Oberdor-
fer's account of the breaking of the story in his book *Tet*, which
claims that when the film was processed at the AP bureau in
Saigon it caused 'jubilation'.[29] Ted Welch, in his paper 'Forward
to the Past',[30] has pointed to further inconsistencies in Adams'
statements about the photograph. Adams, in a *Newsweek* interview
in 1985,[31] said that he had found that the man executed had killed
Loan's best friend, a police major, and his family. Welch finds this
coincidence difficult to believe and asks why, if it were true, Loan

did not divulge the information at the time, given the public attention to the execution. No documentary evidence exists to support Adams' claim, but many newspapers printed an 'atrocities-on-both-sides' balancing story. Adams further stated that as the prisoner fell to the ground 'I didn't photograph it. I just walked away.'[32] Welch points out that Adams took a whole sequence of photographs of the execution, including its aftermath, so the statement cannot be true. It is difficult to suggest why Adams should make such statements. Perhaps he has remembered 'with advantages, what feats he did that day'.[33] Or perhaps, as Welch has suggested, the nub of the matter is that Adams is now 'working within a very different political context, one in which patriotism is again in fashion and in which Reagan can claim that as far as the Vietnam War is concerned "ours was a noble cause"'.[34]

I have sought to show in this essay that the Adams photograph does not show explicitly or timelessly the 'horror of war', and that there is no evidence that it directly changed peoples' perceptions of Vietnam. On the contrary, the photograph was subject to a limited and limiting range of preferred meanings within existing ideological constructs of Vietnam, and its meanings change as the dominant meanings of the war change over time. Tim Page has recently suggested that the Adams picture was one of the 'photographs that changed the course of history';[35] perhaps it is more accurate to say that the course of history changes photographs.

NOTES

1. S. Hall, 'The Determination of Newsphotographs', *Cultural Studies*, 3 (Autumn 1972) 53–88.
2. Ibid., p. 54.
3. The position of the trigger finger and the grimace of the victim.
4. Hall, in *Cultural Studies*, 3, p. 58.
5. *Time*, 9 Feb 1968, p. 24.
6. H. Evans, Introduction to *Pictures on a Page* (London: Heinemann, 1978).
7. J. C. Pratt, *Vietnam Voices* (New York: Viking Penguin, 1984) p. 129.
8. Ibid., p. 373.
9. P. Knightley, *The First Casualty* (London: Quartet, 1975) p. 366.
10. P. Braestrup, *Big Story* (New Haven, Conn. and London: Yale University Press, 1978) p. 348.

11. E. Adams, 'The Tet Photo', in A. Santoli (ed.), *To Bear any Burden* (London, 1985) p. 183.

12. Braestrup, *Big Story*, p. 30.

13. D. Oberdorfer, *Tet* (Garden City, N.Y.: Doubleday, 1971) p. 166.

14. Evans, *Pictures on a Page*, p. 5.

15. Hall, in *Cultural Studies*, 3, p. 58.

16. Braestrup, *Big Story*, p. 348.

17. Quoted ibid., p. 575.

18. *Time*, 9 Feb 1968, p. 24.

19. Adams, in Santoli, *To Bear any Burden*, p. 185.

20. H. Evans, *Eyewitness* (London: Quiller, 1981) p. 62.

21. Braestrup, *Big Story*, p. 348.

22. D. C. Hallin, *'The Uncensored War': The Media and Vietnam* (New York: Oxford University Press, 1986) p. 168.

23. Robert Kennedy, speech to Chicago Book and Author luncheon, 8 Feb 1968, quoted in Braestrup, *Big Story*, p. 484.

24. See note 20.

25. *Life*, 22 Dec 1969, pp. 71–6.

26. Hallin, *'The Uncensored War'*, p. 178.

27. Oberdorfer, *Tet*.

28. Adams, in Santoli, *To Bear any Burden*, p. 184.

29. Oberdorfer, *Tet*, p. 166.

30. T. Welch, 'Forward to the Past', paper presented at the European Society for the History of Photography conference, National Museum of Photography, Film and Television, Bradford, 1985, pp. 18–20.

31. *Newsweek*, 15 Apr 1985, p. 37.

32. Ibid.

33. Shakespeare, *Henry V*, iv.iii.50–1.

34. Welch, 'Forward to the Past', p. 20.

35. T. Page, 'Reliving the Fight to Tell the Vietnam War Story', *Independent* (London), 25 Nov 1986.

13

Rambo: American Adam, Anarchist and Archetypal Frontier Hero

ADI WIMMER

Rambo: First Blood II was launched simultaneously in more than 2000 movie theatres across North America on 22 May 1985, grossing $100 million in its first ten weeks alone. It has since become the most lucrative movie in the history of the cinema, making its star Sylvester Stallone the best-paid Hollywood actor. His fee for *Rocky IV*, which was next in line after *Rambo II*, was $12 million. After a very successful run in North America, the film was launched in Europe, Africa and Asia, playing to packed audiences everywhere. Even the Peking *People's Daily* wrote of an 'outstanding artistic achievement' in its review, and praised its 'social and cultural relevance'. The film was reportedly particularly successful in Beirut and other Arab capitals, which is painfully ironical, considering that President Reagan, by his own account, was inspired by *Rambo* to use tougher methods with certain 'mad dogs of the Middle East'. (Stallone showed his greatfulness for this seal of presidential approval by having a shot inserted in his 1986 movie *Cobra* that shows him, as a private investigator, sitting in his office flanked by a huge portrait of Reagan on the wall.) In Austria, my own country, the Centre for Empirical Social Studies was alarmed to find that by November 1985 Rambo had become the most popular cultural role model in the ten to sixteen years age group, toppling ex-chancellor Bruno Kreisky and racing driver Niki Lauda in the popularity charts.

Undoubtedly the film's success was no mere episode. Nor does it suffice to withdraw into an attitude of righteous indignation and condemnation. Yet, its protagonist is an unappetising character and, yes, the film is a stimulus to violence and nastiness. All that and more was said by American reviewers, whose reactions ranged from ironic scepticism to downright hostility. But that did not prevent the masses from queueing for tickets. We therefore have

to look for alternative critical responses in order to break out of a tautological critical 'discourse' that classifies a 'reactionary film [as] reactionary, militarist, macho, and racist'.[1] The more so, since *Rambo* has left his imprint on the contemporary *Zeitgeist* in, so it seems, the whole Western world. You can now send a 'Rambogram' in most states of the United States, and in Houston you can visit a bar named 'Rambose'. Ruby-Spears Enterprises Inc. of Los Angeles have produced sixty-five half-hour shows of a *Rambo* series, which began to be aired by various independent television stations in autumn 1986; Rambo's adventures in this series include fighting the Commies in Nicaragua.[2] Various other spin-offs include an 'interactive fiction text adventure', a computer game produced by Mindscape Software of Northbrook, Illinois.[3] In political science, the term 'Rambo politics' has become synonymous with an aggressive style in handling foreign affairs. In the area of psychology, 'Ramboism' denotes the revival of macho myths and the growing tendency to resort to physical violence in conflict situations. This has, sadly, also come to the attention of criminologists: in the second half of 1985 both America and Europe experienced a wave of violent crimes, the arrested perpetrators of which were found to be admirers and emulators of Johnny Rambo. (On the day that the Manchester Polytechnic conference began, the *Daily Mirror* reported on a triple murder, running the front-page headline 'DEADLIER THAN RAMBO'.) And finally, the name has also produced a neologism in economics. In May 1986 Brazil lodged a protest with the US State Department against the threat of reduced import quotas following Brazil's refusal to lift its protective policies concerning computers. Such proposed action, the leading Brazilian business journal was quoted as saying, was tantamount to 'Rambonomics'.[4]

The release of *Rambo II* was well timed: two weeks after the media attention surrounding the tenth anniversary of the fall of Saigon had peaked. It has been well established that something akin to collective memory repression descended on America following the end of the war in 1975. But it was not just the memory of an unpalatable war that was repressed: it was also the will to accommodate the justified needs of Vietnam veterans. For a whole decade, the veterans of that war were something like a leprous ethnic minority. They were socio-political orphans in a society that was at best indifferent to their various war-related problems, and at worst denounced them wholesale as drug addicts, psychotics

and baby-killers. But, as veteran after veteran was permitted to speak out in prime-time television interviews, the erstwhile image of a killer generation vanished and that of quietly suffering heroes emerged. 'Veneration of the veteran is [now] the lowest common denominator in the cultural equation', argues Samuel G. Freedman;[5] 'it has become the point of consensus for Americans – and artists – who widely disagree on almost anything else concerning the Vietnam War.' Not surprisingly, the emphasis in such interviews was on the success stories rather than the losers and their unresolved conflicts. The high point was reached when two war-veteran senators, John Kerry (Massachusetts, Democrat) and John McCain (Arizona, Republican) were given the place of honour in the Public Broadcasting Service McNeill–Lehrer news hour on 30 April 1985. Other veterans often pointed out that they had not been the ones to lose the war, having won every single major engagement, including Tet. The South Vietnamese were to blame perhaps, and maybe American politicians, and the American media almost certainly – but not the soldiers who returned and rebuilt their lives in an ungrateful America. Naturally such complaints implied that America had a heavy debt to the veteran, and had to make up for years of neglect. These claims had been given added momentum by the television series *The A-Team* and *Magnum, P. I.*, depicting Vietnam veterans as valiant fighters for law and order and fully integrated members of their society; they had even benefited from their war experience. Moreover, established detective heroes such as Mike Hammer and Matt Houston casually revealed their past as Vietnam veterans in early 1985, something that would have been unthinkable a few years earlier.

Rambo II cleverly exploits collective guilt feelings: the opening shot shows our hero imprisoned and slaving away in a quarry (a visual quote from the 1961 film epic *Spartacus*). When his former Special Forces commander Trautman suggests a secret mission in Vietnam to him, Rambo mutters, 'Do we get to win this time?', thus suggesting that America had let him down the first time; and, when he is questioned by the stunningly beautiful girl agent Co how he 'got into this', the following dialogue ensues:

RAMBO. Well, after I left the army I moved around a lot . . .
CO. Why you leave army?
RAMBO. I, er, came back to the States and found there was another war going on.

co. What war?

RAMBO. Kind of, like, a quiet war. A war against the soldiers returning. That's the kind of war you can't win. That's my problem.

A little later on he describes himself as 'expendable' and in response to Co's request for clarification mumbles, 'This is like when someone you . . . invites you to a party . . . and you don't show up.' His defiant definition speaks of a painful alienation from American society, one that can also be found in many literary works by veterans.[6]

Not only has this society failed to lend a sympathetic ear to Vietnam veterans, it has also failed – so the film insinuates – to do something about those soldiers supposedly still detained as prisoners of war in Indo-China. There is a powerful lobby in the United States that keeps exerting pressure upon the administration to investigate the existence of such POWs and the survival of men listed 'MIA' (missing in action): Charlton Heston is one of its most prominent spokesmen; Gloria Vanderbilt seems to lend financial support.[7] The government, however, pursues a double strategy on the matter. On the one hand, the Pentagon has decided that there is no hard and fast evidence of the existence of POWs in Indo-China, which has enabled it to get rid of the maintenance-pay problem. On the other, President Reagan is kindly disposed towards the lobby, exploiting it for his 'Empire of Evil' hypothesis. This, along with the fact that *Rambo II* is not the first movie on the subject of a search-and-rescue operation in Indo-China (witness *Uncommon Valor*, 1983; *Missing in Action*, 1984; and *Missing in Action II*, 1985) has helped to prepare the ground for uncritical acceptance of the claim that dozens or maybe hundreds of American soldiers are still 'rotting away' inside Vietnam or Laos.

Important as this historical context is, certain timeless elements of the film merit even closer attention. When Trautman asks Rambo at the very end how he is going to live now, the answer is, 'day by day' – i.e. in a timeless, unstructured fashion. It seems only natural, therefore, to receive no historical clues on the Vietnam War anywhere in the film. On the contrary, it supplies us with images that point to a completely different war. The Vietnamese guards wear uniforms and tropical helmets that give them a typical Japanese look, and their Russian commanders have blue eyes, blondish-grey hair, and talk with a distinctly German accent. Such

iconography evokes the familiar ideological constellation of Second World War movies, and superficially puts Rambo in the heroic tradition of John Wayne or Audie Murphy. Rambo's Vietnamese enemies even display certain typical Japanese vices (as they were 'portrayed' in war movies), such as lechery and unmanly subservience to their (Russian) commanders.

In contrast, Rambo resembles Second World War heroes in his boyish asexuality. Almost immediately after his parachute drop into the jungle, where this American Adam feels totally at home, he tames that symbol of original sin, a snake trying to creep up on him from behind. And within another minute he is equally successful with a metaphorical snake, as he grabs and all but knifes the woman who is supposed to help him on his mission. The equation 'woman equals sex equals evil' is fully functional in a later scene too. After Rambo's capture, Co hires herself out as a prostitute to his tormentors, thereby manoeuvring herself into a position where she can help Rambo to escape. This will save his life, but nevertheless the hand of God punishes her for a wicked, because sexual, act. Seconds after she has made Rambo promise to take her with him to America, she is ambushed and shot. For this scene she is suitably dressed in a red robe; all that is missing is the embroidered 'A' on her breast. Her death rids Rambo of the embarrassment of teaming up with a woman, a racially 'inferior' one to boot. Moreover, it allows him to militarise his grief. After burying Co, he takes grim revenge on his pursuers, killing (in the best fascist tradition) dozens of them in retaliation for one casualty.

Rambo's puritanism is underlined by his almost messianic ability to endure pain. His captors dunk him into a cesspool, beat him and subject him to electric shocks, but he never shows the slightest sign of weakness. His countenance is forever set in a reproachful, sad expression, suggesting a certain masochistic pleasure. Here his character intersects with that of his twin brother Rocky, another proponent of stoic suffering combined with physical prowess. While millions of joggers and fitness freaks can only dream their wet dreams of utter muscularity, Rocky and Rambo practise indestructibility, and this makes them idols of narcissistic desires.

Rambo, when pulled from his cesspool, resembles the crucified Jesus: once more the film operates with an iconography of time-lessness. Moreover, when he rescues one of the POWs in the early stages of his mission, he does so by cutting him free from a cross. In an active as well as in a passive sense, Rambo is a redemptive

figure. He takes the sins of the fatherland upon him (like Jesus, through suffering on the cross), and then redeems America by searching out and destroying even greater sins and sinners. As Richard Slotkin would have it, Rambo regenerates through violence.[8] At the same time as he releases a dozen POWs he also releases American society from the burden of understanding the historical, political and moral implications of Vietnam – first by passing the awkward details of that war into an Orwellian memory hole, then by implying that there has been enough purgatory in the shape of POWs still detained in Indo-China. His persistent silence on anything that might historically structure the now-forgotten war for a contemporary audience suggests that this condition is caused 'by the war experience itself, not [by] a social effect of postwar conditions'.[9] Our hero thus erases and rewrites history along those traditional lines which are part of what Lloyd B. Lewis called a 'commonly shared belief system'.[10] We can witness such an act of erasure when Rambo is pursued by a Vietnamese soldier, who, after an agonisingly long aim-taking, gets 'erased' by Rambo's dynamite arrow. In another scene, when he buries Co, we get the sense of a purging from guilt through a combination of metaphorically cleansing rain, elegiac background music, and Rambo's visible suffering.

In Rambo we also find the revival of American cultural arche-types. The noble (Red Indian) savage is one, the anti-authoritarian rebel another. The latter is manifest in the almost arrogant ease with which Rambo evades or destroys his Vietnamese foes. Viewers quickly realise that these are simply no match for this 'perfect fighting machine'. So, if there is no danger emanating from them, where is the tension, the thrill? The tension arises from a much more serious conflict, that between Rambo and Murdock, the unappetising CIA officer. When Rambo first arrives at the CIA base in Thailand, Murdock instantly leads him through a whole array of bleeping computers and other technological hardware. He can feel quite safe on his mission, so he assures Rambo, since the command post is equipped with the most sophisticated electronic surveillance devices with which to back up his assignment. 'I thought the best weapon was the mind', retorts a sulking Rambo. 'Well, times change' is Murdock's view, one that Rambo finds odiously 'modern'. Murdock is thus portrayed as a representative of a degenerate, over-technocratic and over-bureaucratic segment of American society. The outward appearances of Murdock and

Rambo consequently stand in stark contrast with each other. Rambo never wears a uniform and for most of the film not even a shirt. He is the untamed American Adam, reminiscent of Tarzan. Murdock, who should also be wearing a uniform, digresses in the opposite direction: he struts around in a white shirt and tie, sipping coke from a can. He is – as Trautman charges – 'a stinking bureaucrat who's trying to cover his ass'.

Murdock embodies inactivity and voyeurism as he plays around with his bleeping, flashing computers. Accordingly, he demands of Rambo that he only take pictures of the POW camp, expressly forbidding him to engage the enemy. Significantly, while Murdock nervously scurries about amidst his electronic gadgetry, we observe Rambo sitting alone in a quiet corner of the camp, sharpening his combat knife. When Rambo unfortunately does find POWs, taking one along to the rendezvous point, Murdock orders the helicopter already hovering overhead to abort the mission. Rambo's prophecy is fulfilled: he really is 'expendable' to the likes of Murdock, who – and this is clearly an important message of the film – have a history of stabbing American soldiers in the back. Later on Rambo is forced to make radio contact with the base. Instead of transmitting his Russian captors' message, he addresses Murdock: 'I'll come and get *you.*' It is this unveiled threat that provides the real tension in what is yet to come.

In fighting his way out of Vietnam, Rambo relies on the tactics and weaponry of the original Americans, the Red Indians. His combat knife, prominently displayed in a number of scenes (would it really flash so visibly on an actual mission?) and his steel bow are infinitely more deadly than the automatic weapons of his foes. Again Rambo turns history upside-down: in the real Vietnam War, it was the Americans who relied on their superior firepower, while the Vietcong fought with more primitive weapons and had greater tactical skills. By this inversion the film implies that the way the war was waged was not the proper one. Consequently, when Rambo returns to Murdock's base, he will first of all shoot his computer laboratory to pieces. Having done that, he triumphantly erects his machine gun and lets out an orgasmic Tarzan yell. The technological snake has been successfully banished from his Asian paradise.

This orgy of destruction is Rambo's symbolic revenge on high technology, which all but killed him at the beginning of his mission. When he jumped out of the uterine plane that took him over his

operations area, his parachute became entangled in the door of
the jet, dragging him through mid-air by an unwanted umbilical
cord. Murdock's immediate response on learning of the technical
hitch, back at base, was to 'abort the mission'. 'But he'd be torn
apart', objected the pilot. Both sentences seem to hint at obstetrics.
But it is Rambo himself who facilitated his 'birth': unsheathing his
combat knife, he first discarded all the technical gear with which
Murdock had weighed him down, and finally cut himself loose.
With this symbolical severing he also cut himself free from the
excesses of an over-sophisticated America.

It seems legitimate to point to the very similar psychogram of
Rambo's twin brother Rocky. In *Rocky IV* the American champion
meets his Soviet counterpart in a kind of ersatz superpower war.
Long sequences of the film are devoted to the two fighters'
preparation for the bout. The Soviet champion never leaves his
urban environment and practises in a fitness chamber studded
with all sorts of evil-looking muscle developers plus an array of
computers that assess each and every exercise. Rocky, however,
opts for the lonely Russian countryside, where he helps a Russian
farmer and pushes himself to the limits of his endurance when he
pulls, husky-style, a sledge full of firewood. His training is thus
as authentic and archaic as his opponent's is alienated.

Rambo's individualism has a long and venerable tradition in
America's mythic historic landscape. The Lone Ranger is part of
that landscape, as are all the original frontier heroes who won the
Wild West. In the frontier pioneer we find the ability to survive
in an untamed American wilderness, and to do so without the
dubious paraphernalia of a European society. Rambo demonstrates
the ability of a new frontier hero to survive in an untamed Asian
wilderness without the trappings of a decadent American society.
It seems no coincidence that American travellers to Vietnam such
as Mary McCarthy and Susan Sontag remarked that Vietnam was
'the America that no longer exists',[11] and that as such it deserved to
be idealised. In 1971 a British film called *Chato's Land*[12] demonstrated
how one Red Indian who was totally adapted to his environment
could wipe out a squad of heavily armed white intruders. Like its
predecessor *Soldier Blue*, the film was an allegory of mismatched
American behaviour. Fifteen years later *Rambo II* picked up this
modernist trope again, but turned it upside-down: it is the Amer-
ican who is totally adapted to the Asian environment, and he
wipes out dozens of non-adapted Vietnamese and Russians. He

draws strength from a mythical immersion in the jungle foliage, in the water, even the soil of Vietnam.

If Rambo has been called a typical American patriot, then this is only partly true. In his mythical primitivism he is certainly not the sort of patriot to approve of the Strategic Defence Initiative. Nor is he an heir of John Wayne patriotism. The American Second World War hero was part of a collectivist tradition which needed uniforms and military rituals. Its most potent symbol was the American flag, as is evidenced by the single most memorable image of the Pacific war, the raising of the flag on Iwo Jima. In the final scene of such patriotic films the stars-and-stripes banner is either raised on a flagpole, spread over a coffin, or dissolved into the final shot. In striking contrast, Rambo touches no flag, gets rid of his Army fatigues as fast as he can, and scorns a return into the fold of the Special Forces. Moreover, he all but kills Murdock. This emphasis on individual as opposed to collective achievement neatly fits the prevailing *Zeitgeist* of the Reagan years. Rambo is part of the 'Me-decade', as sociologists have called it. He is a jungle yuppie with no respect for the rules of the game. The resurgence of a Calvinist ethic has already led to the crumbling of certain traditional moral values. It is surely no coincidence that Reagan is the first American president with a first lady from a second marriage. In March 1986 Patty Reagan published a thinly disguised autobiographical novel with the title *Home Front*, in which her parents are portrayed as scheming, ambitious, unscrupulous and cold-hearted. Father Ronald was unruffled. 'I hope she makes a lot of money out of it', he joked with reporters.

If Rambo does not conform with the cynical behaviour displayed by the President's daughter, this might be attributed to post-modernist script-writing. Clearly, a coherent characterisation would be the mark of an epigoneous artist. Only the incoherent and baffling is of interest these days. A characterisation along coherent lines would demand of Rambo that he 'wise up', reject all traditional notions of honour, glory and patriotism, and make a fast million by selling his dirty story to the *New York Times*. This would be unadulterated *verismo*. However, Rambo is incapable of such crass selfishness. In his reply to Trautman's bait, 'you mustn't hate your country, Johnny', the virtuous frontier hero comes to the fore again. 'Hate? I'd die for it', he fumes, and 'I want for our country to love us the same way that we love it.' His call for love (and doesn't Rocky also call for love and understanding amongst

nations at the end of *Rocky IV*?) plus his hippie appearance suggest to Russell Berman that 'Rambo is the heir to the iconography of the hippies, the counter-culture turned into a contra.'[13]

Certainly there are some external similarities to a sixties protester: Rambo wears his hair rather long and tames it with a sweatband, and on his bare chest sports an oriental charm. Moreover, his mental attitude resembles that of the protest generation. He rejects public authority. He dislikes fat-assed bureaucrats, arrogant policemen and untrustworthy secret-service agents. By implication, he is against the 'establishment', against politicians, media-makers and idle intellectuals, who lost their nerve after the Tet Offensive, and then the war. The hippie culture is lying in ruins, and anyone can come along and pick up some outlaw shreds of that culture. 'No more orders', Rambo mutters to Co when she reminds him that to enter the POW camp would be in violation of Murdock's scheme. This anarchist will never fit into a military unit again, let alone corporate America. Like Colonel Kurtz in *Apocalypse Now*, he has made the decision 'to go for himself', which means to go it alone. It does not matter that in our time this can only be the mentality of a born loser: we would like to believe that a success story can be shaped from such premises. And supporting evidence seems to be there in the shape of the very movie stars who are the vehicles for such films as *Rambo*: Stallone, son of Sicilian immigrants (in the film he is half German, half Red Indian), becomes the most highly paid actor in history; Charles Bronson, son of Red Indian parents, is still going strong in Hollywood with his new movies *Murphy's Law* and *Death Wish III*; and Arnold Schwarzenegger, a first-generation Austrian immigrant from the Styrian forests, actually marries into the East Coast aristocracy of the Kennedy clan. Come back, Willy Loman: the American dream is alive and well in Reagan's new America!

Even Trautman contributes a few lines that reveal certain sympathies with the protest generation. 'The War and all this here may have been wrong', he claims. In a heated exchange with Murdock earlier in the film he mentions Nixon's unofficial pledge to pay 'four and a half billion dollars in war reparations', adding, 'We reneged.' If we accept the hypothesis that Trautman is Rambo's spiritual father, then we can deduce from such asides that the film is not attempting to restore America's mauled self-perception of a chosen people that can do no wrong – certain revisionary tendencies as regards military aspects of the war notwithstanding. There are

194 *Vietnam Images: War and Representation*

many such seemingly contradictory strands in the film. This eclecticism, however, appears to be the strength of *Rambo II* rather than a dramaturgical flaw. Its success rests on a multiplicity of cultural circumstances, and not just on its aesthetic of violence that offers even the reluctant viewer fragments of an inaccessible experience. For me, the epiphanic scene comes right at the end, when Rambo pulverises Murdock's computer laboratory and thereby reveals himself as an exponent of traditional frontier values. However, an unmistakable contradiction suggests itself in that scene. Rambo destroys computers as symbols of modern alienation. But one cannot help feeling that the way this American Frankenstein was put together, a character that was obviously intended to be acceptable to the largest number of people to the highest degree possible, relied on the help of computers in assessing the importance of current popularity profiles.

NOTES

1. R. A. Berman, 'Rambo: From Counter-Culture to Contra', *Telos*, 64 (Summer 1985) 143–7.
2. According to a newsletter sent out by the War Resisters' League, summer 1986.
3. H. W. Haines, 'The Pride is Back: A Comparative Analysis of *Rambo* and Episodes from *Magnum, P. I.*', paper presented at the Cultural Legacy of Vietnam Conference, Rutgers University, NJ, 25 Apr 1986.
4. 'A North–South Slugfest', *Newsweek*, 2 June 1986, p. 47.
5. S. G. Freedman, 'The War and the Arts', *New York Times Magazine*, 31 Mar 1986, pp. 50–7.
6. Examples too numerous to be quoted individually can be found in the veterans' poetry anthology *Demilitarized Zones*, ed. J. Barry and W. D. Ehrhart (Perkasie, Penn.: East River, 1975).
7. The facts behind the MIA–POW debate are convincingly presented by J. A. Rosenthal in 'The Myth of the Lost POWs', *New Republic*, no. 3676 (1 July 1985) 15–19.
8. R. Slotkin, *Regeneration through Violence: The Mythology of the American Frontier, 1600–1830* (Middletown, Conn.: Wesleyan University Press, 1973).
9. Haines, 'The Pride is Back'.
10. L. B. Lewis, *The Tainted War: Culture and Identity in Vietnam War Narratives* (Westport, Conn.: Greenwood Press, 1985).
11. J. Hellmann, *American Myth and the Legacy of Vietnam* (New York: Columbia University Press, 1986) p. 85.

12. Directed by Michael Winner, starring Charles Bronson. *Soldier Blue* (1969) was directed by Ralph Nelson and starred Candice Bergen.
13. Bermann, in *Telos*, 64, p. 146.

14

Eros and Thanatos: An Analysis of the Vietnam Memorial

JOHN D. BEE

The Vietnam Memorial, consisting of a wall and the group statue, has been completed with remarkable speed. Veteran Jan Scruggs formed the Vietnam Veterans Memorial Fund in May 1979. The Maya Lin wall (**plate 33**) was dedicated in November 1982 and the Frederick Hart statue (**plate 34**) was dedicated on 11 November 1984, as an official addition to Lin's work. Since it was built the memorial has attracted millions of visitors – veterans, their relatives and others – who have taken the occasion to contemplate America's Vietnam experience and by so doing have shown the importance of monuments and memorials as public symbols.

Kenneth Burke observes that marking important events with symbols and observances is a characteristically human behaviour. Speaking of our ritual use of symbols, he says, 'we are all myth-men in the general sense that any notable occasion is felt to call for some kind of symbolic analogue, a fervent saying of thanks, an impromptu jig or lament, and so on'.[1] When such circumstances arise, the need is felt for an appropriate symbolic statement. The symbols must be fitting for the situation, and Burke under-scores the artist's 'sense of congruity, or propriety' in creating the appropriate response. The symbolic statement should be appropriate to the material events.

Burke's comment underscores the interpretative, constitutive character of public symbols and rituals. When important events occur, we choose whether and how to mark them. Our use of an existing symbolic form or creation of a new symbolic form to mark those events reflects our collective assessment and interpretation of those events. Failure to provide an appropriate symbolic comple-ment leaves in doubt the meaning of the events. As Burke notes, 'If a certain song is deemed the "proper" accompaniment to an act of planting, one can readily understand why a myth-man's refusal

to sing that song or his inability to perform it correctly could be felt as a bad omen.'[2] Similarly, our understanding of the connection between a combat and our national values gives rise to expectations about the appropriate symbolic responses to events such as the Vietnam conflict.

More than simply rounding out or completing events, then, public symbols are complex rhetorical events. To create them, we notice a set of events, classify those events and make a set of judgements on how the events do or should fit with the social values and structures to which they pertain. Viewed in this light, a public symbol or monument is a rhetorical statement interpreting the connection between events and the social order. This is the perspective from which I propose to comment on the Vietnam Memorial.

Maya Lin's memorial design was selected from among 1421 competing entries. Though commonly described as a wall, the memorial actually consists of two intersecting walls, with both ends of the memorial starting at ground level and descending to a depth of about ten feet, where the walls meet. The walls are polished black granite, bearing the names of all the casualties listed chronologically in the order of their death. The two walls meet at an angle on lines pointing to the Lincoln and Washington monuments. There is a brief dedicatory statement before the first and after the last name. There is no flag.

When Maya Lin's design was exhibited, some believed it was too stark and unheroic. One dissenting voice was that of Tom Carhart, who appeared before the government committee and described Lin's piece as 'a degrading black ditch' and 'an open urinal'.[3] Carhart found an ally in the wealthy and eccentric H. Ross Perrot, who financed and organised a campaign to modify the design. Their efforts resulted in an agreement to make an addition to the memorial. Sculptor Frederick Hart designed and executed the piece, consisting of three soldiers – one black and two white – dressed in authentic Vietnam gear and situated by a grove of trees approximately seventy yards from the apex of the walls. Hart describes his contribution as follows: 'One senses the figures as passing by the tree line and caught by the presence of the wall, turning their gaze upon it almost as a vision . . . the contrast between the innocence of their youth and the weapons of war underscore the poignancy of their sacrifice.'[4]

If the Maya Lin and Frederick Hart memorials constitute an

interpretation of the Vietnam experience, it will be helpful to outline the core meanings of such events – meanings that inform our expectations for such a memorial and underscore the unique, unexpected message that now stands on the Mall.

The Vietnam Memorial is a public symbol intended to complete or round out the material events of an armed conflict. Implicit in conflicts is the assumption that they are efforts to establish or defend social principles and the accompanying political and social order. The memorial to a conflict, then, stands as an assessment of success or failure. But success or failure is reckoned as more than simply the preservation or loss of life. A battle acts out a wish or desire to defend or establish certain values, and the outcome may be stated in terms either of the fulfilment of the frustration of that wish. Having traced the origins and developments of the combat myth, Joseph Fontenrose finds the meaning reducible to two ideas. 'We may', he says, 'look upon the combat myth in all its forms as the conflict between Eros and Thanatos.'[5] Commenting on Fontenrose, Burke says, 'reduction [of the combat myth] to terms of Eros and Thanatos is in effect reduction to these three categories: purpose, fulfilment of purpose, frustration of purpose.'[6] We expect the combat memorial to interpret events in terms of the larger purpose, that of defending or establishing the national goals and values. The balance of this discussion presents the view that the memorial interprets our experience in Vietnam on the side of Thanatos: death and the frustration of purpose. Specifically, I shall suggest that it marks the human loss of life and the national frustration and loss of purpose in that effort.

The wall's funerary design immediately calls to mind the theme of death, Thanatos. Lin's entry in the contest was an assignment for a class of funerary design and she admits to an interest and fascination with death. 'We are supposedly the only creature that realizes its mortality. . . . We don't tell children about it. We say someone "went away, passed away." We can't admit it to ourselves. That's always disturbed me.'[7] Lin is quite clear that in her memorial she wished to impress on visitors the reality of the death of the 58,000 casualties.

These [American troops in Vietnam] died. You have to accept that fact before you can really truly recognize and remember them. I just wanted to be honest with people. I didn't want to make something that would just simply say, 'They've gone away

for a while.' I wanted something that would just simply say, 'They can never come back. They should be remembered.'[8]

For Lin, the inspiration for the memorial and the summary statement about the conflict is the fact of death.

The Frederick Hart addition was instigated by those who believed the memorial should look beyond the facts of death and pay tribute to the cause. Hart was to provide a more realistic, more heroic monument, with a flag and real soldiers. Hart's work met the material conditions, but Lin's thesis was powerful enough and Hart's artistic sensibilities strong enough to ensure that the addition became a complement to the walls, reinforcing the funerary, death motif. Hart's soldiers stand trance-like as permanent visitors to their own memorial, drawn into Lin's theme of death.

Of the wall's various features, visiting columnists and commentators remark the powerful effect of the names, in driving home the magnitude of personal loss in the conflict. The *Washington Post* commented, 'We are not sure where the idea came from that wars should be remembered through the representation of an unknown soldier. This memorial makes the soldiers known, and the effect is strong and clear, like the morning sunlight.'[9] Lin's list works the awareness of death into the visitor's sensibilities.

But, beyond asserting the fact of death, Lin wished to create an atmosphere for the visitor to contemplate and reflect on that stark reality. 'I wanted people to honestly accept that these people served and some of them died. And I think I wanted to create a very serene, tranquil place after I brought them to this sharp awareness.'[10] The face of the wall is a scene for personal rituals and liturgies. Touching, shielding, making rubbings of names, leaving letters and personal mementos – all these are common observances. To those without a relative or friend's name on the wall, the names prompt the personal reflection Lin intended. One commentator wrote, 'Gradually, the enormous extent of this register of death and loss made its impression, humbling the visitor; revealing to him his own frailty, his own vulnerability, his own mortality.'[11]

The millions of visitors to the wall and the experiences they report serve to validate Lin's focus on death and the theme of Thanatos as the central message of the Vietnam Memorial. But one still asks why visitors are so responsive to this theme for this conflict. Every conflict exacts a toll in lives, but other monuments

commemorate more than death. We find affirmations of heroism, patriotic sacrifice and victory for the cause as themes that go beyond the killing. For Lin's reading to be valid and appropriate, there must be something different or unique about the Vietnam conflict.

The question prompts us to consider the broader meaning of Eros and Thanatos in the combat myth. These terms refer not just to the individual's death or survival, but to the larger outcome. Battles are undertaken to establish or defend a cause. When the victory is won, Eros triumphs. When defeat comes, Thanatos remains. Combats are quests and contests between ideals and systems as well as people.

At this level, the events of Vietnam once again register on the side of Thanatos. Whatever the United States' goals in Vietnam may have been, they were not achieved. Pieces in the press commemorating the tenth anniversary of the fall of Saigon note that Vietnam was the first war the United States lost. Painting the departure of Marines from the embassy roof as a summarising event *Newsweek* commented, 'After 58,000 men had died, after billions of dollars had been squandered, America's crusade in Vietnam dwindled down to the rooftop rescue of a few Marines with a mob of abandoned allies howling at their heels.'[12]

The United States' failure to effect an orderly withdrawal from Vietnam is a synecdoche for the failure in its larger purpose. The larger failure remains vivid in the public mind, as reflected in the comments of a columnist for *Commonweal*: 'Vietnam is not a metaphor for arrogant national ambition, nor a key-word for misplaced national generosity, nor a code-name for national trauma. It is simply a name for loss.'[13] There is still considerable debate on why the United States lost. Whatever the reason, Vietnam became the first American defeat and this sad ending is expressed in the memorial.

Both the Maya Lin and Hart pieces lack the character of triumphant assertion that marks pieces as diverse in mood and character as the Washington Monument, the Lincoln Memorial and the Iwo Jima Memorial. All these proclaim the establishment or preservation of the national values. By contrast, the Lin memorial purposely excludes any such statement. It acknowledges that soldiers served and died. The Hart figures are standing beneath the American flag, but they and the flag are oriented towards the

wall. They are apprehensive. They are reflective. There is certainly no hint of triumph.

To the theme of loss in battle we may add the theme of internal conflict and dissent, the loss of purpose. There never was unanimous domestic support for the US involvement in Vietnam. The reasons for being in the war were murky, the objectives of staying in were often doubted, and the best policy to pursue was never clear either to hawks or to doves. Beyond national loss, the Vietnam conflict produced an element of self-doubt and internal dissent that caused many to question the fundamental validity of the cause. From the time US involvement increased, public support for it decreased. Gallup results show that the number of Americans believing that involvement in the war was a mistake went from some 24 per cent in 1964 to 64 per cent in 1975. As the conflict ended, two thirds of the public felt that involvement had been a mistake.[14]

As news of the war came home, Americans also came to doubt the conduct of US personnel. Images of napalmed civilians, burning villages, the My Lai massacre, drug addiction and other unpleasantnesses became part of America's consciousness. Concurrently, there was strong protest against the war at home. Student marches and demonstrations, the Kent State shootings, the Wisconsin Army Math Research Center bombing and other such events left the image of a deeply divided nation and an uncertain cause. There seemed to be no clarity of national purpose. The memorial reflects the national doubt in its omission of any symbolic statement to the contrary. One may agree that the memorial honours those who served in the war, but there is nothing to affirm or glorify the cause.

Veteran John J. Callahan offers the more typical opinion of the memorial shared by many. 'It's beautiful . . . It's a black scar in the ground – and Vietnam is a black scar on this country.'[15] A Second World War veteran who visited the memorial out of respect for the 'special courage' of Vietnam soldiers commented, 'I don't recognize any of the names on these lists . . . but I know we lost our way in Vietnam.'[16] Barren of the usual symbolic assertions of national purpose and effort, Lin'a piece is a memorial to a 'lost way'. Not only was the purpose frustrated; the purpose itself was a casualty of the effort. One of those who stayed home and protested writes,

my pilgrimage to the Vietnam Memorial may have been guilt-ridden after all. . . . How many of those slabs are there, I must ask myself, not because the home front failed to provide sufficient support but, rather, because that home front took too long to become aware of the essential injustice and immorality of the conflict.[17]

By contrast, the US Secretary of State told a State Department audience that Vietnam teaches Americans the consequences of losing faith in themselves and their cause, a mistake they must never make again.[18]

The Hart figures were intended to satisfy those who saw more clearly in Vietnam the effort on behalf of a noble cause. There was to be a flag. And there were to be realistic figures in Vietnam combat dress. The display was to affirm the legitimacy and heroism of men fighting under their nation's banner. But the poet's vision failed. The figures do not have the effect of a counter-statement ennobling the cause. Inspiration for the positioning and expression of the figures was decisively influenced by and responsive to the walls. Hart speaks of the poignancy of the soldier's sacrifice, but not of the clarity or rectitude of their cause.

The putative conflict set up by the two memorials stands as further evidence of the unclear, uncertain nature of that cause. In an editorial titled 'A Monument to our Discomfort' Ellen Gooden writes,

So, in the end, we have a political pastiche of heroism and loss, a trio of warriors larger than life, and a list of the dead. Instead of a resolution, we have an artistic collision of ideas, an uncomfortable collage of our Vietnam legacy. Maybe, just maybe, that's fitting.[19]

In a similar vein, Frank McConnell comments,

On the one hand, a large black slab with the names of the dead; on the other a craggily heroic sculpture of noble young men alert in the cause of freedom. The Vietnam Monument, in its internal dissonance, is a metaphor, and maybe a perfect metaphor, for the psychic dissonance which was and is that disastrous episode.[20]

Gooden and McConnell attribute perhaps too much force and presence to the Hart addition. By all accounts, the controlling piece of the memorial is the wall, which reminds us that the cause was uncertain and the cost high. The wall speaks not only to the veterans who participated and the relatives who suffered loss, but to everyone who shared in that uncertainty. The activities at home were as much a root cause of that doubt as the activities on the battlefield. In that sense, everyone is a veteran of the Vietnam conflict and everyone senses the loss, the death of purpose, that marked it.

Eros and Thanatos. Eros marks the periods of spring and summer. There is a spirit of youth and innocence. Good and evil are clearly distinguished. Heroic deeds are undertaken and accomplished. Comedy and romance flourish. Thanatos marks the periods of autumn and winter. The spirit of youth is defeated and heroic deeds fail. Good and evil are less clearly distinguished and good loses. Tragedy reigns. Moving from Eros to Thanatos, a society passes from innocence to experience, from romance to tragedy, as the United States did in Vietnam. As one commentator noted, 'Vietnam is tragedy, nothing more or less.'[21] As a statement of Thanatos – death, frustration and loss of purpose – the Vietnam Memorial impresses on us the tragedy of that national experience.

NOTES

1. K. Burke, 'Doing and Saying: Thoughts on Myth, Cult and Arch-etypes', *Salmagundi*, 15 (Winter 1971) 103.
2. Ibid., p. 108.
3. E. Bumiller, 'The Memorial Mirror of Vietnam', *Washington Post*, 9 Nov 1982, section F, p. 10.
4. 'Proposed Viet Sculpture Shown as Architects Fight Additions', *American Institute of Architects Journal*, 71 (Oct 1982) 22.
5. J. Fontenrose, *Python: A Study of the Delphic Myth and its Origins* (Berkeley, Calif.: University of California Press, 1959) p. 474.
6. K. Burke, 'Myth, Poetry and Philosophy', *Language as Symbolic Action* (Berkeley, Calif.: University of California Press, 1966) p. 388.
7. P. McCombs, 'Maya Lin and the Great Call of China', *Washington Post*, 3 Jan 1982, section F, p. 9.
8. Ibid.
9. *Washington Post*, 13 Nov 1982.
10. McCombs, in *Washington Post*, 3 Jan 1982, section F, p. 9.
11. M. T. Gannon, 'War Memorial', *America*, 148 (22 Jan 1985) 55.

12. *Newsweek*, 15 Apr 1985, p. 46.
13. F. McConnell, 'A Name for Loss', *Commonweal*, 112 (9 Aug 1985) 441.
14. *Newsweek*, 15 Apr 1985, p. 37.
15. *Newsweek*, 22 Nov 1982, p. 80.
16. M. Marriott, 'Thousands Pay Tribute at Vietnam Memorial', *Washington Post*, 31 May 1983, section B, p. 6.
17. G. Zahn, 'Memories in Stone', *America*, 149 (15 Oct 1983) 213.
18. G. Schultz, 'The Meaning of Vietnam', *Department of State Bulletin*, 83 (June 1985) 16.
19. E. Gooden, 'A Monument to our Discomfort', *Department of State Bulletin*, 83 (June 85) p. 1.
20. McConnell, in *Commonweal*, 112, p. 441.
21. *Newsweek*, 15 Apr 1985, p. 35.

15

The Vietnam Veterans Memorial: Authority and Gender in Cultural Representation

HARRY W. HAINES

Not all Vietnam combat veterans welcomed the prospect of memorialising the war. While some veterans argued over the appropriate signs whereby Vietnam might enter the sacred ground of the Washington Mall, others argued against any attempt to represent the war in the cultural form of public architecture. William Ehrhart gives voice to this position in his poem 'The Invasion of Grenada'. 'I didn't want a monument, not even one as sober as that vast black wall of broken lives', Ehrhart announces;

> What I wanted was a simple recognition
> of the limits of our power as a nation
> to inflict our will on others.
> What I wanted was an understanding
> that the world is neither black-and-white
> nor ours.
> What I wanted
> was an end to monuments.[1]

Thomas Roberts, an activist in the GI anti-war movement, suggested alterations to what he expected would be the 'typical' war monument: 'Defy the typical motif by situating the slab sunken, sucking air for meaning.' Roberts envisioned an archlight beaming across the Mall, illuminating a monumental crater, 'the ashes of 50,000 John Does . . . scattered in the bottom'.[2]

Ehrhart and Roberts responded angrily to what they saw as the predictable co-optation of their combat experience and of the war dead. They understood intuitively what Walter Benjamin had concluded in the 1930s: 'Even the dead will not be safe from the enemy if he wins.'[3] It seemed that the war's bitter irony would be

finally sealed in the signifying practices of administrative power, determined to use Vietnam as a sign of domination. In the end, it appeared, Vietnam would be transmogrified as the politician's Veterans' Day speech.

But the Vietnam Veterans Memorial (**plate 33**) held several surprises. The design avoids the glorification of war and instead generates a sacred space in which pilgrims enact Vietnam's meaning by touching the names of the dead. The memorial's unique interactive quality demonstrates a feminine interpretation of the Vietnam experience, apparent in the signification of the injured body.

FEMININE CHARACTERISTICS

The memorial's feminine characteristics have less to do with artist Maya Lin than with the design criteria established by the selection committee. More than 1000 design proposals moved through the selection process. An eight-man jury judged each submission against criteria stipulating

> that the memorial must include a list of names of the war dead, that it must relate sensitively to the Washington Monument, the Lincoln Memorial, and other major monuments, and that it should be 'reflective and contemplative in nature', refraining from making any 'political statement regarding the war or its conduct'.[4]

In addition to these constraints, three powerful layers of government bureaucracy (the National Capital Planning Commission, the Commission of Fine Arts and the Department of the Interior) passed judgement on the winning design, prompting one critic to observe that 'those attuned to theoretical and experimental currents in contemporary art might have had reason to fear that these men would agree on a design that was too safe, too staid, and too conservative to cause a stir'.[5]

The design criteria and the politics of selection produced a memorial consistent with Jung's concept of the 'mother archetype'.[6] Because the memorial might not conflict with nearby images of national meaning, it had to take shape as a sign 'integrated into

and interdependent with the earth'.[7] Because the memorial might not overtly represent the politics of Vietnam, it had to avoid the heroic realism of the conventional war monument. Because the memorial was required to inscribe the name of each fallen warrior, it had to develop as a horizontal 'wall' which visitors might read. By necessarily breaking from conventional form, the memorial communicates a 'female sensibility', identified by Sonja Foss as an embrace;[8] it establishes a 'safe, non-threatening' zone, capable of 'engulfing, nurturing, and enfolding' the pilgrim. By specifically avoiding a code of domination, the wall comforts the viewer while simultaneously invoking a sense of loss.

The memorial's feminine embrace demonstrates what Jung interprets as the positive characteristics of the mother archetype, including 'all that is benign, all that cherishes and sustains, that fosters growth and fertility. The place of magic transformation and rebirth, together with the underworld and its inhabitants, are presided over by the mother.'[9] The selection of Maya Lin's design generated an intensely bitter dispute, variously interpreted as a style war between proponents of abstract and realistic art.[10] But the argument was political, not aesthetic. While some veterans worried that the memorial might represent Vietnam as a sign of domination, others argued that it ought to do just that. Criticism of the design focused specifically on the memorial's feminine characteristics as inappropriate signs of war. The enemies of the design attempted to assert 'an ideology of male dominance', based on 'the specialisation of men in warfare',[11] or so the language used to attack the winning entry suggests.

Veteran Tom Carhart, a civilian lawyer at the Pentagon, called the design 'a black gash of shame and sorrow' and asked the Commission of Fine Arts, 'Are we to honour our dead and our sacrifices to America with a black hole? . . . Can America truly mean that we should feel honored by that black pit?'[12] Carhart had proposed his own design of a representational figure of an army officer holding the body of a dead infantryman toward the sky. He called Lin's design 'the most insulting and demeaning memorial to our experience that was possible'. Author James Webb called the design a 'wailing wall for anti-draft demonstrators'.[13] Phyllis Schaffly and writer Tom Wolfe called the memorial a 'tribute to Jane Fonda', and other descriptions ranged from 'degrading ditch' to 'beer garden urinal'. In these and other examples, critics responded negatively to qualities associated with Jung's

interpretation of the mother archetype.[14] From the critical perspective of Carhart and others, the memorial failed to represent the soldier's self-sacrifice as a sign of war.

INJURED BODIES

The wall acknowledges what Elaine Scarry calls 'the referential instability of the hurt body'.[15] In her analysis of 'the structure of war', Scarry focuses attention on the phrases 'to kill for his country' and 'to die for his country', the universal declarations of motive in warfare. The killing and dying constitute 'a deconstruction of the state as it ordinarily manifests itself in the body',[16] requiring 'the appended assertion [either verbalised or materialised as in the uniform] "for my country"'. The wall avoids the 'appended assertion' and assigns no heroic motivation whatever to the injured bodies, significant by their absence. Only individual names accumulate as war's residue, prompting the *National Review* to complain, 'The mode of listing the names makes them individual deaths, not deaths in a cause; they might as well have been traffic accidents.'[17] But the list of names makes it possible for the memorial to comfort the visitor while simultaneously evoking a sense of profound loss.

Because the wounded body always implies 'the unmaking of the civilisation as it resides' in the body, Scarry insists that 'the roll call of death should always be taken as it was first taken by Homer' following the Trojan War, including in the roll call of names 'one attribute of civilization as . . . embodied in that person, or in that person's parent or comrade, for the capacity for parenting and camaraderie are themselves essential attributes of civilization'.[18]

The injured body, represented by the individual name, develops as the sign of the deconstructed nation, and this sign is enacted in the ritual of touching the wall. By touching an individual name, the pilgrim acknowledges the injured soldier's absence from social relationships, locating Vietnam 'as an experiential and historical fact in the lives of . . . families'[19] and in other social networks extending across time.

Each name locates the meaning of war in the lived, individual experience of a specific casualty, whose absence from the social network extends the meaning of war to the community. Each name

is a sign of an injured body, a life lost at a specific moment. Because the names are listed chronologically, and not alphabetically, the reader must search for a specific name according to the specific moment of loss. Occasionally, an alphabetical arrangement breaks the precise pattern of representation, and 'we know that here were the men of a single platoon, wiped out together in a single engagement'.[20] Instead of serving as a sign of the structure of war, the injured body signifies what Carol Gilligan calls the 'structure of interconnection'.[21]

The memorial does not 'separate war and politics', as Charles Griswold has recently argued.[22] On the contrary, it develops as a politically volatile sign of our relationship to others and to the state.[23] By inviting the pilgrim to experience the meaning of war as broken social relationships, the wall demystifies the structure of war and makes the injured body unusable as a sign of domination.

NOTES

1. W. Ehrhart, *To Those Who Have Gone Home Tired: New and Selected Poems* (New York: Thunder's Mouth Press, 1984) p. 71.
2. While on active duty at Fort Carson, Colorado, Roberts was publisher of *Aboveground*, one of 150 anti-war newspapers distributed in the armed services. The source of the quotation is T. Roberts, *Personal Correspondence* (1985).
3. W. Benjamin, *Illuminations*, ed. H. Arendt, tr. H. Zohn (New York: Schocken, 1969).
4. C. Howett, 'The Vietnam Veterans Memorial: Public Art and Politics', *Landscape*, 28, no. 2 (1985) 4.
5. Ibid.
6. C. Jung, *Aspects of the Feminine* (Princeton, NJ: Princeton University Press, 1982) pp. 103–12.
7. S. Foss, 'Ambiguity as Persuasion: The Vietnam Veterans Memorial', *Communication Quarterly*, 34 (1986) 333.
8. Ibid., p. 333.
9. Jung, *Aspects of the Feminine*, p. 138.
10. See Howett, in *Landscape*, 28, no. 2; and E. Hess, 'A Tale of Two Memorials', *Art in America*, Apr 1983.
11. L. Nicholson, *Gender and History* (New York: Columbia University Press, 1986) p. 95.
12. P. McCombs, 'Reconciliation: Ground Broken for Shrine to Vietnam War Veterans', *Washington Post*, 27 Mar 1982, p. 14.
13. Hess, in *Art in America*, Apr 1983, p. 122.
14. Jung, *Aspects of the Feminine*, p. 109.

15. E. Scarry, *The Body in Pain: The Making and Unmaking of the World* (New York: Oxford University Press, 1985) p. 121.
16. Ibid., p. 122.
17. *National Review*.
18. Scarry, *The Body in Pain*, p. 123.
19. R. Berg, 'Losing Vietnam: Covering the War in an Age of Technology', *Cultural Critique*, 3 (1986) 123.
20. W. Hubbard, 'A Meaning for Monuments', *Public Interest*, 74 (1984) 20.
21. C. Gilligan, *In a Different Voice* (Cambridge, Mass.: Harvard University Press, 1982).
22. C. Griswold, 'The Vietnam Veterans Memorial and the Washington Mall: Philosophical Thoughts on Political Iconography', *Critical Inquiry*, 12 (1986) 714.
23. P. Ehrenhaus, 'Names, not Inspiration: When a Memorial Speaks Non-Discursively', paper presented at the meeting of the Eastern Communication Association, Providence, RI, May 1985, p. 14.

16

The Vietnam Veterans Memorial: Ideological Implications

TERRANCE M. FOX

In a 1983 article entitled 'V for Veneer', I argued that the design chosen for the Vietnam Veterans Memorial (**plate 33**) was inconsistent with American values. That such a situation could occur I attributed to the selection process for the memorial design, which I perceived to be overwhelmingly influenced by artistic rather than political and social concerns. That argument was flawed, as it was based on an internalised concept of military service, a subjective concept developed over a relationship of a quarter century. I was projecting a concept of a military model that was now outdated. I cannot plead that the transformation had occurred in the six-year period since I had left the military. In fact, some of my own writing reflects suggestions of such a change.

In the course of my military service, my experience had primarily been with what has been identified as the heroic military model, reflecting a reliance on individual creativity in an essentially monastic environment – that is, a military separated from the mainstream of society by a unique ethos and acceptance of relatively onerous duties and obligations. The gradual change to an institutional military model actually began in the years following the Second World War and continued throughout the 1950s and early 1960s, though possibly retarded by the Korean conflict. The process was accelerated by the Vietnam War and gathered enormous momentum in the late 1970s.[1]

The specific variables involved in the transformation are many and varied and the impact of each of them is a subject of debate. Most military scholars would identify a minimum of four factors: the lack of identification of the individual soldier with a political goal; technological innovation; the imposition of a bureaucratic system; and the convergence of military and civilian lifestyles.[2]

The development of the deterrence strategy by the NATO allies

following the Second World War obscured the political goal with which the individual soldier could identify. 'Unconditional surrender' is a clear, concise and measurable goal. The corporal manning the machine gun, the airman repairing aircraft engines or the sailor operating the sonar can understand the contribution his effort makes toward the goal. When the end is 'deterrence' the contribution such effort makes is called into question. Is the adversary deterred by our effort, or does he choose not to make an effort at this time for reasons of his own which have no connection with our efforts? Korea gave the first indication of the problem. The individual soldier in Korea shared no identification with the political goal for which the war was fought. To capture and occupy he could understand; to deter was a more subtle process with which he could not identify. This undermined the basis for what used to be called *esprit de corps*, an obedience and enthusiasm based on a unity of purpose.[3]

Technological innovation contributed to the advance of the institutional model by mitigating the requirement for individual creative action. An oversimplified but valid analogy is the wooden-ships iron-men adage we learned in our youth, a folk maxim of uncertain origin which proclaims that in days of old we had wooden ships and iron men; today we have iron ships and wooden men. The analogy demonstrates the decline of personal bravery and increasing reliance on technology in its place. Additionally, in a military force dependent on technology the individual represents a significant investment in training. His function is to ensure the proper operation of the equipment, not to improvise solutions.[4]

The maintenance of a peace-time standing army created the need for a bureaucratic system of control. The principle of civilian control of the military in the United States is one which is deeply ingrained. The people have always demanded that the individuals authorised to employ legal force be strictly regulated. In addition, with the coming of the age of technology vast sums were involved in weapons procurement, necessitating a structure which would ensure fiscal accountability. The imposition of bureaucratic control reinforces the restraint on individual creativity imposed by technology. While technology may dictate that the equipment may be properly operated in a given manner, bureaucratic control dictates that it be operated in a given manner and employed only in the bureaucratically sanctioned mode. The net effect is to limit the options available to commanders and subordinates alike. Manage-

ment becomes confused with command, and in fact replaces it.[5]

The last of the four factors identified may be the most pervasive and influential. I would argue that the convergence of military and civilian lifestyles, though already under way for a considerable period of time, was immensely accelerated by the ending of conscription in 1974 and the advent of the all-volunteer force. Not only did the military find itself faced with the pressures implied by a permanent population of dependants accompanying its personnel around the globe, but it was also forced to build an environment which would allow it to compete successfully for manpower in the marketplace. Even casual observation of an overseas US military station today will provide the informed observer with a host of dramatic examples of the nature of the change. Probably the easiest to verify empirically is the shift in emphasis of the European Exchange System, which provides US military members with access to goods available in the United States at representative dollar prices. The system was originally oriented toward providing the overseas member and his family with a minimal level of convenience by providing US standard goods not available on local markets; at the same time, local markets and consumers were protected from excessive demand for goods which the local economy could not supply. Today the system is a market-oriented one, indistinguishable from that practised by US main-street profit-oriented retailers, whose goal is to maximise sales. The US military has traditionally sought to build 'little Americas' at overseas garrisons, for a variety of social and cultural reasons, but the practice has been considerably intensified since the advent of the all-volunteer force. And civilianisation extends to all spheres – to what the individual expects in terms of discipline, relationships, authority, working conditions and monetary compensation.

It is axiomatic that, in the United States and, in all likelihood, all Western states, the military is a reflection of society, and a concurrent change was occurring in American society. A collectivist tendency was gathering momentum in the United States, most readily identifiable in the industrial north and north-east regions. The tendency was characterised by the contention that private and public interests were substantially interdependent, that private action must take account of the public interest. The movement was non-ideological in the sense that it rejected identification with traditional partisan political philosophies in favour of identification

with the public interest.[6] Witness the growth, throughout the United States, of non-profit-making organisations called 'public interest research groups', whose main concern is not research but influencing public policy in the interests of consumers.

This 'new collectivism' had an element of moral appeal, arguing that the redistribution of resources is a moral imperative in an affluent society which harbours poverty in its midst. The movement benefited from the influence of other Western societies in which the collectivist tendency was further advanced.[7] The dissatisfaction of the working classes was exacerbated by the media revolution heralded by the advent of mass television. No more was the disparity between affluent and simple lifestyles left to the imagination; now it could be seen. The relatively prosperous middle classes, a sizable segment of American society, are prone to accede to pressure for social change so long as their freedom to continue to pursue economic goals is not severely restricted or handicapped.

But, in order to spread, the 'new collectivism' needed a soil in which it could be nurtured. The ambivalent attitudes toward the war in Vietnam contributed to a growing lack of consensus regarding the ethical foundations of society.[8] The nation is deeply divided about such fundamental issues as abortion, prayer in schools, and homosexual rights. Drug usage is accepted as the norm by a significant segment of US society and rejected out of hand by another. Cohabitation and single parenthood have become unexceptional events in some circles, while other sectors of society hold such practices to be immoral and objectionable.

If the ethical foundations of society are not a matter of consensus, it follows that educational homogeneity is lost. The educational system no longer functions to inculcate the *nomos* of society; indeed, it is ill-equipped even to define it. The very purpose of education has become a matter of dispute. The concept that socially useful skills should be taught in educational institutions has largely replaced the idea of accumulating knowledge in the hope of its later application. Universities have become accustomed to applying the test of 'relevance' to proposed new courses, and indeed to existing ones.[9]

In a society whose ethical foundations are ill-defined and where the educational system fails to inculcate a set of basic values, pluralism has intensified. 'The society has no prevailing convictions of sufficient strength to warrant their enforcement, beyond a basic legal system designed to protect individual rights', says one student

of civil–military relationships.[10] In such an environment the 1970s slogan 'Do your own thing' becomes the behavioural imperative. The society provides no locus of philosophical principle, a condition which facilitates the proliferation of cults and mind-expanding vogues.

Among the principles of the 'new collectivism' which permeates US society five predominate: government is an instrument which should be used to solve social problems; government has unlimited responsibility for the general welfare; problems will yield to government action; the idea of government is provision of service, not wielding of power; and the expenditure of money is the key to government action.[11]

The Vietnam veteran returned to such a society, a society in which war receives unqualified support only when two conditions are met: national security is threatened and political principles are clearly at stake. Such circumstances have rarely occurred. Only in the Second World War did the US population respond with near-unanimous support for the undertaking. Samuel Huntington has observed that Americans have no trouble conceiving of their government running an 'unAmerican' war, and Vietnam was perceived by a substantial portion of the population to be such a war. To compound the indignity, it was one in which American arms were defeated, a situation to which the US population at large and the US military in particular were unaccustomed.[12]

The bitterness of the internal dispute over Vietnam was exacerbated by an ingrained anti-militarism which equates war with pestilence, a canker to be excised lest it infect the remainder of society. This view allows for no Thomistic dichotomy, no differentiation between just and unjust wars. The soldier is viewed as an individual engaged in a sinister, nasty business. The Vietnam veteran became the target of such attitudes. And he was in general ill-equipped to handle such additional pressure. Although military conscription was intended to spread the burden throughout society, the draft, because of educational and other deferments, had its greatest impact on the less privileged.[13]

The Vietnam veteran became alienated from society in a way that only one who believes himself a fully integrated member of society and yet finds himself deprived of that status can know. The manifestations of this alienation became the hallmark of the stereotypical Vietnam veteran: he saw himself as an object, not a

subject, of political life; he perceived the government as not acting in his interest, as not being 'his' government; and he perceived the rules promulgated by that government as unfair and illegitimate. Fromm has described the roots of alienation as a feeling of estrangement from oneself and others and a sense of homelessness, a lack of a sense of where one belongs. One lacks companionship, the camaraderie of friends; a feeling of place, a sense that this community is one's own community; a function in life, a job with which one identifies; and a specific role in society, from which one can relate to the rest of the body politic.[14]

This description unfortunately describes with telling accuracy the plight of substantial numbers of Vietnam veterans, estranged from companions who had not shared their experience, deprived of a place in the community by suspicion, hostility and contempt, unemployed with scant prospects, and rejected not only by the Rotary Club but also by the institutions which had served as vehicles of rehabilitation and socialisation for previous generations of veterans, the American Legion and the Veterans of Foreign Wars.

The mechanism involved in coping with such estrangement and homelessness evolved over time. The powerless individual, in desperation, seeks out other powerless individuals and forms a powerless group. In time the group unites with other groups until they reach the point where they are collectively able to exert influence.[15]

While this process was under way, society, owing to the change to an all-volunteer force, was becoming more alienated from the military services. This appears at first glance to be a contradiction in terms, as the same change ensured that the military became more and more a reflection of the society which served as its midwife. But the all-volunteer force created a gap between society at large and the military services. Whole segments of society had no reason to think about the military at all, either positively or negatively. It simply no longer required one's attention. The military attracted those whose prospects on the open market were questionable.[16]

Alexis de Tocqueville remarked in another time and place, 'The best part of the nation shuns the military profession because that profession is not honored, and the profession is not honored because the best part of the nation has ceased to follow it.' Despite the unfair nature of the draft, it produced a military force that was

more representative of US society as a whole than that produced by voluntary enlistment.

As this process unfolded, the Vietnam veteran came to be seen increasingly as a victim. This coincided with the rise of what Huntington terms the 'new moralism', a reaction to the Vietnam and Watergate experiences which began under the Carter administration and places morality above self-interest in foreign affairs. In Huntington's formulation, there is a historical gap between US political ideals and institutional reality. When the liberal ideal confronts institutional reality and finds it lacking, tension occurs and produces a cognitive dissonance which must be dealt with. If we are fortunate, a balanced approach will prevail; if it does not, society will be placed at considerable risk.[17] There are four principal ways in which this may happen.

One danger is excessive moralism, characterised by the destruction of institutions in the belief that they are unworthy.[18] It can be argued that the wholesale dismemberment of the CIA under President Carter, and the anti-Washington tendencies of both President Reagan and the New Right, reflect such moralism.

Excessive cynicism represents the opposite approach and is characterised by the abandonment of ideals and the adoption of new beliefs devoid of moral content, such as 'might makes right'.[19] Some would argue that the current 'Rambo-mania' in the United States is indicative of such a phenomena, and the raid on Libya a manifestation of it.

A third means of coping with the cognitive dissonance created by the gap between ideal and reality is complacency – that is, acceptance of the fact that institutions are corrupt and connivance in the continuance of that corruption.[20] The involvement of high municipal, state and federal officials in questionable business practices and schemes to launder illegal profits from the drug trade is viewed by some as an indication that complacency is indeed a presence on the current US political scene.

Finally, a society may resort to hypocrisy, typically imperialistic adventures which carry the risk of defeat abroad and the undermining of democracy at home.[21] Many would characterise the Reagan administration's Central American policy as an example of such hypocrisy.

Elements of all these tendencies were at work while the process which led to the construction of the Vietnam Veterans Memorial unfolded. But so were more durable trends. Long ago de Tocque-

ville identified equality as the key to various aspects of the US national character. The most fervently embraced expression of such equality is the rejection of the *ancien régime* concept of rank, the idea that we are all equal in our common humanity, all equal in intrinsic worth, all equal in rank.[22]

Although the 'new collectivism' claims to be non-ideological, I would suggest that, by most measures, it possesses the attributes of an ideology: it deals with how power is to be used; it is intended to persuade; it offers programmes for institutional reforms; it is normative and moral; it implies belief in an empirical cause-and-effect relationship in human affairs. Considerable evidence suggests the existence of an ideological movement, albeit one without central direction and control. And it is axiomatic that all ideologies have their 'sacred documents'.[23]

I would argue that the Vietnam Veterans Memorial has become a 'sacred document' of the 'new collectivism'. All are equal on the black marble walls. There is no rank or precedent. All are equal in the Hobbesian sense, all equally susceptible to death. Death becomes the badge of rank of those named, establishes their claim to a particular place on the wall and their relationship with their comrades. Individualism is substantially suppressed. The names, not arrayed or organised in lists, run on like words on a printed page.

Almost every American was touched in some way by the Vietnam War. It would be difficult to locate a single individual who had not served, had friends or relatives who served, or knew someone who had suffered because of the death or disablement of a friend or relative in Vietnam. What more appropriate symbol of the 'new collectivism' exists in the United States today? It is my contention that the processes I have outlined have contributed to the immediate extraordinary popularity of the monument among visitors to the nation's capital.

Not only does the memorial accord with the central tendencies of the society, but it is consistent with the change from a heroic to an institutional military model. The Vietnam Veterans Memorial does not resemble other memorials to American fighting men. Nor perhaps should it, any more than the men commemorated should resemble one another when the military forces in which they served were of fundamentally different kinds.

On reflection, I believe it quite possible that a truly representative,

politically oriented design-selection process would have led to the same choice as that determined by the artists.

NOTES

1. For a discussion of the changing military see C. Moskos, *Public Opinion and the Military Establishment* (1971) and *Peace Soldiers* (1975); and A. Yarmolinsky and G. D. Foster, 'The Impacts on American Society', *Pardoxes of Power: The Military Establishment in the Eighties* (Bloomington: Indiana University Press, 1983).
2. Yarmolinsky and Foster, in *Paradoxes of Power*, pp. 71–92.
3. Ibid.
4. Ibid.
5. Ibid.
6. For a discussion see R. R. Lane, *Political Ideology* (New York: Free Press, 1962) pp. 187–96.
7. Ibid.
8. D. A. Zoll, 'A Crisis in Self-Image: The Role of the Military in American Culture', *Parameters*, Dec. 1982.
9. Ibid.
10. Ibid.
11. Lane, *Political Ideology*, pp. 187–96.
12. S. P. Huntingdon, 'American Ideals versus American Institutions', *Political Science Quarterly*, Spring 1982.
13. Zoll, in *Parameters*, Dec 1982, pp. 24–31.
14. See Lane, *Political Ideology*, pp. 161–86; and E. Fromm, *The Sane Society* (New York: Rinehart, 1955) p. 120.
15. Lane, *Political Ideology*, pp. 161–86. A historical reference for the unification of powerless groups till they reach the point where they are able collectively to exert influence may be found in the anti-Vietnam War movement itself, which originated with small groups outside the political, and often social and cultural, mainstream. Other groups were gradually attracted, broadening the base of the movement, until the point was reached when the momentum became overwhelming.
16. For a discussion of the impact of the all-volunteer force see Zoll, 'A Crisis in Self Image', *Parameters*, Dec 1982; Yarmolinsky and Foster, 'The Impacts on American Society', *Paradoxes of Power*; and L. Baritz, *Backfire: A History of How American Culture Led us into Vietnam and Made us Fight the Way we Did* (New York: William Morrow, 1985) pp. 321–50 and pp. 378–9.
17. Huntingdon, in *Political Science Quarterly*, Spring 1982, pp. 1–37.
18. Ibid.
19. Ibid.
20. Ibid.
21. Ibid.

22. For a discussion of American national character see D. M. Potter, 'The Quest for National Character', in J. Higham (ed.), *The Reconstruction of American History* (London: Hutchinson, 1975).

23. Lane, *Political Ideology*, pp. 13–16.

Index

221